BRYAN PETERSON'S

UNDERSTANDING PHOTOGRAPHY
FIELD GUIDE

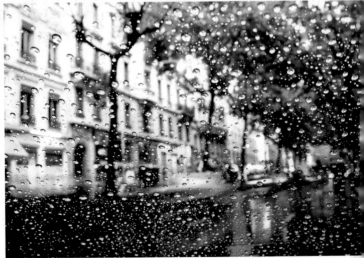

BRYAN PETERSON'S

UNDERSTANDING PHOTOGRAPHY FIELD GUIDE

HOW TO SHOOT GREAT PHOTOGRAPHS WITH ANY CAMERA

Amphoto Books
an imprint of Watson-Guptill Publications
New York

To my three publishing heroes, Victoria Craven, Julie Mazur, and Alisa Palazzo, thanks for speaking *my* language.

ACQUISITIONS EDITOR: Victoria Craven
PROJECT EDITOR: Alisa Palazzo
ART DIRECTOR: Jess Morphew
DESIGNER: Karla Baker
PRODUCTION MANAGER: Alyn Evans

Page 1: Nikon D2X, 70–200mm lens at 120mm, $f/11$ for 1/60 sec. Page 2: 28mm lens, graduated ND filter, ISO 50, $f/8$ for 1 second, tungsten film (top); 35–70mm lens, $f/16$ for 1/8 sec. (bottom). Page 5: Nikon D2X, 17–55mm lens at 17mm, $f/22$ for 1/15 sec. Page 6: Nikkor 35–70mm lens, ISO 100, $f/22$ for 1/8 sec. Page 7: Nikon D2X, 17–55mm lens at 40mm, ISO 100, $f/18$ for 2 seconds. Page 12: 35–70mm lens at 35mm, $f/4$ for 1/250 sec. Page 13: 17–55mm lens, ISO 100, $f/8$ for 1/15 sec. Page 26: 80–200mm lens at 200mm, $f/16$ for 8 seconds. Page 27: 300mm lens, 36mm extension tube, $f/5.6$ for 1/250 sec. Page 44: Nikkor 35–70mm lens, ISO 50, $f/8$ for 1/60 sec. Page 45: 18–70mm lens, $f/8$ for 1/180 sec. Page 74: Nikon D2X, 105mm lens, ISO 200, $f/10$ for 1/2000 sec. Page 75: 17–55mm lens at 17mm, ISO 125, $f/10$ for 1/30 sec. Page 116: Nikkor 12–24mm lens, Canon 500D close-up filter, $f/22$ for 1/60 sec. Page 117: 20mm lens, $f/22$ for 1/60 sec. Page 160: 20mm lens, $f/22$ for 1/60 sec. Page 161: Nikkor 300mm lens, 36mm extension tube, ISO 100, $f/5.6$ for 1/60 sec. Page 252: 12–24mm lens, graduated ND filter, $f/22$ for 1/8 sec. Page 253: 35–70mm lens, $f/11$ for 1/125 sec. Page 322: Micro-Nikkor 70–180mm lens, $f/13$ for 1/40 sec. Page 323: Micro-Nikkor 70–180mm lens, $f/11$ for 1/125 sec. Page 344: Nikon D2X, 17–55mm lens at 50mm, ISO 400, $f/3.2$ for 1/750 sec. Page 345: 17–55mm lens at 26mm, $f/5.6$ for 1/125 sec. Page 354: 12–24mm lens, polarizing filter, 4-stop ND filter, ISO 100, $f/16$ for 1/2 sec. Page 355: 70–200mm lens at 116mm, ISO 200, $f/22$ for 1/2 sec. Page 378: 70–200mm lens, ISO 100, $f/11$ for 4 seconds. Page 379: 70–180mm lens, $f/8$ for 1/125 sec.

First published in the United States by Amphoto Books
an imprint of Watson-Guptill Publications
Crown Publishing Group
a division of Random House, Inc., New York
www.crownpublishing.com
www.watsonguptill.com

Portions of this material were published previously in the following best-selling Bryan Peterson books: *Learning to See Creatively, Understanding Exposure, Understanding Digital Photography, Beyond Portraiture, Understanding Shutter Speed,* and *Understanding Close-up Photography.*

Library of Congress Cataloging-in-Publication Data
Peterson, Bryan, 1952–
 Bryan Peterson's understanding photography field guide : how to shoot great photographs with any camera. -- 1st ed.
 p. cm.
 Includes index.
 ISBN 978-0-8174-3225-6 (pbk.)
 1. Photography--Handbooks, manuals, etc. I. Title. II. Title: Understanding photography field guide.

 TR146.P42356 2009
 770--dc22
 2008053968

ISBN: 978-0-8174-3225-6
Printed in China
10 9 8 7 6 5 4 3 2 1
First Edition

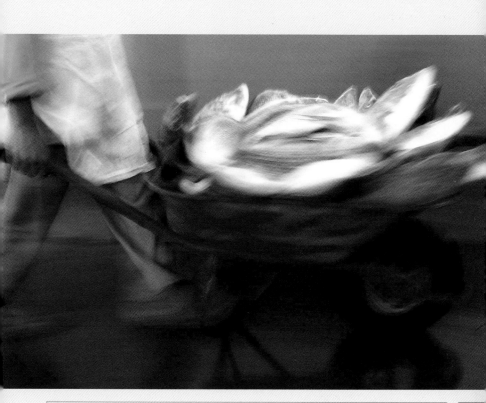

The question is not what you look at but what you see.
—*Henry David Thoreau*

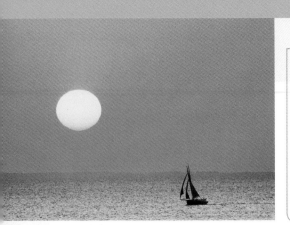

CONTENTS

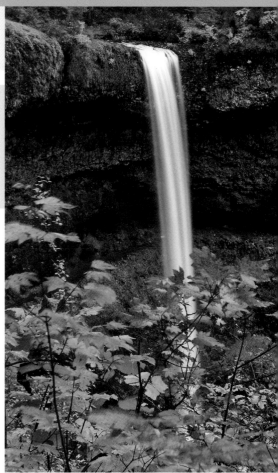

INTRODUCTION

I have yet to meet anyone who hasn't expressed at least once in their lifetime, "Where did all the time go"? For me, writing this field guide has been a real eye-opener in many respects, in particular in making me suddenly aware of where all the time did actually go. More than 38 years have passed since that fateful day when my oldest brother, Bill, placed a camera in my hands. If nothing else, this sudden awareness of time is proof that passion is truly the great, *invisible* time-keeper. I know that the calendar tells me I'm 56, but it is in marked contrast to what my "18-year-old" heart still feels today—that every day is a photographic opportunity!

Back in 1970, fresh out of high school, I honestly had no plans to be a photographer. Back then, I had already made my career choice as a commercial artist and cartoonist, having begun to enjoy the success of selling my pen-and-ink landscape drawings at local arts and crafts festivals. My one and only complaint in my life back then was about the time I had to spend at each location actually drawing these images as I traveled around the Pacific Northwest in my VW van. It was Bill who suggested I borrow his camera, photograph these landscapes, make some 8 x 10–inch prints in his darkroom, and then draw my landscapes from the photos while seated in the comfort of my own home.

With minimal instruction, I headed off and shot two rolls of black-and-white film over the next three days. A day later, with my brother's help in the darkroom, I was absolutely mesmerized by the immediacy of the photographic print—and I was hooked! I bought more black-and-white film and shot everything I could for the next eight months, when I made what proved to be one of the best mistakes of my life. Reaching into a basket on the counter in a local camera store, I bought three rolls of "outdated" Agfachrome 35mm film, not having a clue that it was color slide film. I spent the weekend photographing, and when I showed

up at my brother's darkroom, he pointed out that the film wasn't black and white but rather color slide film. I wasn't thrilled to have to make the trip to the camera store to have the film processed, but my brother convinced me that I should "because you never know . . . you might like the colors." Just how happy was I with the colors? Let's just say that over the course of these past 38 years, I've shot 99 percent of everything in living color!

In so many ways, I feel fortunate to have been introduced to photography when it was still a "manual world," since I was forced to learn the mechanics of things. In addition, I was forced to invent, to find ways to make the shot work, since my gear was also limited to one basic lens back then (a fixed 50mm F1.4). I did eventually buy a Nikkormat FTN, along with a 28mm F3.5 and a 200mm F4, but only after my brother Bill called to ask, "Any chance I can get my camera gear back?" Bill is, obviously, a patient and kind brother.

Back in those days, there weren't a lot of how-to books on photography either, and that actually forced me once again to really learn how my camera and lenses worked. I had to unravel the mystery of exposure, of depth of field, and of depth and perspective, and I had to learn both the challenges of making a well-composed image and the need to pay attention to light. I kept journals of the f-stop, shutter speed, and lens choice of, literally, all my exposures. I also noted time of day and location. It was this journal that enabled me to go back and see exactly why some of my exposures worked and some didn't, why sometimes the depth of field was exactly as I had hoped while at other times it wasn't, and why sidelight was in fact best for textures and backlight for silhouettes.

So much has changed in the world of photography since the summer of 1970, not the least of which is the advent of the digital age. Yet it needs to be said that the more things change, the more they stay the same. Every camera is still nothing more than a lightproof box with a lens at one end and a light-sensitive device (be it film or a digital chip) at the other. The process of light entering through the lens to record an image (be it on film or digital media) is still the same. And the recorded image is still called an exposure.

I recall joking at a seminar I taught back in 1990 that I was waiting for the industry to come out with a 20–400mm F2.8 zoom lens with ED glass and internal focusing. Although there's still no such lens on the market today, I can truthfully say that we're a lot closer today than I would ever have imagined. Today, you can leave the house with no more than a camera and one lens and be ready for just about any subject that crosses your path—whether it be a close-up of a butterfly, a distant brown bear, or that big ball of orange flames setting in the western sky. Due to optical advances in the zoom lens arena, zoom lenses now rival, and compete head-to-head

with, the once-favored sharper single-focal-length lenses.

However, the challenge still remains: To advance your personal vision, you must really practice with, and exploit the vision of, your lenses no matter their zoom ratio or amazing sharpness. To that end, this field guide explores the subject of personal vision in great depth and promises to unleash the visionary in you—regardless of technology. Whether you're using film or, like most photographers today, not bothering with film anymore and instead shooting everything digitally, it has very little impact on the one vital ingredient that separates a ho-hum image from an OMG ("Oh my God!"): creativity.

Creativity is perhaps best described as a combination of inventiveness, imagination, inspiration, and perception. The photography industry has yet to introduce a camera that searches out unique and interesting subject matter. There still isn't a camera that will alert you to the two other compelling compositions that lie in wait next to the one you're currently shooting. There still isn't a camera that instinctively recognizes the "decisive moment." And, there still isn't a camera that will systematically arrange your composition in a balanced and harmonious fashion before you expose it digitally or on film. These are challenges that continue to be part of the wonderful world of image-making, challenges for which the sole responsibility of success or failure rests squarely on the photographer's shoulders.

As is true in all of my previous books, this field guide is intended to

dispel the myth that the art of image-making is for the chosen few. You, too, can and will quickly see and understand the difference between a correct exposure and a *creatively correct* exposure. You, too, can learn the myth of ISO. And you, too, will no doubt find yourself seeing in ways you never imagined if you put work through the many exercises and challenges this guide offers up. I've left no stone unturned, offering insights, ideas, and helpful hints and tips on landscapes and cityscapes, close-ups of flowers and close-ups of people, figurative subjects and those that are more abstract.

Nikkor D2X, 17–55mm lens at 17mm, ISO 100, f/8 for 1/1250 sec.

All in all, this field guide addresses the what, where, and why of successful image-making. It's a book about ideas—ideas from the river that flows through all of us. It is my intention to help you find the knowledge of where to fish, the courage to cast your net, and the strength to pull in your catch and harvest those ideas. For many readers, the material in this field guide will be brand new territory, while for others, it may serve as an affirmation of what is already known. Whether you try several or all of the suggestions, you will gain the ability to say, with certainty, that you do know what your exposure will be—and to say, "Not only am I seeing much more than ever before but I am understanding what to do with it!"

And most of all, I want you to have fun with the information provided. Don't become preoccupied with "doing it right"; if there's one thing my students and peers have taught me over the years, it's that there are no set formulas in the pursuit of image-making. It's a simple—and ever-evolving—combination of knowledge, observation, thought, and the courage to press the shutter release.

A FEW
DIGITAL BASICS

Over the past 5 years, I've shot everything digitally, and I see limited use for the more than 200 rolls of E100VS I still have in my freezer. Other than for the occasional client who wants both film and digital and the occasional exposure beyond 30 seconds, I'm now 100 percent digital! Like so many other seasoned professionals, I started over, in many respects. Initially, it was a formidable task, as I had so much to learn. But with that effort has come a reawakening of my early years when I first held a camera in my hand. Back then, each day was one of wonder, amazement, and challenge, and that same childlike feeling is again upon me. I can't read enough about what's hot, nor can I wait to try this or that. I'm like a kid in a candy store! Whether you're just starting out or have been at it for a few years, before getting into the meat of image-making, I want to share with you just a few important thoughts and tips on shooting digitally.

FILE FORMATS

Most commonly, digital imaging offers you the choice of shooting your images into one of two formats or types of electronic files, which are then saved to a memory card. The one you choose will affect not only the immediate outcome of an image's detail, clarity, contrast, and color but also its long-term stability. These two types are: JPEG (Joint Photographic Experts Group) and raw (sometimes seen as RAW, although it isn't an acronym but means *raw*, as in *raw meat*). It's important to understand that both formats are assigned a specific file size, meaning that the exposed image is made of a certain number of megabytes—for example, 1.7 megabytes or 5.7 megabytes or 17 megabytes and so on.

So, after you take a digital image, say, of your son that's made up of six million pixels, that picture information is sent to the camera's image processor. It is then processed as a JPEG, or if you've chosen the raw format, it won't be processed at all but will be stored in a buffer for processing later. It's also important to understand that both of these formats generate a unique file size that's determined by the format. The JPEG format results in smaller files than raw format. The number of files you can store on a memory card will vary depending on which camera era you own, but on average, you can store about three to four times as many JPEGs as raw files. This accounts for why many shooters still shoot JPEGS, even thought it is my preference that you shoot raw, and I'll get to my reasons in a moment.

JPEG

What many shooters don't realize is this: JPEG files *do not* offer up the color range that raw files do, nor can you "play" with the exposure as much in postprocessing. For this reason, every camera manual, digital photography book, and digital photography magazine recommends the same thing that I'm about to recommend: If you insist on shooting in JPEG format (file extension .jpg), and if you care at all

about the life expectancy of your images, then after you've carefully chosen which JPEGs are truly keepers you must save each and every one with the image quality set to 12, making it a "permanent" file with all data saved. This is found in the JPEG Options dialog box in Photoshop. It's important to note that it will be a permanent save as long as you don't do more work on it. If you "play" with the file again (say, open the image and further adjust color balance, contrast, and so on, and then save again), it compresses the file more, which causes a loss in image quality. So, make it a point to do all of your "playing" once, at the same time.

Despite this solution of saving JPEGs as permanent files, there's still something else to consider when shooting with JPEGs: Due to this thing called *compression*, using the JPEG format is akin to listening to your favorite music on AM radio. Rather than capturing every tiny detail of color and contrast in a scene, a JPEG takes a shortcut, averaging out the "like" colors and the "like" contrast and squeezing the data like a sponge—compressing it—so that it becomes a tiny file. Just as you lose a lot of the high-end treble and low-end bass on AM radio, you lose a lot of the subtleties in the color spectrum with JPEGs.

As far as I'm concerned, the only time JPEG should be your choice is when you're just planning to share the photos with family and friends via the Internet. And you should be generating these JPEGs from your original raw files, which is a snap, as you'll soon discover. So, in my mind I'm all for the use of JPEGs, but again, they should always be generated from your raw files.

MEMORY CARDS & WRITE SPEED

When deciding which brand of memory card is best, consider the *write speed*. The faster/higher the write speed, the less time your camera's image processor will spend processing an exposure (writing the data) and the faster it will send it to the LCD screen for viewing.

Most memory cards use the same formula for data transfer rates as the CD-ROM industry—a data transfer rate of 1X equals 150 kilobytes (KB) per second. So, a memory card that offers an 80X write speed is faster than one that offers a 40X write speed—and of course, you pay a bit more for speed. *And note*: All things being equal, your camera's processor speed is of equal importance; your processor must be able to write at the speed listed on your memory card; if it can't write at as fast a speed as listed on the card, it doesn't make sense to buy that faster card.

Raw

Again, the word *raw* isn't an acronym for anything. But since I obviously cannot live in a world without creating my own acronyms (see page 64), I came up with one: Really Amazing Work. If you want the best possible exposure, the best possible color, and the best possible contrast in your photos, then raw—or RAW—is for you.

The term *raw* is also not a file extension (there is no .raw), since there isn't just one raw file format but many. A raw file contains minimally processed picture data from the camera's image sensor, and different camera models have different raw file formats and extensions. Unlike with JPEGs, this image data must first be processed by raw converter image-processing software before it can be printed or further manipulated. Think of a raw file as you would a film negative: It's not directly usable as a picture but contains all the necessary information to create an image. And just as a film negative can be manipulated in chemical processing, so a raw image can be adjusted with software programs such as Adobe Bridge, Adobe Photoshop Lightroom, Apple's Aperture, or Nikon's Capture.

With raw, you can change most of your 2- and 3-stop underexposures and most of your 1- to 2-stop overexposures into correct exposures! With raw, you can also change the white balance and color temperature, increase the clarity and vibrance, add sharpening, and convert a color image to black and white or sepia while it's still in its raw state. After you're done

JPEG & RAW:
TWO IS NOT ALWAYS BETTER THAN ONE

Many cameras offer up the ability to shoot both a JPEG and a raw file simultaneously, and personally, I'm not crazy about this unless you're shooting for newspapers (which are fans of the JPEG file since newspaper print quality doesn't demand the higher image quality that one can record in raw format) or have a large family or social circle. The extra memory that both file formats take up means your memory card fills up quicker. Yes, I know memory cards are ridiculously cheap, but all these images do find their way to the computer, and as you may already know, your computer's

making minor (or major) image adjustments, you can then move this new image into a photo-editing program such as Photoshop and do whatever else you deem necessary. After those tweaks, you choose the Save As option, select TIFF as your file type, and permanently save those changes. If, for whatever reason, you wish to go back and start over, you can go back to the original raw file and select Reset Camera Raw Defaults to return the raw file to its untouched state.

So, when you consider the chief differences between JPEG and raw, think about this way: JPEG is prepared meat loaf; it has the basic ingredients and you simply go home, put it in the oven, and have a decent but uneventful meal. Raw, on the other hand, is raw meat that, with your chef's hat in place, finds you in the kitchen with all of the necessary ingredients and spices at your disposal. How you prepare the raw meat, what you add or don't add, is completely up to you. You're in charge of the recipe, and even with limited cooking knowledge, you can learn some really basic yet valuable skills. Soon, you'll be placing a meal to remember in front of your family and friends.

hard drive fills up quickly (as do any external hard drives), and for what? Out of every 100 shots you take, chances are that no more than 10 are keepers. If only you could become a ruthless editor and start dumping those other 90 shots that you and I both know will never be shared with anybody, you would free up more space to store images that are truly worthy. If you really need to shoot both JPEG and raw, I'd recommend starting the editing process right there in-camera and dumping those JPEG/raw pairs that honestly don't make the grade.

RETURNING TO
AN ORIGINAL RAW FILE

Oh, how wonderful a place the world would be if we humans could simply push a button and return to *our* "raw" state. Think about it! Whether it be that first date or that job interview, all of us have probably invested a little extra time on our hygiene, our appearance, and our wardrobe only to discover later that our great expectations for that anticipated event were misplaced. If only we could turn back the clock and start the day all over, perhaps the outcome would be far more positive.

Sometimes when we go through the steps of processing our raw image files, the outcome is eerily similar. *But* unlike our own lives, you can always turn back the clock and start the process of raw-image processing all over again. Perhaps in your first processing attempt, and based on viewer response to the images, there was a bit too much color saturation or not enough contrast or the white balance was just too garish. To the surprise of many shooters who have discovered the joys of shooting in raw format, you can always return to the original raw state no matter how many times you open that raw image and start all over again with whatever changes you wish to make.

So just how do you return to the original raw file, you ask? In the case of Adobe's Camera Raw, you will find a bar the word Basic just above the White Balance adjustment feature; in the far right lower corner of the Basic bar, you will see a small arrow. Click on that arrow to reveal a pop-up menu, and scroll down to the last item, Reset Camera Raw Defaults. Click that and, presto, you're now back to the original raw file that came right out of your camera. Yep, just like that you can start all over again and again and again. . . .

RETURNING TO AN
ORIGINAL RAW FILE

16-BIT MODE AND COLOR SPACE

Most of us do make corrections—minor though they may be—to our digital raw files in postprocessing. When processing your raw files, you should do so in 16-bit mode. In 8-bit mode, you have 256 levels (or what are called *shades*) per channel (red, green, and blue). In 16-bit mode, you have over 65,000 levels (shades) in each channel! And, with Photoshop CS3 and CS4, you can make corrections in 16-bit mode while using Layers.

When you're finally done, you should convert the file from 16-bit mode to 8-bit mode, and then and only then should you select Save As and save the raw file to TIFF. Converting to 8-bit mode will create a smaller file—about 50 percent smaller in terms of megabytes—without a loss in quality.

Along the same lines of getting the biggest color bang for your buck, it makes no sense to do all your raw processing if the color space of your monitor is set to sRGB. The folks at Photoshop continue to make sRGB the default color space. sRGB is a color space designed for "Web colors," which is another way of saying "color is not that important." But color *is* important, especially when processing raw files. So, if you haven't already done so, press Shift + Command + K (for Macs) or Shift + Control + K (for PCs) to call up the Color Settings dialog box. Click on Working Spaces and choose Adobe RGB 1998. Don't change this setting unless you hear of a new color space that's even better (which, in all likelihood, will happen some day, but for now, Adobe 1998 is where you want to be).

Also, and equally, important: Most of the DSLRs on the market offer up a color space that's either sRGB or Adobe 1998, so again, make certain that you've selected Adobe 1998. This assures you that the color profile in your camera is matched to the color profile in your computer. If you don't match the camera and computer profiles, you'll get a message on your computer screen every time you open an image that reads something like, "Color profiles do not match; change or ignore?"

Rare is the photograph that shows *absolute* (or pure) colors, such as absolute red or absolute yellow or absolute orange, and this photograph is no exception. This is an image of various *shades* and *tones* of red, yellow, and orange shot in the color space of Adobe 1998 and processed in 16-bit mode. If you aren't seeing the colorful results on your monitor that you saw with your own eyes, perhaps your problem can be solved by the simple fix of changing your color space.

When you are *completely* done processing that award-winning image and you do want to put it out there on the World Wide Web, you must take the following into account: After resizing the image for the web (to 72 dpi or ppi), you must convert the color space back to "Web colors," which is a color space of sRGB, and then save as .jpg.

Micro-Nikkor 105mm lens, ISO 50, *f*/11 for 1/30 sec.

WHITE BALANCE

For me, next to the histogram, the white balance (WB) setting is one of the most overrated controls on the digital camera. People have very strong feelings about the importance of white balance, but until someone can really show me otherwise, I'll continue setting my white balance only once and leaving it alone. Here's why.

Every color picture has some degree each of red, green, and blue in it. How much will depend on the color temperature of the light. Perhaps counterintuitively, blue light, although described as *cooler*, has a higher temperature than red. This is because color temperature is measured by the Kelvin scale in degrees Kelvin (K), from roughly 2,000 K to 11,000 K. A color temperature between 7,000 and 11,000 K is considered "cool" (bluer shades), between 2,000 and 4,000 K is considered "warm" (reds), and between 4,000 and 7,000 K is considered "daylight" (a combination of red, green, and blue).

Cool light is found on cloudy, rainy, foggy, or snowy days, or in areas of open shade on sunny days. Warm light is found on sunny days, beginning a bit before dawn and lasting for about two hours tops, and then beginning again about two hours before sunset and lasting till 20 or 30 minutes after

the sun has set. The light generated by 60-watt incandescent lightbulbs on a winter morning or a summer evening is also warm light.

Today's digital cameras make you think that with every lighting situation you should turn your WB control to that specific color temperature before you shoot. This requires using a color temperature meter (which can be expensive to buy) or instead holding an 8 x 10-inch bright white card in the front of the lens every time you change lighting conditions. Your camera will then know where to set the white balance, getting you "perfect" color.

This is the thinking shared by many, but not me, and here's why: I love color! When still using film, I shot 90 percent of all my images with the most saturated films available at any given time, especially Kodak's E100VS, a highly saturated color slide film. In fact, one of the problems I had with

The image above is a classic example of midday light with the camera set to the Auto white balance setting. This recorded accurate color, since midday light is blue (cool) overall. The image at right reflects a Cloudy WB setting, which is warmer.

Both photos: 17–55mm lens at 24mm, f/16 for 1/125 sec.

digital photography in the beginning was its inability to produce in the raw file these same highly saturated colors (until I stumbled upon the Cloudy white balance setting, that is). And over the years, when out in overcast, rainy, snowy, foggy, or open-shade/sunny-day conditions, I used 81-A or 81-B warming filters to eliminate much of the blue light present at those times (I prefer my images warm). These would add red to a scene, knocking down the blue light.

This brings me to my one WB setting: Cloudy. Most cameras offer this setting, and I leave my WB there. If the Cloudy WB setting adds too much color for your tastes, you can always fine-tune it or change it to Auto, Daylight, Shade, Tungsten, Fluorescent, or Flash in postprocessing—assuming, of course, that you're shooting in raw

mode. (This is yet another good reason to shoot raw files.)

The reasoning behind my WB choice is that I seldom, if ever, shoot interiors, regardless of the interior artificial light source. I'm a natural-light photographer, working primarily outdoors (this is a *field guide*, after all). I only change my WB when I use my home mini-studio setup to shoot objects on white backgrounds or when I do commercial work that requires a number of strobes to light a given interior. In both of those situations, I usually choose the Flash WB setting. I'm also a specific-time-of-day photographer: On sunny days, I shoot in the early morning or from late afternoon to dusk. Midday light, between 11:00AM and 3:00PM, is what I call poolside light: If there's a pool nearby, that's where you'll find me, sunning myself poolside.

With my WB set to Cloudy, it's like shooting with Kodak E100VS. And I never change this setting when

outdoors, whether it's sunny, cloudy, rainy, foggy, or snowy. If I determine, on only those rarest of occasions, that I may have been better off with a different WB setting, I change it in post-processing after downloading my raw images into the computer.

I've found that, at least initially, most beginning photographers don't shoot in the very early morning or late afternoon when the light is much warmer (even though this warmth makes for much more inviting images). Instead, midday photography is the norm for many beginners, who reason that "it's now bright enough." But truth be told, midday light is much harsher and *cooler*. Still, with the WB set to Cloudy, you can fool your friends into thinking you're a morning person (or late-afternoon person). Just watch out for the discerning eye: Morning- and late-afternoon light casts lots of long shadows, while midday light is "shadowless." Savvy viewers will recognize this.

The Cloudy WB setting gets me a sun that looks more like what it is; the Tungsten WB setting, on the other hand, cools things down and renders a sun that looks more like a moon. Neat trick!

Both photos: Micro-Nikkor 105mm lens, *f*/2.8 for 1/100 sec. Top: Cloudy WB. Bottom: Tungsten WB

EXPOSURE

The speed with which digital photography has roared onto the scene would make even Jeff Gordon take notice. This week's hot item, whether it be a camera, a lens, or photo-imaging software, is soon replaced by another that can do it even faster with greater efficiency at higher quality. Despite the rapid pace of digital technology, however, two constants still remain in the world of image-making, and I doubt if they will ever really change. Almost since day one, 99 percent of all successful photographic imagery has relied on the *photographer's* skill in (1) setting a creatively correct exposure and (2) creating a well-balanced, compelling composition. These two basic elements are the foundation of photography and still apply today—regardless of whether you shoot film or digital. Sure, getting a correct exposure has never been easier, with today's digital cameras and the related software programs, but there is truly a vast difference between a correct exposure and a *creatively correct* exposure, as you are about to find out.

WHAT IS MEANT BY
EXPOSURE?

Since the invention of photography, the image recorded on light-sensitive material has been called—since day one—an _exposure_, and it still is. Sometimes, the word refers to a finished slide or print: "Wow, that's a nice exposure!" At other times, it refers to the film or digital card: "I've only got a few exposures left." But mostly, the word _exposure_ refers to the amount, and act, of light falling on photosensitive material (film or digital sensor). In this context, it comes up most often when you wonder what your exposure should be (how much light should hit the sensor/film for how long). My answer: "Your exposure should be correct!" Although this sounds flippant, it really is the answer.

Up until about 1975, before many autoexposure cameras arrived on the scene, you had to choose both an aperture and a shutter speed that would record a correct exposure. These choices were directly influenced by the film's ISO (speed or sensitivity to light). Most exposures were based on natural light. When this wasn't enough, you'd use flash or a tripod. Today, most cameras—film or digital— have so much automation that they promise to do it all for you and let you concentrate solely on what you wish to shoot. P or Program mode has the camera make all the settings for you. Oh, if that worked! To me, P mode stands for _poor_ choice, since P mode often yields erratic results.

Most likely, you have a camera with a P option, yet you still find yourself befuddled, confused, and frustrated by exposure. Why? Your do-it-all-for-you camera isn't living up to that promise, or you've reached the point where you want to _consistently_ record correct photographic exposures.

Use your camera's manual settings (right) and get magnificent results every time—or at the very least, know how light and dark interact on digital media or film so that you can get it right even when you're in Aperture Priority or Shutter Priority mode. To my mind, M mode also stands for Magnificent choice!

Both photos: 12-24mm lens at 24mm. Left: f/11 for 1/1000 sec., Shutter Priority mode. Right: f/6.3 for 1/1000 sec., Manual mode

exercise:
MASTERING THE BASIC PRINCIPLES OF DESIGN

The do-it-all camera often yields disappointing results. If you learn just one thing, it should be how to use your camera fully in M (Manual) mode. I know no other way to consistently make correct exposures. It's easy to learn, and you'll better understand the outcome of your exposures when you choose to shoot in A or S modes, which do have their place in the world of exposure. Try this exercise: Set your camera to M. Grab a friend for a subject, and go to a shady outdoor area. If it's overcast, anywhere outside will do. Set your lens opening to f/5.6. Place your subject against a wall or in front of some 6- to 8-foot-tall shrubbery and focus. As you look through the viewfinder, adjust your shutter speed until the camera's light meter indicates a "correct" exposure, and take the photograph. You've just made a manual correct exposure!

THE PHOTOGRAPHIC TRIANGLE

As liberating as manual exposure is, you'll still need to know the basic exposure concepts. These will help you make consistently correct exposures. A correct exposure is a combination of three important factors: aperture, shutter speed, and ISO. These three factors are always at the heart of every exposure (whether correct or not). I refer to them as *the photographic triangle.*

Your viewfinder shows a series of aperture numbers or it's on the lens itself. Take special note of 4, 5.6, 8, 11, 16, 22, and 32, if you have it. (On point-and-shoot digital cameras with fixed-zoom lenses, these may not go past 8 or maybe 11). Each of these numbers corresponds to a specific opening in your lens, called an *f*-stop. So in photographic terms, the 4 is called *f*/4, the 5.6 is *f*/5.6, and so on. The primary function of these lens openings is to control the volume of light reaching the digital sensor or film during an exposure. The *smaller* the *f*-stop number, the *larger* the lens opening; the *larger* the *f*-stop, the *smaller* the lens opening.

For the technical-minded, an *f*-stop is a fraction that indicates the diameter of the aperture. The *f* stands for the focal length of the lens, the slash (/) means *divided by*, and the number represents the stop in use.

For example, for a 50mm lens set at an aperture of *f*/1.4, the diameter of the actual lens opening would be 35.7mm. Here, 50 (lens focal length) divided by 1.4 (stop) equals 35.7 (diameter of lens opening). It makes my head spin just thinking about it, so thank goodness these calculations have very little to do with achieving a correct exposure.

Each time you descend from one aperture opening to the next, or *stop down*, such as from *f*/4 to *f*/5.6, the volume of light entering the lens is cut in half. Likewise, if you change from *f*/11 to *f*/8, the volume of light entering the lens doubles. Each halving or doubling of light is referred to as a full stop. This is important since many cameras today offer not only full stops but one-third-stop intervals—i.e., *f*/4, *f*/4.5, *f*/5, *f*/5.6, *f*/6.3, *f*/7.1, *f*/8, *f*/9, *f*/10, *f*/11, and so on. (The underlined numbers represent the original, basic stops, while the others are the newer one-third options.)

Turning to shutter speed, depending on the make and model, your

camera may offer shutter speeds from a blazingly fast 1/8000 sec. all the way down to 30 seconds. The shutter speed controls the amount of time that the volume of light coming through the lens (determined by the aperture) is allowed to stay on the film or sensor. The same halving and doubling principle explained prior also applies to shutter speed. To explain, if you set the shutter speed to 500, this number represents a fraction—1/500 sec. If you change to 250, this represents 1/250 sec. From 1/250 sec. you go to 1/125, 1/60, 1/30, 1/15, and so on. Whether you change from 1/30 sec. to 1/60 sec. (decreasing the time light enters the camera) or from 1/60 sec. to 1/30 sec. (increasing the time light enters the camera), you've shifted a full stop. Again this is important to note since many cameras

offer one-third-stop shutter speed increments: 1/500 sec., 1/400 sec., 1/320 sec., 1/250 sec., 1/200 sec., 1/160 sec., 1/125 sec., 1/100 sec., 1/80 sec., 1/60 sec., and so on. (Again, the underlined numbers represent the original, basic stops while the others are the newer one-third options often now available.) These one-third-stop options reflect the camera industry's attempts to make it easier to achieve "perfect" exposures, fine-tuning, if you will, but as you'll learn, it's rare that you'll want a perfectly fine-tuned exposure each and every time.

The final leg of the triangle is ISO. Whether you shoot film or digital, your choice of ISO has a direct impact on the combination of apertures and shutter speeds you can use. It's so important that it warrants its own discussion and exercise, which follows.

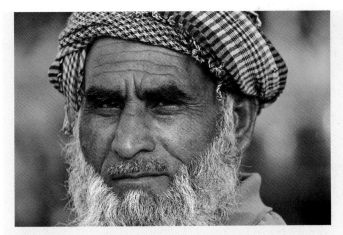

Outside the town of Charja in the United Arab Emirates, I came upon a lone man working at a local nursery. Following several minutes of conversation, told him that I would *love* to take his photograph. A somewhat large aperture enabled me to throw the background out of focus (see page 56 for more on this) and required a fast shutter speed to compensate for the "blast" of light coming through the larger opening.

Nikon D2X and 70–200mm lens at 200mm, tripod, f/5.6 for 1/400 sec.

To better understand the effect of ISO on exposure, think of the ISO as an amount of worker bees. If I use ISO 100, I have 100 worker bees; if you use ISO 200, you have 200 worker bees. The job of these bees is to gather the light coming through the lens and make an image. If we both set our lenses at an aperture of f/5.6 (meaning the same volume of light comes through our lenses), who will record the image the quickest, you or me? You, since you have twice as many worker bees at ISO 200 than I do at ISO 100.

How does this relate to shutter speed? Let's assume the subject in question is a lone flower on an overcast day. Remember, your camera is set to ISO 200 and mine to ISO 100, both with an aperture of f/5.6. So when you adjust your shutter speed for a correct exposure, you get 1/250 sec., but when I adjust my shutter speed for a correct exposure, I need 1/125 sec.—a longer exposure. This is because your 200 worker bees need only half as much time as my 100 to make the image.

Since this is such an important part of understanding exposure, put the book down for a moment and get your camera, a pen, and some paper. Whether you're in Manual or Aperture Priority mode, set the ISO to 200. (If you're still using film, you can do this even if the film in your camera isn't ISO 200; just don't forget to set the ISO back to the correct number when you're done.) Now, set your aperture opening to f/8, and with the camera pointed at something that's well illuminated, adjust your shutter speed until the camera meter indicates a correct

exposure, and write down this shutter speed. Then, change your ISO to 400, leaving the aperture at *f/8*, and again point the camera at the same subject. Your light meter will now indicate a different shutter speed for a correct exposure. Again, write down this shutter speed. And finally, change the ISO to 800, and repeat the steps above.

What have you noticed? When you change from ISO 100 to ISO 200 your shutter speed changed: from 1/125 sec. to 1/250 sec. or perhaps something like from 1/160 sec. to 1/320 sec. These shutter speeds are examples, of course (not knowing what your subject was, it's difficult at best to determine your actual shutter speeds), but one thing is certain: Each shutter speed is close to if not exactly half as much as the one before it.

Again, when you increase the number of worker bees (the ISO) from 100 to 200, you cut the time necessary to get the job done in half. Going from 1/125 sec. to 1/250 sec. is half as long an exposure time. When you set the ISO to 400, you went from 1/125 sec.—passing by 1/250 sec.—to 1/500 sec. Just as each halving of the shutter speed is called 1 stop, each change from ISO 100 to ISO 200 to ISO 400 is considered a *1-stop* increase (an increase of worker bees). You can also do this exercise by leaving the shutter speed constant, for instance at 1/125 sec., and adjusting the aperture until a correct exposure is indicated. Or if you choose to stay in autoexposure mode, select Shutter Priority, set a shutter speed of 1/125 sec., and the camera will set the correct aperture for you.

THE HEART OF THE TRIANGLE:
THE LIGHT METER

Your camera's light meter is what I call the heart of the photographic triangle. It is at the core of every exposure and is a precalibrated device designed to react to any light source, no matter how bright or dim that light source may be. It is, ultimately, behind the calculations of every correct photographic exposure. The light meter recognizes the chosen camera settings (an aperture of $f/5.6$ and ISO of 200, for example) and will react to indicate when you have selected the appropriate shutter speed.

To illustrate this another way, imagine that your lens opening (again, let's say $f/5.6$) is the same diameter as your kitchen faucet. The faucet handle is your shutter speed dial, and waiting in the sink below are 200 worker bees, each with its own empty bucket. The water coming through the faucet is the light. It's the job of the camera's light meter to indicate how long the faucet stays open in order to fill all the buckets with water/light. Since the meter knows there are 200 buckets and an opening of $f/5.6$, it can now tell you how long to leave the faucet open—to get full buckets of light, if you will. If the water/light is allowed to flow for longer than the light meter indicates, the buckets become overfilled (too

much light). In photographic terms, this is called an *overexposure*; in an overexposed image, the colors or tones look washed out. Conversely, if the water/light is not allowed to flow as long as the light meter indicates, the buckets will be underfilled (not enough light), and the result is an *underexposure*, which appears too dark.

So, knowing this simple basic concept of exposure, can you record perfect exposures every time by just relying on your camera's light meter? Not quite. The catch is that most picture-taking opportunities rely on the one *best* aperture choice or the one *best* shutter speed choice. What's the one best aperture? The one best shutter speed? That depends, as you'll soon discover. Learning to *see* the multitudes of creative exposures that exist is a giant leap toward photographic maturity.

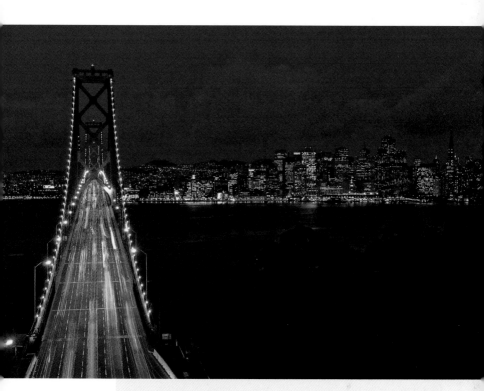

The view of San Francisco from atop an overlook on Treasure Island is, indeed, a view to treasure! With my camera mounted on a tripod, I set my aperture to f/22 to get the extended depth of field I'd need, and this, in turn, forced the longest possible exposure time. (The smallest aperture on any lens will always require the slowest possible shutter speed). I wanted a long exposure time to emphasize the flow of traffic moving across the bridge. To meter, I simply pointed the camera to the dusky blue sky to the right of the bridge and adjusted my shutter speed dial until the camera's light meter indicated 15 seconds as a correct exposure. I then recomposed and shot this image with the aid of my electronic cable release and the added security of mirror lock-up. (See page 384 for more on getting razor-sharp images with cable releases and mirror lock-up.)

Nikkor 200–400mm lens, ISO 100, f/22 for 15 seconds

THE HEART OF THE TRIANGLE:
THE LIGHT METER

SIX CORRECT EXPOSURES VS.
ONE CREATIVELY CORRECT ONE

Whether you shoot in Program, Shutter Priority, Aperture Priority, or even Manual mode, don't assume that if the light meter says everything's okay, then it's okay to shoot. If you want to shoot only "correct" exposures, be my guest. Eventually, you might record a *creatively correct* exposure. But you won't do it *consistently*.

Most picture-taking situations have at least six possible combinations of *f*-stops and shutter speeds that will all result in a correct exposure. Yet, normally, *just one* of these combinations of *f*-stops and shutter speeds is the creatively correct exposure.

Yes, every correct exposure is simply the quantitative value of an aperture and shutter speed working together within the confines of a predetermined ISO. But a creatively correct exposure always relies on *the one f-stop* or *the one shutter speed* that will produce the desired and most creative exposure.

For pictures of powerful surf crashing against rocks, for example, ISO 100 and *f*/4 at 1/500 sec. may be just one exposure option. But there are other combinations that can record a correct exposure. If you cut the lens opening in half with *f*/5.6 (*f*/4 to *f*/5.6), you'll need to increase the shutter speed a full stop (to 1/250 sec.). If you cut that aperture in half again with *f*/8, you'll need to increase the shutter speed again by a full stop (to 1/125 sec.). Continuing in this manner would also produce the following correct exposure pairings: *f*/11 at 1/60 sec., *f*/16 at 1/30 sec., and finally *f*/22 at 1/15 sec. That's six possible aperture and shutter speed combinations that will all result in exactly the same correct exposure.

However, *same* here means the same in terms of *quantitative* value only! A picture of crashing surf taken with a correct exposure of *f*/4 at 1/500 sec. would capture action-stopping detail of the waves, while a correct exposure using *f*/22 at 1/15 sec. would show the surf as far more fluid and wispy. If you get in the habit of determining which aperture/shutter speed combination will render the most dynamic exposure for your subject, you'll reap countless rewards. The choice in exposure is always yours, so why not make it the most creative exposure possible?

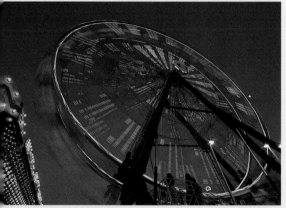

Moving subjects offer the perfect example of the vast difference between three quantitatively identical exposures—the difference is in the *creative* exposure value and interpretation of motion. Usually, the longer the exposure time, the greater the visual effect of that motion in a scene. Here, the top exposure was the shortest, while the bottom was the longest.

The next time you're shooting lights at dusk and your composition includes moving elements, don't hesitate to use the slower shutter speeds. Often, the exposure with the slowest shutter speed has the most interesting effect. (And just so there's no confusion, this is *not* bracketing, since these are all the same exposure in terms of their quantitative value.)

Top: *f*/8 for 1/4 sec. Middle: *f*/11 for 1/2 sec. Bottom: *f*/16 for 1 second

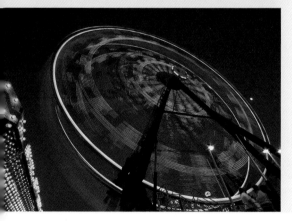

SIX CORRECT EXPOSURES VS.
ONE CREATIVELY CORRECT ONE

Of all the exposure lessons I've taught none is more revealing than this one. It will lead you further into the world of creatively correct exposures. Choose a moving subject (an easy one is to ask a friend to run through the scene parallel to you). If possible, photograph on an overcast day and compose the scene without including any of the overcast sky in the shot.

With your camera on a tripod, set the camera to Manual mode. (Get used to being in Manual mode, at least for a few months—this is where you'll spend a great deal of your "quality time.") Set your aperture to wide open (the smallest number on your lens, such as *f*/2, *f*/2.8, *f*/3.5, or *f*/4). Do your best to fill the frame with your subject, adjust your shutter speed until a correct exposure is indicated (in the viewfinder), and then shoot one frame as your subject runs through the scene.

Now change your aperture 1 stop (for example, from *f*/4 to *f*/5.6), readjust your shutter speed 1 stop to maintain a correct exposure, and shoot 1 frame. Then change the aperture from *f*/5.6 to *f*/8 and so on, each time remembering to change the shutter speed so as to keep the exposure correct. For each exposure, write down the aperture and shutter speed used. Depending on your lens, you'll have no less than 6 different aperture/shutter speed combinations, and even though each exposure is exactly the same quantitatively, you will notice a difference in the overall definition and sharpness. At the faster shutter speeds, motion is "frozen." At the slower shutter speeds, moving subjects look ghostlike. Look at your notes and decide which combination of aperture and shutter speed resulted in the most creatively correct exposure for you.

Finally, find yourself a flower bed, focus on one flower, and repeat the above exercise. Note how the background becomes increasingly defined as you approach *f*/16 and *f*/22. Congratulations! You've just discovered the creative role of aperture: its effect on depth of field.

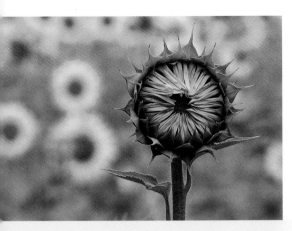

With my camera and my Nikkor 80–400mm zoom lens at 300mm and mounted on a tripod, I shot the first image at *f*/16 for 1/60 sec., the second at *f*/8 for 1/250 sec., and the third at *f*/4 for 1/1000 sec. All three exposures are exactly the same in terms of quantitative value but quite different in the arena of "creative" exposure. Note how at the wide open aperture of *f*/4 the sunflower is isolated—in effect, all alone—but at *f*/16, due to the increase in depth of field, it has quite a bit of company.

Top: *f*/16 for 1/60 sec. Middle: *f*/8 for 1/250 sec. Bottom: *f*/4 for 1/1000 sec.

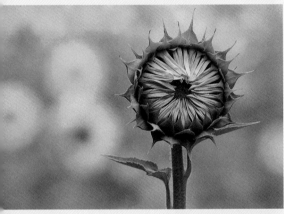

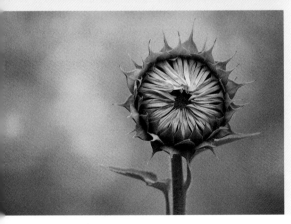

SIX CORRECT EXPOSURES VS.
ONE CREATIVELY CORRECT ONE

SEVEN CREATIVE
EXPOSURE OPTIONS

Since every picture-taking opportunity allows for no less than six possible aperture and shutter speed combinations, how do you determine which combination is the best? You must decide, first and foremost, if you want to simply make an exposure or if you want to make a creative exposure.

As we just saw, you can make many different exposures of a given scene, but only one or maybe two are the creative exposures. In fact, you can break down the components of exposure to get seven different types of exposures, with aperture and shutter speed being the more integral exposure elements in these seven options: [1] Small apertures (*f*/16, *f*/22, and *f*/32) are the creative force behind what I call *storytelling* exposures—images that show great depth of field (see page 46 for more on depth of field). [2] Large apertures (*f*/2.8, *f*/4, and *f*/5.6) are behind what I call *singular-theme* or *isolation* exposures—images with shallow depth of field. [3] The middle-of-the-road apertures (*f*/8 and *f*/11) create what I call *"Who cares?"* exposures—images in which depth of field is of no concern. [4] Aperture is also the element in *close-up* or *macro* photography that showcases specular highlights, those out-of-focus circular or hexagonal shapes. [5] Fast shutter speeds (1/250 sec., 1/500 sec., and 1/1000 sec.) are the creative force behind exposures that *freeze action*. [6] Slow shutter speeds (1/60 sec., 1/30 sec., and 1/15 sec.) are behind *panning*. And finally, [7] the superslow shutter speeds (1/4 sec., 1/2 sec., 1 second, and longer) are behind exposures that *imply motion*.

You can call on these seven possible creative exposures each and every time you make an exposure. The next two chapters take a closer look at aperture and shutter speed, respectively, as they pertain to all seven of these situations.

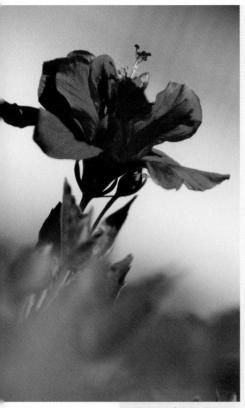

f/2.8 for 1/4000 sec. f/4 for 1/2000 sec.

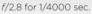

Glancing quickly at these seven images of a hibiscus (here and on the following pages), it may not register that each is a bit different from the previous one. But note the difference in the background and immediate foreground, both of which become more defined in each one—eventually demonstrating a striking difference between the first image and the last.

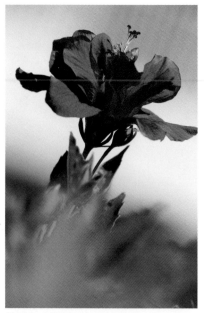

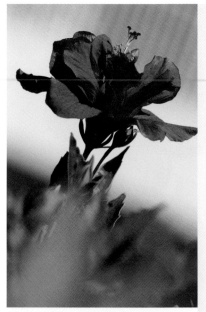

f/5.6 for 1/1000 sec.

f/8 for 1/500 sec.

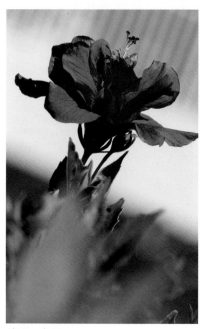

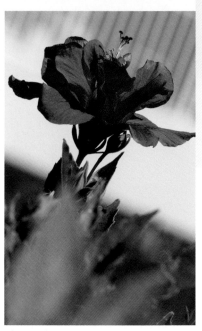

f/11 for 1/250 sec.

f/16 for 1/125 sec.

Each of these images is the same quantitative value, but they are all different in terms of overall depth of field. The type of background you want—out of focus or clearly defined—will ultimately determine which of these seven images is the "correct" one for you.

f/22 for 1/60 sec.

APERTURE

The aperture is the hole or opening located inside the lens. Also known as the diaphragm, this hole is formed by a series of six overlapping metal blades. Depending on your camera, you either make aperture adjustments on the lens or you push buttons or turn dials on your camera. As you do this, the size of the opening in the lens either decreases or increases. This, in turn, allows more light or less light to pass through the lens and onto the film (or digital media). And as you'll see in this chapter, aperture choice has an important creative effect on your photographic results.

APERTURE AND DEPTH OF FIELD

So, how are lens apertures (or openings) identified? For all lenses, the smallest aperture number—either 1.4, 2, 2.8, or 4 depending on the lens—reflects the widest opening and admits the greatest amount of light. Whenever you set a lens at its smallest numbered aperture (or *f*-stop), you are shooting "wide open." When you shift from a small aperture number to a larger one, you are reducing the size of the opening and "stopping the lens down." The largest aperture numbers are usually 16, 22, and in a few small cases 32 (or 8 or 11 with a fixed-lens digital camera).

Why would you want to be able to change the size of the lens opening? Well, for years, the common school of thought has been that since light levels vary from bright to dark, you want to control the flow of light reaching the film. And, of course, the way to do this is simply by making the hole (the aperture) smaller or larger. This logic suggests that when shooting on a sunny day on white sandy beaches, you should stop the lens down, making the hole very small. Doing so would ensure that the brightness of the sand didn't "burn a hole" in the digital sensor. This same logic also implies that when you're in a dimly lit cathedral you set the aperture wide open so that as much light as possible can pass through the lens and onto the film/digital media.

Although these recommendations are well-intentioned, I could not disagree with them more. They set up the unsuspecting photographer for inconsistent results, because they give no consideration to a far more important function of aperture: its ability to determine depth of field. Depth of field is the area of sharpness (from near to far) within a photograph. As you've undoubtedly noticed when looking at photographs, some contain a great deal of sharpness. You perhaps have wondered about how to record extreme sharpness throughout an image (for example, from foreground flowers to distant mountains). You may find that when you focus on the foreground flowers, the mountains go out of focus; when you focus on the mountains, the flowers go out of focus. Well, you just have to use depth of field to your advantage. Likewise, exposures of a lone flower

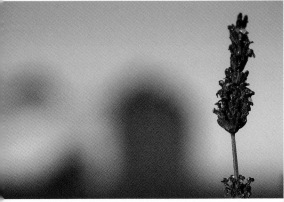

These two quantitatively identical exposures have two unique messages due to the aperture choices—and it's *only* the aperture that's controlling the visual weight here. Realize that one version isn't necessarily "correct"; what's important is which one best expresses the intended message. While the background below is thrown completely out of focus by the larger aperture and shallower depth of field, the slightly greater depth of field rendered by the smaller aperture above still keeps the focus on the flower while offering a little more information about place to put everything in context.

Both photos: 17–55mm lens at 40mm. Left: *f*/4 for 1/640 sec. Above: *f*/22 for 1/20 sec.

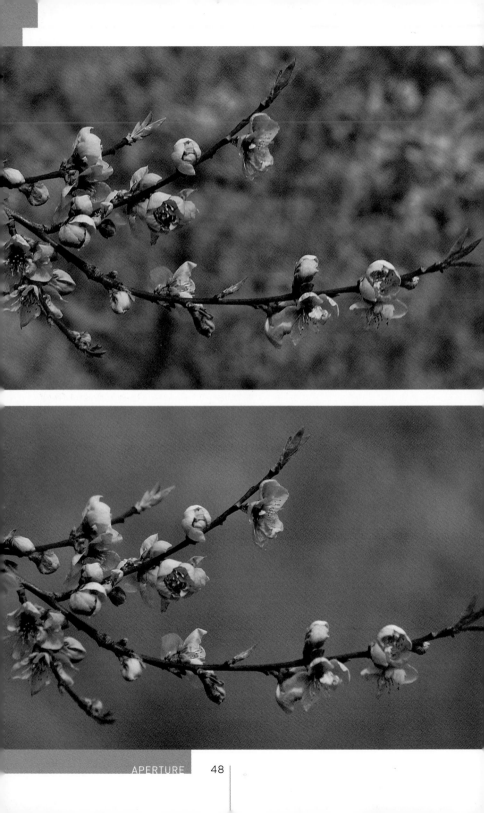

against a background of out-of-focus colors and shapes are the direct result of creative use of depth of field.

What exactly influences depth of field? Several factors: the focal length of the lens, the distance between you and the subject you want in focus, and the aperture. Of these three elements, aperture is the most important.

In theory, a lens is able to focus on only one object at a time; as for all the other objects in your composition, the farther away they are from the in-focus subject (whether in front or behind), the more out of focus they'll be. Since this theory is based on viewing a given scene through the largest lens opening, it's vital that you appreciate the importance of understanding aperture selection. Of course, the light reflecting off a subject makes the image on film or digital media, but the chosen aperture dictates how well this image is "formed." Optical law states that the smaller the opening of any given lens (large f-stop numbers—16, 22, or 32), the greater the area of sharpness or detail in the photo. When using apertures at or near wide open (smaller f-stop numbers—2.8, 4, or 5.6), only the focused subject will be rendered on film as "sharp"; all the other objects in the scene—the out-of-focus light, if you will—will "splatter" across the film or sensor. In effect,

this unfocused light records as out-of-focus shapes.

Conversely, when this same object is photographed at a very small lens opening, such as $f/22$, the blast of light entering the lens is reduced considerably. The resulting photograph contains a greater area of sharpness and detail because the light didn't "splatter" across the film plane or digital sensor but instead was confined to a smaller opening as it passed through the lens. Imagine using a funnel with a very small opening to pour a 1-gallon can of paint into an empty bucket. Compare this process to pouring a 1-gallon can of paint into an empty bucket without the funnel. Without it, the paint gets into the bucket quicker, but it also splatters up on the bucket sides. With a funnel, the transfer of paint is cleaner and more contained.

Keeping this in mind, you can see that when light passes through a small opening in a lens, a larger area of sharpness and detail always results. Does this mean that you should always strive to shoot "neat" pictures instead of "messy and splatter-filled" ones? Definitely not! The subject matter and the depth of the area of sharpness you want to record will determine which aperture choice to use—and it differs from image to image.

The choice in backgrounds can *always* be yours, *if* you know how to control the area of sharpness. This is especially true when using a telephoto lens. With $f/32$ (opposite, top), I assured that not only the branch but also the background would be more defined than in the $f/5.6$ version below it—due to the added depth of field. I much prefer the less-defined background.

Both photos: 80–400mm lens at 400mm. Top: $f/32$ for 1/30 sec. Bottom: $f/5.6$ for 1/1000 sec.

STORYTELLING APERTURES

There are three situations when aperture choice is paramount. The first is when you want to make what I call a *storytelling composition*—an image that, like the name implies, tells a story. There's a beginning (the foreground subject), a middle (the middle-ground subject), and an end (the background subject). Such an image might contain stalks of wheat (the foreground/beginning) leading to a farmhouse 50 to 100 feet away (the main subject in the middle ground/middle) that stands against a backdrop of white puffy clouds and blue sky (the background/end). The wide-angle zoom lens is the common choice for these compositions.

Assuming you want everything from front to back in your composition to be sharp, the laws of depth of field would require you to use the *smallest* apertures, such as *f*/16 or *f*/22. (If you think about how you squint to try to make something appear sharper, you see why you need a smaller aperture to render greater depth of field.)

So, for what kind of subject might you want everything sharp? Most commonly, landscapes. We've all admired those endless mountain vistas with everything tack sharp front to back. For subjects like this, exacting sharpness is king! And *f*/22 lets you obtain this.

In addition, in order to include as much visual information as possible, you want a lens that captures the widest view, hence the wide-angle lens choice mentioned previously. If using the increasingly popular 12–24mm lens or the "standard" 18–55mm or 18–70mm lenses (or a wide-angle lens from your film days, such as a 17–35mm or 20–35mm), you have the right lens. You also need to know

which focal lengths work best here. With a 12–24mm zoom lens, it's the 12–16mm focal range. With 18–55mm, 18–70mm, 17–35mm, or 20–35mm lenses, you'll only call on the 17–18mm range. It's within these focal lengths that the angle of view lets you create those wide, sweeping compositions.

While these wide-angle focal lengths are the favorites and do offer the greatest angle of view, it is absolutely imperative—crucial, in fact—that you *choose the right aperture* to go along with these wide angles of view.

An aperture of *f*/22 got me the desired storytelling sharpness from front to back. Note that foreground subject matter doesn't always have to be at the bottom of the frame; here, it falls at the left side of the composition.

12–24mm lens, *f*/22 for 1/15 sec.

If you do that, you'll record pictures that you previously thought were only possible with a more expensive camera or with more technical know-how. That's the secret: *f/22* (which every wide-angle lens or wide-angle zoom lens made for SLRs and DSLRs has).

The Beginning of the Story

Chances are good that you'd feel shortchanged if you bought a book in which the first nine pages were blank. Yet, this is how many photographers "write" their storytelling images: with the photographic equivalent of blank pages—*empty foregrounds*. And, for obvious reasons, these images are seldom compelling. To avoid recording empty foregrounds, you *must* move in close to that foreground.

Most photographers aren't inclined to think of the wide-angle lens as a close-up lens, but if they did, their images would improve tenfold. When shooting wide and sweeping scenes, the tendency is to step back so that you can get more stuff in the picture's composition. Big mistake! From now on, try to get in the habit of stepping closer—closer to the foreground flowers, closer to the foreground trees, closer to the foreground rocks. Embrace the "2-foot rule": If you are 2 feet from the flowers, tree trunk, sandy shoreline, or rocky outcroppings, you are assured of filling up the first 9 pages of your story with "text."

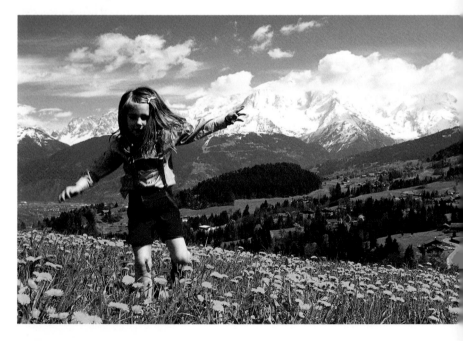

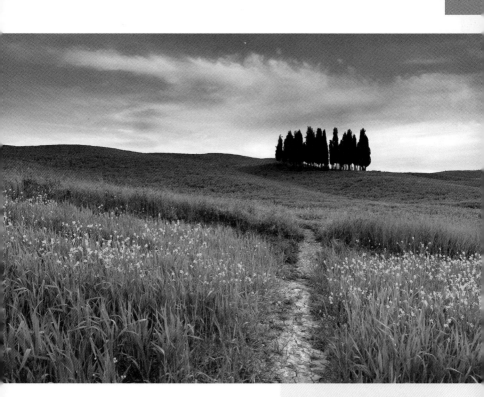

The depth of field in this image is extreme. My aperture choice shows that you can bend the "rules" a little: I was working with *f*/16 (not *f*/22) but still managed to get excellent sharpness from front to back. It might seem unusual to include a person in the beginning of your "story," but when my daughter Sophie ran through my shot years ago, I couldn't resist the photo op. I was in Aperture Priority mode and had already set the aperture and focus for maximum depth of field, so I only had to fire off several frames when Sophie appeared.

35–70mm lens at 35mm, *f*/16 for 1/60 sec.

This Tuscan scene benefits from the use of the wide-angle lens combined with an *f*/22 storytelling aperture. I have the beginning of my story in the foreground flowers and a path that acts as a leading line to take the eye to the wheat field that is the middle of the story. Beyond this is the story's end with the stand of trees against the sky and clouds.

Nikkor 17–35mm lens at 28mm, ISO 100, *f*/22

FOOLPROOF FOCUSING FORMULA

For good reason, my students often wonder where the heck to focus when making storytelling compositions. Try my foolproof "formula." It's guaranteed to work each and every time. First, you must turn off the autofocus. Use the focal length that has at least a 75-degree angle of view (17mm or 18mm on a DSLR that isn't a full-frame DSLR and 28mm on a film camera or full-frame DSLR). Now, set the aperture to $f/22$ and focus on something that's approximately 5 feet from the lens. Then, if you're in Manual exposure mode, adjust your shutter speed until the camera's light meter indicates a correct exposure and shoot. If you're in Aperture Priority mode, simply shoot, since the camera will set the shutter speed for you.

If you're using a 12–24mm digital wide-angle zoom lens on a DSLR that isn't full frame and your focal length is between 12mm and 16mm, set the lens to $f/22$ and focus on something 3 feet away. Then repeat the final steps mentioned above.

If you're using a digital point-and-shoot camera, you can use an aperture of $f/8$ or even $f/5.6$, and if you can't turn the autofocus off, then autofocus on something 5 feet from the lens. Use the autofocus lock, and then recompose the scene you want to shoot.

You might be skeptical the first time you use this technique, since you'll certainly notice that the landscape doesn't look the least bit sharp when you look through your viewfinder. But trust me on this; it will be sharp, from front to back, after you press the shutter release. And for those of you shooting with a DSLR, you have the LCD screen on the back of your camera, so you can check the finished exposure yourself right away and put to rest any doubts about the image being sharp. The only reason it doesn't appear in sharp focus in the viewfinder is because you're viewing through your lens at wide-open apertures (i.e., $f/2.8$, $f/3.5$, or $f/4$ depending on the lens) and not the much smaller picture-taking aperture, the storytelling aperture of $f/22$.

Short Stories

Is storytelling limited to use of the wide-angle lens? Absolutely not! There are many opportunities to shoot story-telling compositions with a telephoto lens. The angle of view will be much narrower, and so the depth and distance will be lessened—but a storytelling effect will nonetheless result. The wide-angle offers up a novel, while the telephoto lens tells a short story.

And unlike the foolproof focusing technique used with the wide-angle lens, the telephoto works with a different recipe for maximum sharpness. Once you've composed your "short story" with the telephoto and set the aperture to f/22 (or f/32 you have it), you simply focus one-third of the way into the scene and fire the shutter release. Sharpness will be evident from front to back.

This is an idyllic scene from France. A telephoto lens and an aperture of f/32 created a "short story" with sharpness from front to back. Standing atop the roof of my van with my camera on a tripod and my aperture set, I focused one-third of the way into the scene and then adjusted my shutter speed until a correct exposure was indicated.

70–200mm lens at 200mm, f/32 for 1/60 sec.

ISOLATION APERTURES

The second picture-taking situation when aperture choice is paramount is when making what I call *isolation* or *singular-theme* compositions. Here, sharpness is deliberately limited to a single area in the frame, leaving all other objects—both in front of and behind the focused object—out-of-focus tones and shapes. This effect is a direct result of the aperture choice.

Since the telephoto lens has a narrow angle of view and an inherently shallow depth of field, it's often the lens of choice for these types of photographic situations. When combined with large lens openings (*f*/2.8, *f*/4, or *f*/5.6), a shallow depth of field results. A portrait, either candid or posed, is a good candidate for a telephoto composition, as is a flower and any other subject you'd like to single out from an otherwise busy scene. When you deliberately focus selectively on one subject, the blurry background and/or foreground can call further attention to the in-focus subject. This is a standard "visual law" often referred to as *visual weight*: whatever is in focus is understood by the eye and brain to be of greatest/most importance.

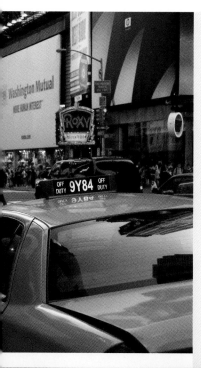

I was drawn to this cab in New York City's Times Square because of the illuminated off-duty sign. The combination of a large aperture and a telephoto zoom lens let me zero in on just the off-duty sign but still communicate a sense of place with the out-of-focus Roxy Deli sign behind. The large aperture enabled me to limit the visual weight of the Roxy sign and ensure that it remained a secondary element. The importance of attention to detail can't be overstated; if I had used f/22, both the off-duty sign and the Roxy sign would have been in sharp focus—and would have been fighting for attention. In addition to the aperture, using the telephoto lens places emphasis on whatever you choose as the main point of interest in the composition.

80–400mm lens at 350mm, f/5.6

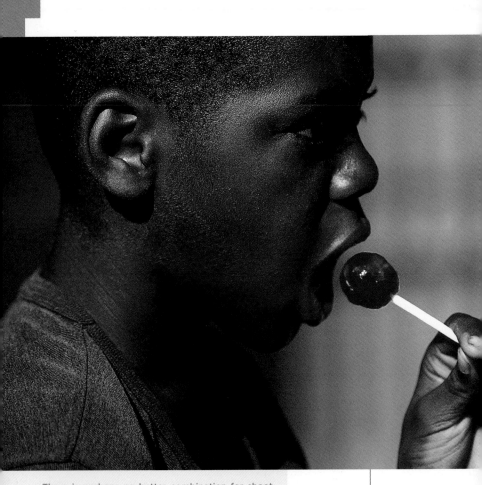

There is perhaps no better combination for shooting a portrait than a telephoto lens and a large lens opening (a small aperture number). When we think of aperture's importance and its ability to render either a great deal of sharpness beyond what we focus on or no added sharpness beyond what we focus on, it of course becomes paramount that we choose the right aperture each and every time. When a large lens opening is combined with a moderate telephoto focal length, such as 100–200mm, depth of field is extremely shallow, as in this portrait.

This combination enabled me to render the wall of buildings behind this boy in Havana as a soft wash of blue tones. The background succeeds because it complements the main subject, allowing the boy and his prized lollipop to have center stage. (Note: To meter this scene, I took a reading off the blue buildings and then recomposed to take the shot.)

105mm lens, f/5.6 for 1/500 sec.

PEOPLE & BACKGROUNDS

The mere act of combining the telephoto lens with large lens openings is often all that's needed to render a successful isolation shot—but your odds of creating really amazing isolation compositions will improve dramatically if you faithfully seek out the "right background" and work at the "right distance." If there's an Achilles' heel in the arena of isolation photography, it's the photographer who doesn't get close enough to the subject, who fails to place an adequate distance between the subject and the background, or who fails to recognize the "right" background.

This is particularly true for outdoor portraits. The closer your background is to the main subject, the greater the risk of recording detail in that background. That's fine for storytelling work, but for isolation portraits, the last thing you want is visual competition from a distracting background. What's the secret to muting the background? Distance!

For example, let's say you're photographing someone standing 3 to 4 feet before a wall of graffiti. You have your 70–200mm lens at 200mm and set to $f/5$. The result: You would record the person and some of the graffiti since both are at or very near the same focused distance. But if you pull the person to a distance of about 15 feet away from the wall, the person will be in focus while the background will be rendered as out-of-focus color. The reason: There's distance between your subject and the background. Since you increased the distance between subject and background, the background is no longer at the same focal distance as the subject.

Likewise, the closer you focus on a subject, the more the depth of field falls off dramatically. This is also why experienced photographers are quick to set up a long tele-zoom lens on a tripod to its maximum focal length *and* with the lens set to Macro mode (or with the addition of an extension tube). Not only does this achieve very close working distances but the subsequent short distance introduces very shallow depth of field.

ANGLES OF VIEW

What are the most obvious differences in these three images? The angle of view and the depth of field. All three images were shot at the same aperture and shutter speed: *f*/8 for 1/350 sec. All share a similar composition in that the doll fills up approximately the same space in the frame. But note the *vast* difference in the angles of view.

With a 12–24mm lens at 15mm, the result was an approximately 90-degree angle of view—we see the doll and the large church behind. With an 18–70mm lens at 45mm, the result was an approximately 52-degree angle of view and a more limited shot of the church. With a 70–300mm lens at 135mm, the result was an approximately 16-degree angle of view and a background only of out-of-focus tone and shape.

Clearly, you get more of the story with the wide-angle (storytelling) lens, and when you want to isolate a subject from its surroundings to shoot a singular theme, the telephoto lens is the more obvious choice.

12–24mm lens at 15mm

18-70mm lens at 45mm

70-300mm lens at 135mm

Isolation and the Wide-Angle Lens

The wide-angle lens is seldom thought of as capable of isolating a subject, separating it from its background. Due to its natural ability to encompass a large angle of view, and thereby get a lot of stuff in the frame, it just doesn't make sense for isolating—at least, that's what many photographers believe. A wide-angle lens does have the uncanny ability to focus close, though, and when you combine this close-up vision with isolation or singular-theme apertures, some quite striking and informative photographic compositions can result. So consider using the wide-angle in this new way.

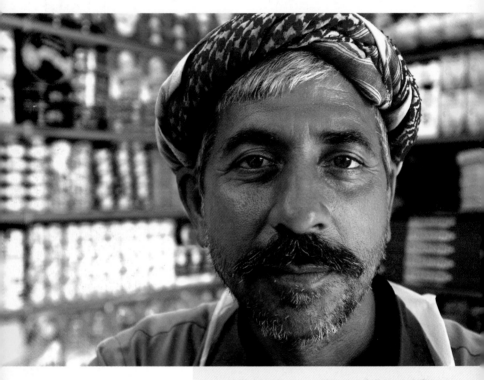

I met this shopkeeper at the local fish market in Dubai. He was a more than willing subject, as he not only gladly posed for the camera but went so far as to put a "Closed" sign on his door until he felt I had gotten enough images. What I found most appealing about his store were the colorful food items stacked high on the shelves behind him. This background provided a wonderful contrast to his somewhat monochromatic face.

17–35mm lens at 28mm, f/3.5 for 1/30 sec.

Although not often called on for singular-theme images, the wide-angle lens *can* isolate subjects. And not only can you isolate subjects from the background but you can isolate only certain parts of a subject while throwing the rest of that subject out of focus. Here, the depth of field is severely limited, keeping the visual weight where I wanted it—on the freshly picked bouquet.

35-70mm lens at 35mm, *f*/2.8 for 1/1000 sec.

Subject distortion is the norm with extreme wide-angles (20–28mm for film shooters and 12–16mm for digital shooters), but you can use this to your advantage. When combined with a large aperture, you can isolate a given subject and still maintain a story. With this greengrocer, it only seemed natural to emphasize his produce. I moved in as close as possible to the pear, and due to the extreme angle of view, I was able to capture him plus a portion of his storefront. The aperture of *f*/4 limited the sharpness to the pear.

Nikon D2X, 12–24mm lens at 12mm, *f*/4 for 1/125 sec.

THE DEPTH-OF-FIELD PREVIEW BUTTON

Also known as the DOF button, the depth-of-field preview button is one of the most useful tools found on many DSLRs and SLRs, yet you wouldn't know it based on the high amount of confusion it causes among many amateur photographers. Over the years, I've heard a host of explanations of its importance, or lack thereof, as well as of how it "works," and at the end of the day, the general consensus still seems to be that it's a "useless" tool. I, of course, couldn't disagree more!

If your camera has a DOF button and you actually learn how, where, and when to use it, you'll soon be wondering how you ever lived without it. (If your camera doesn't have this feature, no worries: There's a way to achieve the same benefit, which I'll get to in a minute.) Whether you're isolating your subject with a macro, telephoto, or wide-angle lens, the DOF button is the tool to embrace!

The depth-of-field preview button gets its name from the function it performs. While looking through your viewfinder and pressing the DOF button, you are able to preview your depth of field. This lets you check whether or not you have chosen the right aperture. Because of this, I refer to it not as the DOF button but as the DIM-TRAC button—as in, Did I Make The Right Aperture Choice? Additionally, I like this nickname because when you press the "DIM-TRAC" button, the image in your viewfinder does go quite *dim* and the feature does allow you to *track* how much or how little depth of field you currently have.

When I made this shot at *f*/22, it looked fine in my viewfinder—but that was without depth-of-field preview activated! Note how busy the image actually is and how the main flower is not alone. Fortunately, I was able to see this when I pressed the DOF button. At that point, I moved toward the smaller aperture numbers (the larger aperture openings), all the while looking through the viewfinder while DOF preview was activated. I was then able to see the background get progressively blurrier until I settled on the lone-flower effect I was going for at *f*/5.6.

Both photos: 75–300mm lens at 280mm. Left: *f*/22 for 1/30 sec. Above: *f*/5.6 for 1/500 sec.

THE DEPTH-OF-FIELD PREVIEW BUTTON

POOR MAN'S DEPTH-OF-FIELD PREVIEW

Those of you without a depth-of-field preview button may feel you're missing out on a valuable tool. Well, you are, but there are two solutions. (1) If you must have a DOF button, buy a new camera (hopefully the same make as your current one so that you don't have to buy all new lenses, too). Or (2), the less expensive approach: Before shooting an isolation image and while still looking through the viewfinder, turn your lens one-quarter of a turn or so (as if you are about to remove it from the camera body—but don't actually remove it). When you do this, you'll see the actual depth of field that the chosen aperture will render. (The viewfinder will also become darker in the same way it does when pressing an actual depth-of-field preview button.)

 This is what I call *poor man's depth-of-field preview*. At this point, take note of how much stuff comes into play behind and in front of your subject. If you're satisfied with the way the background is rendered, click the lens back on and fire away. If not and you want a less-defined background, open up the lens to the next *f*-stop (for example, from *f*/5.6 to *f*/4), execute the quarter lens turn again, and take another look.

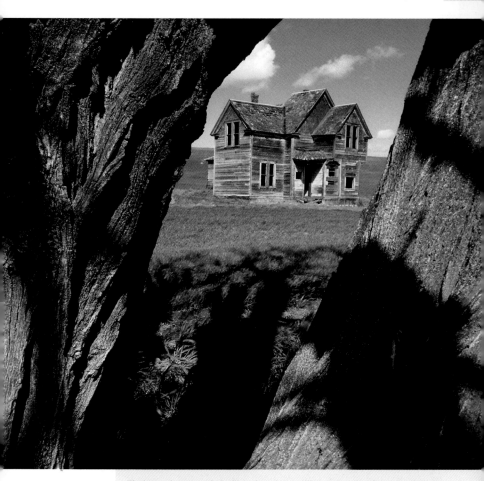

Their numbers are dwindling, but there still remain a few farmsteads from yesteryear in Central and Eastern Oregon. By one such farmstead, the rough, textured bark of a lone locust tree and its looming shadow made for a dramatic and inviting foreground, but where do I set my focus? With my 24mm lens and camera mounted on tripod, I chose an aperture of *f*/22 and then preset my focus to 3 feet via the distance marker. This assured sharpness from 2 feet to infinity. The smaller photograph shows the effect you would see in your viewfinder once you preset the focus via the distance setting. When you see this, you might think you did something wrong (since the scene appears too out of focus). However, don't touch a thing; rather, fire that shutter release anyway, and voilà, the image that shows up on your LCD is, in fact, sharp—from front to back. What happened? Prior to pressing the shutter release, you are viewing the scene through a wide-open aperture (in my case, that would be *f*/2.8); it's not until you press the shutter release that the lens stops down to the actual chosen aperture (here, *f*/22) and renders the promised depth of field of 2 feet to infinity. (Don't forget that it's vitally important to turn off autofocus when you preset your focus for storytelling shots.)

24mm lens, *f*/22 for 1/60 sec.

THE DEPTH-OF-FIELD
PREVIEW BUTTON

Exposure without DOF Preview

To be clear, succeeding in the world of photography does not depend on your camera having a depth-of-field preview button. There are many photography opportunities that never require the use of DOF preview. I can offer up at least three situations in which using DOF preview would prove not only useless but even futile.

SITUATION 1: The subject is filling the frame and is parallel to the camera. In this situation, there are *no* major depth-of-field concerns. Your choice in aperture could be any of the choices your lens provides.

SITUATION 2: You're using a wide-open aperture. Keep in mind that the image you see in the viewfinder is always an image of how the subject would look if shot with a wide-open aperture. As you focus on a subject, you might think it looks good just as it is (viewed wide open). If that's the case, simply set your aperture wide open, adjust the shutter speed until the camera meter indicates a correct exposure, and shoot. Since your aperture's wide open, it would be futile to use the DOF preview button; the lens can't possibly stop down when you've set a wide-open aperture.

SITUATION 3: You're using what I call a "Who cares?" aperture. These apertures, namely *f*/8 and *f*/11, are called on at times when aperture is not a concern. I discuss them in detail in the next section.

While this is a striking composition, with its majestic palm trees in stark contrast to the tiny child, depth of field wasn't really a concern. This is because both the trees and the child are on the same plane and parallel to the camera. Plus, the background wasn't a major element. There was no real need to check things with the DOF button.

17–55mm lens at 17mm, *f*/9 for 1/320 sec.

Although very different from the image opposite, the same concept applies: Depth of field was not a concern because all the shoes were on the same plane, close to me and parallel to my camera. There's no foreground and background—it's a true "Who cares?" situation.

Nikkor 17–55mm lens at 35mm, ISO 100, *f*/11 for 1/125 sec.

THE DEPTH-OF-FIELD
PREVIEW BUTTON

"WHO CARES?"
APERTURES

Okay, simple enough: You can shoot storytelling imagery with small aperture openings and singular-theme/isolation imagery with big aperture openings. But is there ever a time when you don't have to worry about choosing the right aperture? Yes! In fact, there are many wonderful exposures to be made with nary a care in the world about aperture, and I refer to these picture-taking opportunities as *"Who cares?"* aperture choices. *Who cares* what aperture you use when photographing a subject against a wall, since the subject and the wall are at the *same* focused distance? *Who cares* what aperture you use when shooting straight down on those fallen autumn leaves, since the leaves and the ground are at the same focused distance? *Who cares* what aperture you use for that distant hot-air balloon floating against the clear blue sky, since the balloon and sky are at the same focused distance? (The word *same* is understood to mean that the relative distance of every subject in the scene before you is at or near the same distance.)

Although you can make these kinds of exposures easily at any aperture, and despite my affection for calling them "Who cares?" images, I recommend that you use apertures of *f*/8 or *f*/11. If you're using a digital point-and-shoot camera, use *f*/4 or *f*/5.6. Why? Because these apertures let you take advantage of your lens's "sweet spot." Every lens offers the greatest edge-to-edge sharpness and contrast at *f*/8 to *f*/11 (or *f*/4 to *f*/5.6 with digital point-and-shoots), hence the term *sweet spot*.

This sweet spot seldom offers up enough depth of field for effective storytelling compositions and often produces far too much depth of field for singular-theme compositions. But again, the world isn't made up entirely of those types of subjects. There are just as many—if not more—"Who cares?" exposures out there, and I will always choose apertures from *f*/8 to *f*/11 for them.

Although the purpose of any traffic light is to control traffic flow, it can also be a place of refuge for pigeons. With my camera on a tripod, I was able to isolate just the traffic light and pigeons from an otherwise busy and chaotic cityscape. An added bonus was having the traffic light in open shade yet set against the much brighter background of blue sky. With my aperture set to f/11 (Who cares?), I adjusted my shutter speed until 1/200 sec. indicated a correct exposure from the brighter blue sky. This exposure choice rendered the stark shapes as silhouettes, yet it also proved to be a correct exposure for the red light. (With this one exposure, I was able to use a "Who cares?" aperture for a single-theme image!)

80–400mm lens, f/11 for 1/200 sec.

If you want to try your hand at "easy" exposures, grab your camera and an 18–55mm zoom lens, head out the door (with your tripod, of course), and pay close attention to what lies on the street as you walk. Chances are, whatever you find at your feet can be shot effectively at f/8 or f/11. And, who knows? Maybe you'll make some unexpected discoveries, as I have over the years. It's amazing what most people don't even notice right at their feet!

For instance, how long it had been there was anybody's guess, but this crushed Schweppes can lying on the ground was reason enough to frame a "Who cares?" exposure. Since I already knew the aperture was f/11 and I was in Aperture Priority mode, I was able to simply frame, focus, and shoot.

35–70mm lens, f/11 for 1/30 sec.

"Who cares" what aperture you use when making a portrait against a wall? While on assignment at a steel mill in Ukraine, I met one of the maintenance workers in the employee cafeteria. As we walked from one part of the mill to another, we came upon this entrance, and I knew the color and texture would make for a simple yet telling backdrop. Since depth of field wasn't a concern (the flat wall would be my background), I chose f/11 and adjusted my shutter speed until the camera meter indicated a correct exposure for the overcast light.

ISO 100, f/11 for 1/60 sec.

SHUTTER SPEED & ISO

As mentioned, every picture-taking opportunity allows for no less than 6 possible aperture and shutter speed combinations, so how do you decide which pairing is best? Think about what you want to do. Do you want to freeze action? Fast shutter speeds—1/250, 1/500, and 1/1000 sec.—are what you need. Do you want to suggest motion via panning? Then use 1/60, 1/30, and 1/15 sec. And superslow shutter speeds from 1/4 sec. to 30 seconds imply the motion in a waterfall, the wind blowing through a field of wheat, or traffic flowing down the freeway at night. Keep in mind that when it comes to motion-filled subjects, you must first think about which shutter speed will convey motion the way you want. Then, and only then, should you think about ISO and how to take a meter reading. The good news is that ISO isn't as restrictive as you might think and the built-in light meters in today's cameras do a fantastic job of rendering a correct exposure.

THE IMPORTANCE OF SHUTTER SPEED

The shutter mechanism lets light into the camera and onto the film or digital sensor for a specific length of time, called the *shutter speed*. All SLR cameras and most digital point-and-shoot models offer a range of shutter speed choices. Shutter speed controls the effects of motion in your pictures, and this is why it is such an integral part of exposure. Fast shutter speeds freeze action, while slow ones can record the action as a blur. Shutter speed also becomes important when you find yourself shooting in low-light conditions without a tripod.

Speed Extremes

Motion-filled opportunities are everywhere. In capturing them, you'll often find yourself on either end of the shutter speed spectrum, using either fast shutter speeds to freeze the action in crisp, sharp detail or slow shutter speeds to blur or imply the motion you saw. There's rarely a middle ground when it comes to the moving world, so it won't be long before you discover that most of your action (and also low-light) photography occurs anywhere between 1/500 sec. and 1/1000 sec. or between 1/4 sec. to 8 seconds.

With my camera mounted on a tripod, I shot the first image at *f*/4 for 1/500 sec. and the second at *f*/22 for 1/15 sec. The decision of exposure and which shutter speed to use will always be yours, so why not aim to make the most visually compelling creative exposure possible?

Both photos: Nikkor 80–400mm zoom lens at 300mm.
Above: 1/500 sec. at *f*/4.
Right: 1/15 sec. at *f*/22

THE IMPORTANCE OF
SHUTTER SPEED

THE SPEED/APERTURE CONNECTION

In keeping with the idea of extremes, note the following: (1) You'll always attain the fastest possible shutter speed at any given ISO when you use the largest possible lens opening, and (2) you'll attain the slowest possible shutter speed at any given ISO by using the smallest possible lens opening. This is one of the best lessons I know.

To explore this concept, choose a moving subject, such as a waterfall or a child on a swing. Set your camera to Aperture Priority mode and your ISO to 100 (or 200 if that's your camera's lowest); then set your aperture wide open (f/2.8, f/3.5, or f/4) and take the shot. This will be an exposure at the fastest possible shutter speed based on the ISO in use, the light falling on your subject, and, of course, your use of the largest possible lens opening.

Now stop the lens down 1 full stop. If you started with f/2.8, go to f/4; if you started with f/4, go to f/5.6. Make another exposure. Do this over and over, each time with the aperture set to f/8, then f/11, then f/16, and finally f/22. Each time you change the aperture by a full stop, your camera recalculates and offers up the "new" shutter speed to maintain a correct exposure. Since you're stopping the lens down with each full-stop change (making the aperture half as big as it was), your shutter speed doubles in time to compensate—in other words, your shutter speed becomes progressively slower. The slower your shutter speed, the more likely that the resulting image will exhibit some blurring effects, since the shutter speed is too slow to freeze the action.

For waterfall shots, that well-known cotton candy effect doesn't start until you use apertures of f/16 or f/22. For that image of your child on the swing, note how the faster shutter speeds freeze your child in midair but the slower shutter speeds turn your child into a ghost. Take notes on your exposures to learn which combinations of aperture and shutter speed resulted in the most creatively correct photographic exposure.

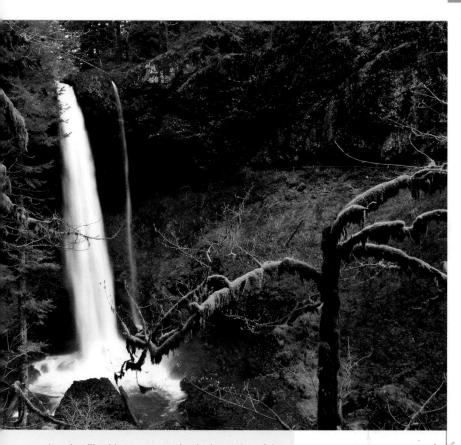

In a shot like this, you want to imply the motion of the water (with slow shutter speeds) and get maximum depth of field, so you set the camera to the smallest aperture (to force the slowest shutter speed) and combine this with a low ISO (100 or 200). That will achieve the type of exposure you see here.

THE IMPORTANCE OF
SHUTTER SPEED

THE MYTH OF ISO
EXPOSED

The ISO you choose will determine which of the 6 combinations of apertures and shutter speeds you can use in creating a correct exposure. Think of ISO as a group of carpenters who respond to light and, in turn, build a house with that light (or in other words, they record an image). A group of 100 carpenters would take longer to build 16 houses than a group of 400 carpenters. If it takes 100 carpenters 16 days to build 16 houses, it takes 400 carpenters 4 days to build those same 16 houses.

So how does this apply to photography? Well, if you expect to record—in exacting sharpness—an ocean wave slamming hard against rocky cliffs or a motocross racer flying over the track, you'll need all the "carpenters" you can get your hands on, right? Wrong! Just because 400 carpenters (ISO 400) can build 16 houses 4 times as fast as 100 carpenters (ISO 100), it doesn't necessarily mean the quality is better. In fact, when it's all said and done, each house, at least on the surface, looks exactly the same! But—and here's the critical part—once that house is finished, all 400 or 100 carpenters will be moving in with you *permanently*. If 100 people in a house can make some noise, imagine how much more noise 400 people can make!

Noise, or what in photographic terms is called *grain*, begins to be a real problem at high ISOs such as 640, 800, and beyond. Grain affects overall sharpness, color, and contrast. In addition, when you employ 800 carpenters (ISO 800), you often end up using smaller lens openings, which have this uncanny ability to make "things" even clearer. So, not only will the overall depth of field (sharpness) increase but, because of the added sharpness, so will the noise.

On closer inspection, images "built" with higher ISOs reveal more unwanted detail not just in your subject but around it, too. Having to use too small an aperture (f/16 or f/22, for instance) when shooting with high ISOs may result in a composition that offers up far too much depth of field. By comparison, the images "built" with ISO 100 appear flawless, and if there are any unsightly houses nearby, you either don't notice them or find them barely a distraction.

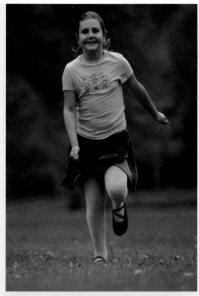

ISO 100

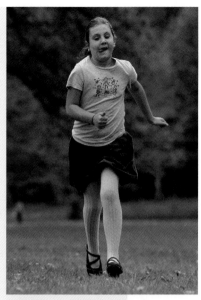

ISO 400

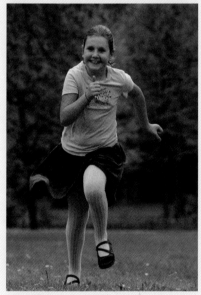

ISO 800

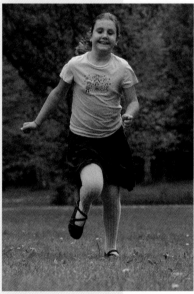

ISO 1600

In all four of these shots of my daughter, I used the same action-stopping shutter speed of 1/250 sec. but a different ISO and aperture to keep the exposure constant. As the ISO increased, so did the visual effects (with increased noise and depth of field).

My point is that most fleeting moments can be captured at shutter speeds that are well within your reach—even when you use ISO 100. The need to use high ISOs (400, 800, or 1600) to freeze the action in exacting sharpness is a myth! Camera manufacturers are making some great strides in noise reduction at the high end of the spectrum (800 to 2400). With the promise of "fine grain" at these high ISOs, it's easy to become seduced and even think you can say good-bye to your tripod—yikes!

So keep the following in mind: In a shot of your son's winning touchdown made with ISO 1000 at f/16 for 1/1000 sec., your son competes for attention with the hot dog vendor over his shoulder up in row 15. Shot with ISO 200 at f/5.6 for 1/1000 sec., there is no evidence of that hot dog vendor, since the much shallower depth of field of f/5.6 would have been limited to your son's touchdown. Furthermore, the use of higher ISO settings also decreases your opportunity for using longer shutter speeds.

And one more thought: This field guide isn't only about action photography; it also explores night and low-light photography, and it does so on the assumption you'll be shooting with ISO 100 or 200. However, if you're shooting at night, in low light, or indoors and you can't or don't wish to use a tripod, you can certainly opt to use ISO 800 or 1600. The primary purpose of ISOs of 800 and higher is not so much to freeze action but to shoot in low light. Note, though, that without the aid of the tripod, you *will*

not record the motion-filled opportunities for which nighttime photography is often noted. You will be able to shoot, handheld, some more static images of those same low-light scenes, and these can be beautiful, too; however, you will be missing out on a host of creative exposures.

Due to the low light levels in this store in Singapore's Little India neighborhood, I needed ISO 800, and although local flavor and composition of this image are strong, you can see the pronounced grain that comes with the higher ISO. Grainy pictures, I am sure, will soon be a thing of the past with ISOs of 800 and even higher, but for now, most of us will have to accept the noise that comes when using ISOs such as 800.

17–35mm lens at 24mm, f/8 for 1/60 sec.

FREEZING ACTION AT ISO 100, 200 & 400

The table below shows how you can freeze most action subjects with as little as ISO 100, resulting in an image that's flawless. These calculations are based on sunny lighting conditions with a frontlit or sidelit subject.

ISO 100	ISO 200	ISO 400
f/4 for 1/1600 sec.	f/4 for 1/3200 sec.	f/4 for 1/6400 sec.
f/5.6 for 1/800 sec.	f/5.6 for 1/1600 sec.	f/5.6 for 1/3200 sec.
f/8 for 1/400 sec.	f/8 for 1/800 sec.	f/8 for 1/1600 sec.
f/11 for 1/200 sec.	f/11 for 1/400 sec.	f/11 for 1/800 sec.
f/16 for 1/100 sec.	f/16 for 1/200 sec.	f/16 for 1/400 sec.

Fine Grain with the Higher ISOs

There was great fanfare when Nikon announced their Nikon D3 camera recently. Among the features was ISO 25,000+ and the capability to record images at ISO 6400 that were almost noise free (almost grainless)! The Internet photo chat rooms were abuzz with everyone jumping on the bandwagon of this latest innovation; I, however, was not.

Having a camera with fine-grain high ISOs sounds cool, for sure, but what does it really mean for creative exposure? When will I ever use ISO 6400 or even 800, for that matter? I like to shoot in available light, and that means just about 100 percent of my work is done outdoors mostly during predawn, early-morning, late-afternoon, and dusk hours. During that time, I'm looking to shoot creative exposures, *not* correct exposures. That means I'm looking for ways to

"story-tell" and "isolate," as well as capture any motion-filled opportunities that I come upon. How is ISO 1600 going to help me "isolate" that lone frontlit flower against a background of thousands of other out-of-focus flowers in a meadow? It won't! In fact, it will actually will hurt my chances of making that happen. With f/5.6 and ISO 1600, my shutter speed needs to be a whopping 1/12800 sec. Yikes! I don't have that shutter speed, do you? With ISO 800, my shutter speed must be 1/6400 sec., and with ISO 400, it must be 1/3200 sec. Looks like I'm better off with ISO 200, doesn't it?

And how about the shot of the Bay Bridge from atop Treasure Island in San Francisco? With ISO 1600, the slowest possible exposure I can record, even with the lens stopped all the way down to f/22, is 1 second! So much for recording ribbons of red tail-lights crossing the bridge into the city by the bay. For a shot like this, one

needs, at least, shutter speeds closer to 4 seconds, and with ISO 200, I can record that scene at *f/22* for 8 seconds. (See the image on page 35.)

Or how about that thunderous 60-foot waterfall in the woods? Even with the lens stopped down all the way to *f/22* to force the slowest possible shutter speed (even on a very cloudy day), the slowest shutter speed I can record is 1/15 sec. This is certainly not slow enough to record a cotton candy effect in the waterfall; I need at least 1/4 sec. (Yes, I could use a 3-stop neutral-density filter, but why not instead just shoot that scene at ISO 200?)

Ah, but what about freezing action? Aren't these the times to choose those higher ISOs? Maybe, but what are we talking about here, a speeding arrow bursting a balloon? Sure, it sounds like a good idea, but how many speeding-arrow-bursting-balloon shots do I need to shoot before I'm ready to move on to something far more compelling?

Sports? Not on your life would I resort to using the higher ISOs for outdoor sports. I don't need the faster shutter speeds it would afford me; long before the digital camera showed up, sports photographers were freezing the action just fine with ISO 200 and 400. Again, the higher ISOs open up a new problem with those faster speeds: the smaller apertures needed to maintain a correct exposure. This could spell disaster in my isolation shots of the action; not only do I catch the hurdler in midstride over the last hurdle, but because I'm at ISO 1600 and an aperture of *f/16* along with my

fast shutter speed of 1/1600 sec., I also record the distracting background of fans due to the added depth of field. (If the sporting event is indoors, however, then I'm all for the higher ISOs of 1600 to 6400, and at this writing, that would mean using Nikon's D3 and D700.)

Finally, digital photography makes it extremely easy to change your ISO from one shot to the next, and that leads to another problem. I've heard countless stories of people changing from one ISO to another and then forgetting to change back for the next shot. You'll miss a lot of shots that way. Sure, you can doctor things in Photoshop later, but man, why would you want to invest that kind of time—15 to 30 minutes at the computer—when you can do it in-camera?!

FREEZING ACTION: FAST SPEEDS

So just how fast is 1/100 of a second? Believe it or not, it's ten times faster than the blink of an eye, which averages around 1/10 of a second. And since 1/100 of a second is ten times faster than the blink of an eye, you'd think that should be plenty fast enough to freeze the action of most anything that's on the move—but, of course, you'd be wrong. For great action shots, next to ISO, the right shutter speed is the most important element. For most outdoor action-filled shots, shutter speeds of 1/500 or 1/1000 sec. are the norm.

Many shooters often speak about the photographer-to-subject distance, but this is really a moot point. I can be 50 feet from that motocross biker, but if I'm using a 400mm lens from that 50-foot distance, it's as if I'm right in front of him. If my frame is more than 75 percent filled with the subject, then as far as I'm concerned, we're sharing the same bed—and when you share a bed with anyone, you are close!

Assuming you are indeed "sharing the same bed" with your subject, then you have to consider another important factor before determining your shutter speed: Is the action coming toward you or is it moving side to side— or even up and down? When action is coming toward you, you can get away with using a shutter speed of 1/250 sec.; this is especially true with sports. When the action is moving side to side or up and down, shutter speeds between 1/500 and 1/1000 sec. are better, and in some cases, you may even have to resort to 1/2000 sec.

These are very different representations of motion, both made with 1/250 sec. With my camera on a monopod and my lens at 400mm (left), I simply waited for the horses to fill the frame as they raced down the track to the finish line. Since the action was coming toward me, 1/250 sec. was fast enough to freeze it.

Meanwhile, for some, crossing paths with a black cat is a bad omen, but for me it proved a most fortunate thing. I followed this cat for some 5 minutes until it came to rest at the top of these blue steps. I then got into a position that allowed me to shoot diagonally down on the stairs. All that remained was to wait for the cat to run down the steps, but it seemed content to just sit there—so content that it was soon lying down when a large, barking dog came our way. That was all it took to get things moving.

Above: 200–400mm lens at 400mm, ISO 200, f/14 for 1/250 sec. Left: 17–55mm lens, ISO 100, 1/250 sec. at f/11

A NOTE ABOUT HANDHOLDING FOR ACTION SHOTS

As a general rule of thumb, you should never handhold your camera at a shutter speed that's slower than the longest focal length of your lens. However, with today's vibration-reduction (VR) and image-stabilization (IS) lenses, it's now possible to break this "rule" and handhold at shutter speeds that are 2 to 3 stops slower than the old rule of thumb would normally allow.

To get the top shot opposite, I instructed my daughter to stay in one spot and not move her feet when she came up from under the water and threw her head back. This enabled me to prefocus, as well as precompose, so that on the count of three I was ready.

Since this surfer in Maui below was moving from side to side through the frame, I opted for a faster shutter speed of 1/1000 sec. here. I took a meter reading off the sky about 30 degrees above the horizon, which let me properly expose for the white foam since the sky isn't too dark or too light. (See page 298 for more on this metering technique.) Since the action was moving at such a frantic pace, I switched my autofocus mode to AF-Servo, a feature on my Nikon that continuously keeps my subject in focus as I track it inside the viewfinder.

Opposite, top: 20–200mm lens at 100mm, ISO 400, 1/800 sec. at f/11. Opposite, bottom: Nikkor 200–400mm zoom lens, monopod, ISO 100, 1/1000 sec. at f/5.6.

To capture my daughter Chloë under this pool waterfall in Cancún, I handheld my camera (in the *shallow* end of the pool!) and set the shutter speed and then the aperture.

70–200mm lens, ISO 100, 1/250 sec. at f/10

GO TO THE WATER

Where does one begin to get great action shots? In the past few years, I've begun to realize just how much activity takes place in and around water. Water accounts for more than 70 percent of the earth's surface. That's almost three-quarters of the earth, so it should really come as no surprise that we are drawn to water. We swim in, splash, or dive into it. We surf, water-ski, Jet Ski, sail, and kayak atop it, and mountain bikers cycle through it. And it's that same water whose moisture eventually makes clouds, which, in turn, dump record snowfalls during the winter months—to the delight of skiers everywhere. We wash with water, drink it, grow fruits and vegetables with it, and even put out fires with it! Water is everywhere, and it is a great source of action-filled photo ops.

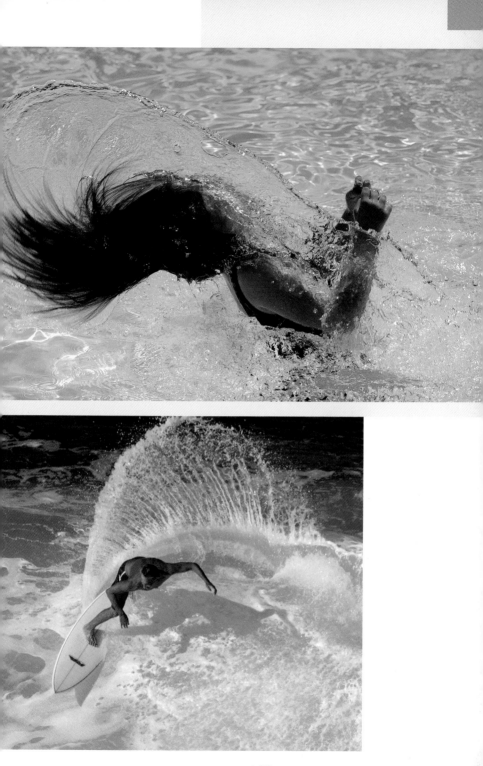

FREEZING ACTION: FAST SPEEDS

Leaving Las Vegas during a fairly violent summer storm did provide a few minutes of reflection as the plane seemed to jerk, dart, dip, and rock in its attempt to break through the clouds above and ahead. Once we found ourselves above the raucous weather below, I reached for my camera and hurriedly began firing shots of the violent yet beautiful storm that was, no doubt, continuing to unfold below.

Nikkor 17–55mm lens at 17mm, ISO 100, f/8 for 1/500 sec.

Aerial and Airborne

It was in the summer of 1970 that I bought my first camera—a DeJur twin-lens reflex—at a garage sale for 10 bucks. I recall distinctly that the DeJur had a maximum shutter speed of 1/500 sec. and yet my brother's Nikon F had 1/1000 sec. Of course I felt cheated by this but soon discovered that there isn't a whole lot of action that you can't bring to a screeching halt at 1/500 sec. This comes as a surprise to many. Sure, there'll be times when your point of view may allow you to be within several feet of the action, and with your wide-angle lens at the ready, by all means, employ the faster shutter speeds of 1/1000 or 1/2000 sec. But remember that, for the most part, 1/500 sec. is more than sufficient. The key, when possible, is to prefocus on the spot where you know the action is headed and, as the saying goes, let her rip!

This is even true for aerial photography and airborne subjects. Aerial photography is something you do because you're flying from point A to point B on a commercial airliner or you have a friend who has his/her own plane or you're a tourist taking a helicopter tour and so on. I absolutely

I love any excuse to shoot down on subjects, frequently from much higher vantage points. I often wonder, "How would this look from overhead?" After walking along Bondi Beach in Sydney, Australia, I felt the answer would be "Simply amazing!" Then came the more important questions: Could I get a helicopter rental on a Sunday? And, would a helicopter be allowed to fly above this beach or was it a restricted zone? Two hours later, I was airborne, hanging out the open back door of a helicopter—with the safety harness secured around my shoulders and waist, of course.

Nikkor 80–200mm zoom lens at 200mm, 1/500 sec. at f/8

love to shoot aerials. Even when I'm on a commercial airliner, I do my best to get a window seat if I think we'll be passing over any areas of interest.

Of course, I never check my camera equipment. Wherever I go, my gear goes with me, all packed neatly inside my Lowepro Trekker. Depending on what's in store for the upcoming journey, I determine if I should use my 17–55mm or 70–200mm lens. And,

since the action below me is moving either left to right or right to left, depending on what side of the plane I'm on, using a shutter speed around 1/500 sec. is often the norm.

When you're back on the ground but your subjects are airborne, you'll do well with shutter speeds from 1/500 sec. to 1/1000 sec. In fact, 1/500 sec. is often enough to capture up-and-down motion crisply.

This friend of a friend wanted shots of his daughter, and I wanted shots of people jumping. The result was satisfying for all involved, as his daughter loved all the leap-frogging going on that morning. Since jumping is an up-and-down activity, the faster shutter speed of 1/500 sec. is essential to freeze it, and I also found that shooting at the peak of the action best conveyed the jump.

Nikkor 12–24mm lens, ISO 200, f/9 for 1/500 sec.

There was plenty of time to set up this shot, since each race at this motocross event had as many as 12 to 15 riders, and every rider had to take on this hill—so if I missed the first few, no worries. As the first riders came by, I manually set my focus on an area they all seemed to hit. With ISO 400, I was able to use an aperture of *f*/13 and still maintain an action-stopping speed of 1/500 sec. I wanted the extra depth of field just in case my focus was off a bit. Man is not supposed to fly, but perhaps these motocross riders will make you change your mind.

70–200mm lens, tripod, ISO 400, 1/500 sec. at *f*/13

THE MOTOR DRIVE

Nowhere else in image-making is the use of a motor drive more important than in action photography. Most cameras today come fully equipped with a built-in winder or motor drive, allowing photographers to reach a higher degree of success when shooting action-filled scenes. (This is often known as Burst mode on.) Without the aid of a motor drive or winder, it is often a hit-or-miss proposition as you try to anticipate the exact right moment to fire the shutter. With the aid of a winder or motor drive, you can begin firing the shutter several seconds ahead of the peak action and continue firing until a second or two after the action has stopped—and it's a very safe bet that at least one exposure will be successful.

SLOWING DOWN

Most photographers, professionals and amateurs alike, seem to only record razor-sharp images of action-filled subjects rather than explore the "art of possibilities" with much slower shutter speeds. Instead of relying primarily on the action-stopping shutter speeds of 1/250 sec., 1/500 sec., and 1/1000 sec., try turning your attention to the opposite end of the shutter-speed dial: 1/60 sec. to 1 second. To my mind, slower speeds offer far more outlets for creativity than faster ones. At the same time, they are incredibly unpredictable, but it's in this unpredictability that, if you can be patient, you will find the diamond in the rough. Action-filled subjects take on a whole new meaning when deliberately photographed at unusually slow shutter speeds.

Try shooting, without benefit of a tripod, for just one hour in your backyard or in the city, at speeds of 1/4 sec. or 1 second. Much of what you'll do will be experimental, but as is often the case, some new and exciting discoveries can be made only in the laboratory. Using slow shutter speeds when common sense suggests otherwise has proven to be a successful venture for many photographers. The resulting compositions are often filled with tremendous movement and tension. They convey strong moods and emotions and are anything but boring. You might not be able to identify the sport or activity, but in the midst of all of this blurred activity is an image of great energy.

Lying flat atop the roof of a car moving down a tree-lined country road, I found myself deliberately shooting at a slow shutter speed. I wanted to convey the feeling of flying down the road, and working from the safe confines of the passenger seat was out, since the angle was too low to the ground. I had some apprehension, and hanging on while shooting caused an anxious moment or two; however, my friend Killian drove "slowly."

Contrasting with the top image in which I was moving and the subject was still, for this shot of the truck passing the meter, I remained stationary and let the subject do the moving.

Top: Nikkor 17–55mm lens, 4-stop ND filter, ISO 100, 1/15 sec. at *f*/11.
Bottom: 70–200mm lens, ISO 100, 1/30 sec. at *f*/16

PANNING

Unlike photographing motion while your camera remains still, panning involves deliberately moving the camera parallel to—and at the same speed as—the action, keeping the action in the same spot in the viewfinder as you make the exposure. You should try to follow through with a smooth motion; sudden stops or jerky movements could adversely alter the panning effect. So, from a point directly parallel to your subject, when your moving subject enters the frame from the left or right (or top or bottom), you simply follow it with the camera, moving in that same direction while depressing the shutter release button. The idea is to ensure that your moving subject remains relatively "stationary" and in fairly sharp focus, while all of the stationary objects surrounding it record as either horizontal or vertical streaks.

To pan effectively, you'll want to use a shutter speed of at least 1/30 sec. But again, I'm all about experimentation, and if you're shooting digitally (i.e., with no film costs to worry about), consider panning at even slower shutter speeds, such as 1/15 sec., 1/8 sec., or even 1/4 sec. Digital photographers have it made here, because it's a challenge getting panning right. A lot of shots are wasted until you get that one. So, this technique can be a nightmare for photographers who still shoot film.

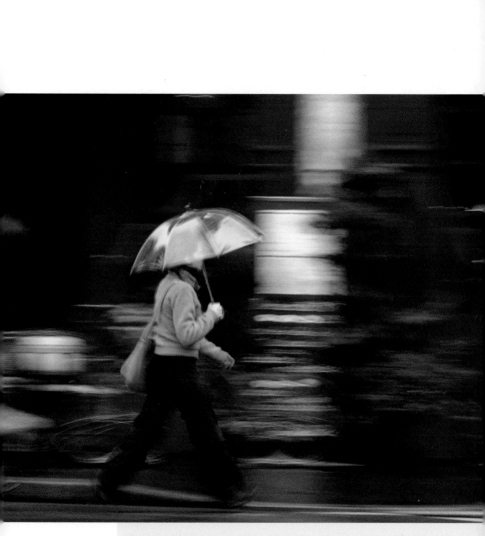

Opportunities to pan are everywhere, but when it comes to finding an abundance of these photo ops, the city really is king. Cities are on the move day or night. And when you throw in some rain, sidewalks of pedestrians are transformed into flowing rivers of colorful umbrellas. Here, I handheld my camera, aimed at the sidewalk directly across from me, and followed these two girls as they scurried across the street. The overall combination of color and movement creates an energized image.

80–400mm lens at 300mm, 1/15 sec. at f/16

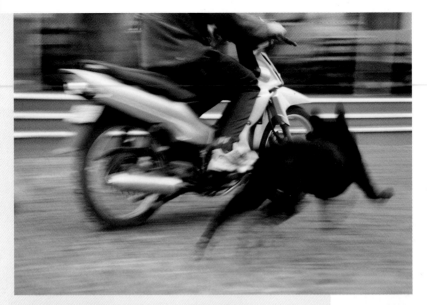

While on Santorini one morning, I was quickly adopt-
ed by several wild dogs—an easy thing when you of-
fer them food. After shooting the sunrise, "my dogs"
and I found ourselves at a small outdoor café. All
was quiet, but as the day progressed and the square
came alive, the dogs would take off running after
every oncoming scooter, apparently thrilled at the
prospect of nipping riders' heels. It was the perfect
opportunity to try some panning shots.

17–55mm lens, ISO 100, 1/15 sec. at f/16

I fell in love with Singapore's Little India neighbor-
hood and was anxious to make a panning shot of
the tourists speeding by in their pedal-driven taxis. I
stood on a street corner with my aperture set to f/22
and adjusted my shutter speed to 1/30 sec.

35–70mm lens at 35mm, ISO 125, 1/30 sec. at f/22.

BACKGROUNDS FOR PANNING

When you pan any subject, you must have an appropriate background in order to be successful. What, exactly, is an appropriate background? Something colorful. Since backgrounds are rendered as blurred streaks of color and tone when you pan, you'll find that the busier and more colorful the background, the better the panned subject will look in front of it. Try to stay away from background patterns that are too solidly horizontal; when you pan, horizontal forms of solid color look like nothing more than solid bands of color (with no evidence of the panning). Similarly, panning a jogger against a solid blue wall, for example, will show little, if any, evidence of the panning technique because of the lack of tonal shift or contrast in the background; however, if that same wall is covered with posters or graffiti, it will provide an electrifying background when panned. Simply put, the greater the color and contrast of the background, the more exciting the panned image will be.

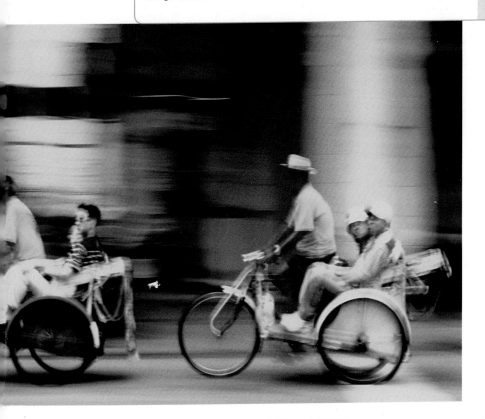

While spending the day at New York's Coney Island, I certainly didn't plan on taking a photograph of a little girl being rescued from the ocean by a team of lifeguards. As I watched the lifeguards come rushing up from the beach with the girl on a stretcher, I immediately set my aperture to the smallest lens opening (f/22), knowing this would force the slowest possible shutter speed (here, 1/30 sec.). I then shot while following the movement with my camera. A photographer from the New York *Daily News* noticed me and asked to see the shots via the digital monitor. She quickly phoned her editor, and the next morning, I saw the image in black and white on page 2 of the paper. And fortunately, the little girl made a full recovery.

17–55mm lens at 35mm, f/22 for 1/30 sec.

What's different here is that the panning is vertical rather than horizontal. My hand entered the bottom of the frame, and I followed its upward motion as I took the shot. Spend an hour with your hand! While holding the camera with one hand, photograph the other at various slow shutter speeds, such as 1/15 or 1/8 sec. You'll be surprised at the results.

12-24mm lens, ISO 100, 1/15 sec. at f/16

VERTICAL MOTION

Normally, subjects are moving right to left or left to right, but you should expand your horizons and consider panning vertical motion, too—for example, kids on pogo sticks or seesaws and the up-and-down "free-fall" rides at amusement parks.

MOTION WITH A TRIPOD

When the camera remains stationary—usually on a firm support such as a tripod—and there are moving subjects within the composition, the photographer is presented with the opportunity to *imply motion*. The resulting image shows the moving subject as a blur, while stationary objects in the composition are recorded in sharp detail. The list of potential moving subjects is long: Waterfalls, streams, crashing surf, planes, trains, automobiles, pedestrians, and joggers are but a few of the more obvious ones. Some of the not so obvious include a hammer striking a nail, toast popping out of the toaster, hands knitting a sweater, coffee being poured from the pot, a ceiling fan, a merry-go-round, a seesaw, a dog shaking itself dry after a dip in the lake, windblown hair, and even the wind blowing through a field of wildflowers.

Choosing the right shutter speed here is, oftentimes, a process of trial and error. (Once again, digital shooters have the advantage, since they can view instantly the results of the right or wrong choice in shutter speed on their LCD panel and there are no film costs involved.) Some general guidelines can be good starting points. For example, a shutter speed of 1/2 sec. will definitely produce the cotton candy effect in waterfalls and streams. A shutter speed of 1/4 sec. will make the hands that knit a sweater appear as if they're moving at a very high rate of speed. A 30 mph wind moving through a stand of fall-colored maple trees, coupled with a 1-second shutter speed, can render a composition of wispy, wind-driven leaves against stark, sharply focused trunks and branches.

Fall colors often go hand in hand with wind and rain. You may find yourself waiting and waiting for the wind to die down until finally you move to another location, never taking the shot. So why not shoot the wind? With my camera on my tripod, I first set the lens to the smallest aperture to force the slowest shutter speed. At ISO 100, the slowest shutter speed I could use was 1/2 sec. I deduced this was slow enough, since I was looking at a constant 30-mph wind.

70–200mm lens, ISO 100, *f*/22 for 1/2 sec.

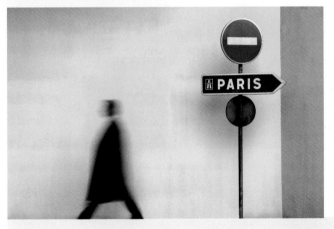

When I first saw this yellow wall, the contrast between it and the blue and red signs was enough for me. But once I processed the image, I felt the composition lacked some much-needed tension. So I had my friend Phillip walk at a normal pace in the opposite direction of Paris. With my camera on a tripod and a neutral-density filter on my lens (to reduce the light and force a slower shutter speed), I was able record him as a blurry figure. (This is also a good example of incorporating motion into the background of an image, which I talk about more on page 106.)

Nikon D2X, 17–55mm lens at 55mm, neutral-density filter, *f*/22 for 1/4 sec.

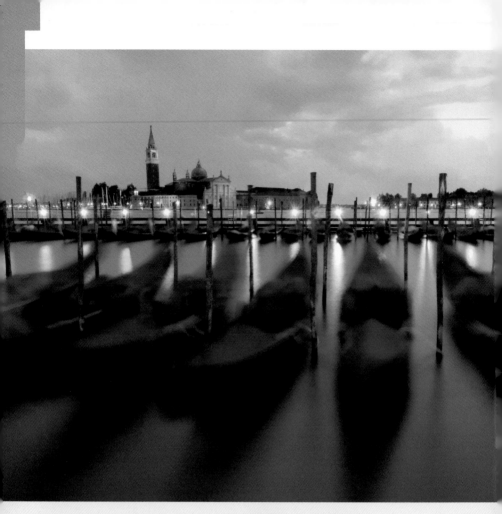

Rising before sunrise in Venice has its rewards, not the least of which is having the world all to yourself. Of course, at this hour you'll need your tripod since whatever you shoot will likely require really slow shutter speeds, but you can still capture a sense of motion. My first exposure opposite doesn't record much movement, which has a lot to do with the exposure time of 1/8 sec. at f/8). After a large ferry passed by, kicking up quite a wake, the gondolas were dancing atop the water. So I changed to a longer exposure time in combination with my polarizing filter (for a 2-stop light reduction) and the stopping down of the lens further.

Opposite: 1/8 sec. at f/8. Above: 4 seconds at f/22

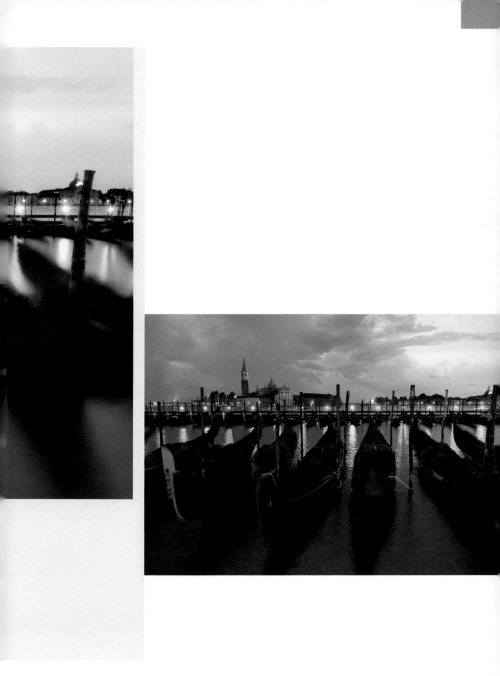

MOTION IN THE BACKGROUND

One of my favorite techniques is to "add" motion to a composition. When I say *add* motion, I'm not referring to some Photoshop technique but rather simply being aware of any motion in the shot— even subtle motion like a flag waving in a slight breeze. More often than not, photographers are sticklers for exacting sharpness, and I've witnessed my share of shooters waiting patiently for the wind to die down so that they can get their razor sharpness. However in my view, when motion is present and shot at the right shutter speed (usually between 1/8 and 1/2 sec.), the often subtle addition of blur to an otherwise exactingly sharp image energizes the overall composition. Including subtle motion in your compositions is something really worth considering, and depending on the shot before you, this motion could easily show up in your backgrounds, foregrounds, or on the left or right sides of your overall frame.

During a workshop in Tampa, I was in a small beachside parking lot when I noticed one of my students isolating a weathered meter with her telephoto. She made a point to shoot the meter as a car or truck passed through the frame on the nearby highway. My excitement at her idea was soon overheard by everyone else in the workshop, and suffice it to say, all of us had more than enough keepers of parking meters with streaked backgrounds of moving cars and trucks.

70–200mm lens, ISO 100, 1/30 sec. at f/16

Environmental portraits (ones that include the subject and a portion of the surroundings) are best made with what I call *street zooms*, or all-purpose lenses (for example, 24–105mm, 28–70mm, or 35–70mm for film-camera lenses and 18–70mm, 17–50mm, or 24–70mm for digital-camera lenses). While I was composing this portrait of one young boy, another boy repeatedly leapt at the soccer balls his friends kept kicking his way. The background motion of that second boy made a whimsical addition. In fact, if you cover him with your hand, the image immediately appears flat and ho-hum. (Note the shutter speed of 1/250 sec.—as I've said, this is often all you need to interpret a little action.)

Nikkor 35–70mm lens at 35mm, tripod, 1/250 sec. at f/11

When life gives you lemons, make lemonade. In this case, that meant motion-filled imagery. With one of my students in position with a tattered umbrella, I made a point to shoot *only* when large tour groups came through Piazza San Marco in Venice (despite the inclement weather, the tour groups were not deterred). It's the "layering" effect of this image that I like the most, and the depth and feeling created from combining color (the umbrella), line (the curvilinear arches in the background), and motion (the brisk walk of the large tour group) into a single image.

70–200mm lens at 105mm, ISO 100, 1/4 sec. at f/4.5

MOTION IN LOW LIGHT:
1 SECOND AND BEYOND

There seems to be this unwritten rule that before sunrise or after sunset it's not possible to get any good pictures. The three reasons I hear for this are always the same: (1) "There's not enough light," (2) "You need a more expensive camera, don't you?" or (3) "I don't know how to get a meter reading." But there's always enough light, and getting a meter reading couldn't be easier. Truth be told, I'm convinced that the real reason most photographers don't venture out at night to shoot is because it can interfere with one's lifestyle (just ask my wife and kids!).

Once you've decide where you will set up, the question is how to set the exposure for the upcoming "light show." With the sophistication of today's cameras and their highly sensitive light meters, getting a correct exposure is commonplace, even in the dimmest of light. Yet this often causes photographers a lot of confusion: "Where should I take my meter reading from? How long should my exposure be?" In all my years of taking meter readings, I've found there is nothing better nor more consistent than taking a meter reading off of the sky—whether I'm shooting backlight, frontlight, or sidelight, or the first light of dawn or the last light at dusk. (See page 298 for more on this metering technique.)

The question of what the exposure should be will be based on the very same principles of creative exposure discussed elsewhere in this book. Does the scene present any motion-filled opportunities, or are you simply shooting a classic skyline of some city, large or small? Either way, the principles of metering and where to take a meter reading from are the same, but if there's motion involved (such as the flow of traffic), then you do have the option of setting an exposure that will render that flow of traffic as fluid streaks of color. And that's where exposures of 1 second and longer come in. At a minimum, a 4-second exposure will render taillights as streaks; with your shutter speed set, simply aim at the sky above the scenes, adjust your aperture, and recompose, triggering the shutter release either via the self-timer or with a locking cable release.

Note that the examples here focus on interpreting motion in low light, while more stationary subjects are

shown starting on page 306 in the Light chapter.

Low-light photography can pose special challenges: using a tripod (assuming, of course, that you want to record exacting sharpness) and some degree of mathematical skills (simple addition or subtraction) to come up with a correct exposure. But again, I think the greatest hindrance is in the area of self-discipline. (And if you have safety concerns about working alone at night, you can join a camera club.) In my classes, students quickly learn just how much photographic opportunity exists before the sun comes up and after the sun goes down—especially in the motion department. The rewards far outweigh any inconveniences. If it's your goal to record compelling imagery—and it should be—then low-light photography is the area in which compelling imagery abounds.

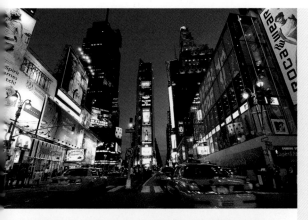

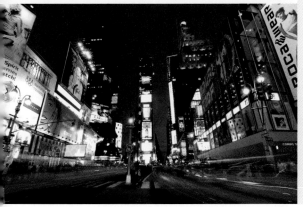

With New York City's Times Square, as with other popular locations, you'd be wise to stake your claim and set up your gear about 30 minutes *before* dusk. When the lights come on and the sky turns darker blue, you have several exposure options, and as you can see, the effects rendered with a longer shutter speed in low light are stunning. You will need a tripod, however. If you don't bring one, you can still get a handholdable exposure with ISO 640 (top), but you will freeze the motion in the scene. It's always my preference, though, to shoot urban scenes that capture all of the motion therein—complete with streaks of taillights—and this involves using the longest possible exposure times. So for the lower photo, I used my tripod to enable a longer, slower shutter speed. (Note that in both shots I took my meter reading off the distant sky.)

Both photos: 12–24mm lens. Top: ISO 640, 1/30 sec. at f/8. Bottom: ISO 100, 4 seconds at f/22

MOTION IN LOW LIGHT:
1 SECOND AND BEYOND

When I made this long exposure of St. Peter's Basilica in Rome, I started shooting shortly after the streetlights came on, yet the Vatican itself never lit up! In any event, I used a filter I can't live without (besides the polarizer and Tiffen 3-stop graduated): the FLW. It's a magenta-colored filter not to be confused with the FLD. The magenta color of the FLW is far denser and far more effective on normally greenish city lights, giving them a much warmer cast. Additionally, this filter also imparts its magenta hue onto the sky, which is perfect for those nights when there isn't a strong dusky blue sky.

With my camera mounted on a tripod, I at first set my aperture to f/4. I pointed the camera to the dusky gray sky and adjusted my shutter speed to 1/2 sec., but since I had already determined that I wanted the longest possible exposure time, I did the math and ended up at f/32 for 30 seconds!

105mm lens, 30 seconds at f/32

CHIMPING: EDITING ACTION SHOTS

Whether you're freezing action, implying motion, or panning, you should make use of "chimping." What's this? It is the viewing and then trashing of unsuccessful action shots in-camera. Rumor has it that chimping was born at an NFL game during which a professional sports photographer was seen chimping in between the time-outs. He would delete the "bad" images from his compact flash card, keeping only the truly compelling ones—and when he came upon those compelling images, he would make a gleeful sound like that of an excited chimpanzee. A few other professional photographers nearby felt that this was cheating, as it was assumed—correctly—that the chimping photographer would then present his photo editor with only his best work. Their issue was that this seemed like a misrepresentation of his true skill. For anyone to even be concerned with this sounded like playground immaturity to me, however.

For me, editing as I go is the norm, since it serves two useful purposes: (1) It frees up space on the digital media, and (2) it saves time in postprocessing as I will have already deleted the obvious bad shots. So I embrace chimping with a zeal akin to watching Seattle Seahawks games—as behaviors I won't be giving up anytime soon—and I would suggest you do the same. Don't just look at your images; have the confidence to edit out the bad ones right then and there. This kind of ruthless editing will make you even more attentive to what's really going on inside that viewfinder as you pay closer attention to the edges of your frame and your background.

If there's light in the sky and I've got the time, I'm going to shoot the scene before me and try to work in the landscape. This was the case in Arches National Park, Utah, years ago. I was searching for some silhouetted rocks and sky, and having trouble finding anything compelling. Then it hit me: The shot was right in front of me! I set up my camera on a tripod in front of my car's headlights and framed the winding road and distant rock out-croppings against the predawn sky. I took a me-ter reading off the sky above the rocks of f/4 at 1/2 sec. Since I wanted an exposure time long enough to record streaking taillights, I stopped the lens down to f/16, which got me a shutter speed of 8 seconds and also achieved the depth of field from foreground to background that I needed.

17–35mm lens at 24mm, ISO 100, 8 seconds at f/16

MOTION IN NONURBAN LOW LIGHT

Just because you aren't near a city doesn't mean you can't find low-light motion images. Consider the following, and no, I'm not kidding: If you have a large yard and a long extension cord, consid-er pulling out the Christmas lights, wrapping them around a willing model, and capturing the results as your model walks and twirls before you—while you shoot up at them from a low viewpoint into the dusky sky. The results will be anything but ho-hum.

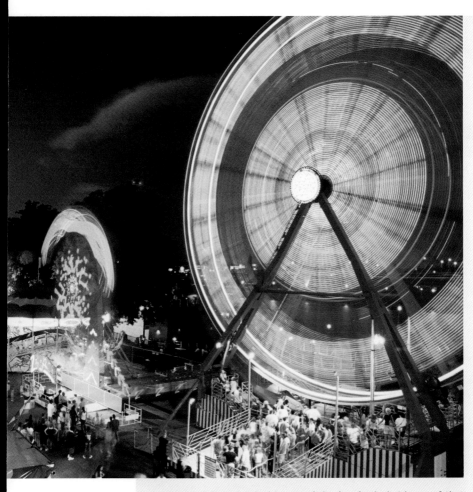

The Portland Rose Festival is one of the few festivals I know of that affords the photographer a view from above, courtesy of the Morrison Bridge. The motion and lights of festival and amusement-park rides provide good opportunities to capture low-light movement. And as with traffic, you'll want shutter speeds of longer than 1 second, which will give you plenty of chances to see motion (but stay on your tripod, of course).

Again, I took my meter reading from the sky and recomposed to take the shot. The relative absence of noise here came courtesy of a Kodak noise reduction filter that was a downloadable plug-in I ordered from the Kodak Web site.

12–24mm lens, tripod, ISO 100, 4 seconds at f/11

LEARNING TO SEE

At this point, it's fair to say that you're on your way to learning the unlimited potential of creatively correct exposures, whether via the use of aperture or shutter speed. But that in and of itself does not guarantee a lifetime of beautiful images. Beyond the art of exposure is the next most important skill: learning to *see*. Developing a photographic vision is the goal of many shooters, yet despite months (if not years) behind the camera, this artistic vision still eludes them. This section addresses the obstacles that stand in the way of learning to see and also suggests exercises designed to get you past those obstacles on your way toward not only a much more expanded vision but also the formation of a personal style. Not truly seeing is, no doubt, one of the greatest hurdles every photographer has to overcome, yet I am convinced—especially after over 30 years of teaching—that everyone can learn to see creatively!

LEARNING THE LANGUAGE

All of us who are blessed with sight can see, but why is it that someone right next to us can see something of interest yet we somehow miss it? If you've ever participated in a photography workshop in the field or gone out shooting with a friend, you know what I mean: You're standing at the head of a trail bewildered, while not 3 feet away your companion is zeroing in on a graphic composition of autumn-colored leaves. You wonder, "Why didn't I see that?" The answer may be a combination of things: Perhaps you were preoccupied with thoughts about your job or hadn't dressed appropriately and were shivering like crazy. Or, perhaps it was the most common reason of all: You don't truly know how to use your equipment.

I've lived abroad in Germany, Holland, and France. I often faced the challenge of communicating in a foreign language. Learning my home country's language was a necessary—if not the polite—thing to do to truly integrate myself into the cultures. A daunting task perhaps, but there's nothing like the full-immersion method. Just like putting a baby in a swimming pool where it quickly learns to swim, when you move to a foreign country, you quickly "learn to swim" in order to survive. And what does this have to with learning how to see creatively? Everything! Truth be told, as a photographer your camera and lenses are your language—a unique one all its own—and unless you are willing to learn this language, you will forever be the "awkward American" who, not surprisingly, records your share of awkward images.

What language does the wide-angle lens speak? The telephoto? The fish-eye? How close can you focus with your wide-angle or telephoto lens? How close can you focus with your macro lens when combined with that set of extension tubes you just bought? What's the widest angle of view with your wide-angle lens? What's the angle of view of your telephoto lens? What does the world look like through the wide-angle lens at ground level or from a 6-foot ladder or while lying on your back? When using your 80–200mm zoom lens, is the angle of view greatest

at 80mm or 200mm? Does zooming from 80mm to 200mm or from 200mm to 80mm get the exploding effect in a long exposure? Does a 2X teleconverter achieve the same result as an extension tube?

The road to fluency is a lot shorter when you move to the host country or, in this case, when you practice the language of your lenses week in and week out. Learning to speak French is far tougher if you only visit Paris for 2 weeks once every 3 years, and the same is true with learning to see; if you only shoot a few weeks a year, you'll be a slow learner compared to the photographer who shoots every week.

When I made this image, I came out of my hotel lobby, headed west, and was faced with a marvelous sunset over the a church in Venice, Italy. Moments like this are *not* the time to be asking yourself, "What lens should I use?" Assuming you took the time to study a few Italian phrases before you arrived in Italy, you have hopefully invested a few minutes a day into also knowing the "language" of your lenses. For a shot like this, you would then know instinctively to set the focal length of your 70–200mm tripod-mounted lens toward 200mm. With your aperture set to *f*/22, you would note that a shutter speed of 1/15 sec. indicates a correct exposure as you take your meter reading to the left of the sun itself. And when 3 large pigeons fly into the scene as you re-compose, you would be prepared to fire away, taking advantage of the luck of this added flurry of motion, this fleeting moment in time.

70–200mm lens at 200mm, ISO 50, *f*/22 for 1/15 sec.

SEEING STARTS
WITH YOUR LENSES

So, how do we see? Is there a connection between how we see and our lenses? Here's a hint: If you cover one eye and look around, you see in much the same way as a 50mm lens, and therefore, this lens is appropriately called a "normal" lens. When you look with both eyes, you see in much the same way as your 18–70mm lens does when set at 18mm. That's about as creative as your own eyes will ever get. The human eye cannot zoom out and bring distant objects closer or see objects as extreme close-ups or create fish-eye views just by the flick of a switch, but a camera lens can.

In my early years as a photographer, I had nothing more than a 50mm lens. I soon realized the need to physically walk closer to my subjects to better fill the frame. I learned how physically changing my point of view could invoke a greater sense of participation with my subjects when I followed my 2-year-old cousin around the backyard at her eye level. After climbing the stairs of a 10-story parking garage, I discovered a new and exciting vision shooting down to the street below. Not long after that I began climbing trees and shooting down on landscapes.

I also have a vivid memory of the first time I looked up with my 50mm lens. After spending most of one morning shooting fallen leaves on the ground in a large aspen grove, I decided to take a break. While lying on my back, I reached for my camera just to take a look at the canopy of trees and blue sky overhead. Wow! Then, at some point, I learned I could render a background of muted and out-of-focus color simply by focusing as close as possible and using the biggest lens opening. Little did I realize back then just how valuable these lessons were. And my ability to learn them was solely due to my having but one lens: the 50mm.

But even if you have more than one lens, or you have a lens with variable focal lengths, the point is that you must really use it to learn how to see. You must exhaust the possibilities. It is when you know what your lenses can do that you can use them to fully develop, and successfully express, your vision. It is then that you learn how to see.

Many shooters will take the "high road" when presented with a wonderful landscape opportunity. This results in a photograph taken at the photographer's eye level, showing us the observer's point of view. But what about compositions that show us the participants' (subjects') points of view. If I want to hear, as well as speak, the language of a tulip, I must become a tulip, and that simply means taking the "low road" and getting down low where the tulips can be heard.

Nikkor 20mm lens, tripod, ISO 100, f/22 for 1/60 sec.

exercise:
KNOWING YOUR LENSES

Today, most shooters have at least one variable focal length lens: the "street zooms," as I call them (also see page 132). Some examples are 18–70mm, 17–40mm, and 24–105mm. With a lens like this, there's no excuse to not bang out one prizewinner after another. If you have a street zoom, set the focal length to either 17mm, 18mm, or 24mm depending on the lens range, and don't change it during this exercise.

Choose a subject, or take your spouse, child, or a friend into the backyard or over to the local park. Position yourself at whatever distance necessary to place your subject in the middle of the frame, allowing for a lot of "empty space" above, below, and to both sides. Make your first exposure, and then begin walking toward your subject. Every five paces, take another exposure, being mindful to keep the subject in focus. Keep walking closer until your lens can no longer capture the subject in sharp focus. Your first composition will record not only your main subject but a lot of other stuff that probably detracts from it, and your final composition should record a close-up of your subject that not only cuts out the other stuff but maybe some important stuff, too.

Now, repeat this while on your knees and then again while on your belly. Finally, once you've gotten as close to your subject as you can on your belly, turn over onto your back and take just one more shot while shooting straight up.

While on your knees, you probably made a far more intimate portrait of the small child. Perhaps while on your belly, you discovered a fresh composition of the surrounding park framed through the feet and lower legs of your friend. Most of all, you learned the inherent vision (when combined with differing points of view) of your 17mm or 24mm focal length lens.

Make a point of doing the same exercise at 50mm, 60mm, 70mm, 80mm, 90mm, and 105mm. (Note that if you only have a fixed lens, you can still do this exercise at your one focal length, as I did in my beginning years with a 50mm, a 28mm, and a 200mm.) If you do this once a week for three months, you'll have a vision that's shared by fewer than 10 percent of all photographers, and it will pay off. At that next on-location photography workshop, you won't be one of the students wandering around uncertain about what lens to use. Once you've integrated the vision of your lenses into your mind's eye, you can stand at the edge of a meadow or lake and scan the entire scene, picking out a host of compositions even before you place the camera to your eye. Understanding the unique vision of your lenses and differing points of view will set you on a journey of unlimited possibilities.

In Bavaria there are a number lakes, many of which are homes to families of swans. Getting a family of swans to approach and hang around for a while is quite easy if you have enough of that great German bread. As the sun was setting to the west and I lay down at the water's edge with my tripod-mounted camera, I fired off a number of frames with my right hand while throwing bread to the swans with my left.

20–35mm F2.8 lens, tripod, ISO 50, f/16 for 1/250 sec.

WIDE-ANGLE LENSES

In addition to its much greater and sweeping angle of view, the wide-angle lens increases the sense of distance from foreground to background. This wonderful illusion of depth and perspective can serve as the "hook" that results in the viewer's immediate participation when a foreground subject is utilized. Noted photographers such as Ansel Adams, David Muench, Carr Clifton, Pat O'Hara, and John Shaw, to name just a few, have used their wide-angle lenses to make some truly emotion-filled storytelling imagery. Almost always without fail, their images have viewpoints that encompass immediate foreground interest: the bark of a tree framing a distant farmhouse, the round stones at the edge of a lake, or the vivid wildflower blooms in a meadow at the base of distant mountains.

Compositions of this type will always evoke powerful emotional responses from viewers whose senses of smell, touch, and sometimes even taste are awakened. Oftentimes, all that's required of you to make images like this is to place yourself in that wildflower meadow and be willing to change your point of view.

In addition to your willingness to get down low in a meadow, don't forget the literally thousands of other landscapes. All it takes is a little imagination and one very simple question: What does the world look like when viewed through the "eyes" of fresh strawberries on the vine or a child's crushed glasses at the local playground or a lost pacifier at the local shopping mall or the dead owl along the interstate or a flat tire in the Nevada desert or a rake gathering autumn-colored leaves or a starfish clinging to the rocks at low tide? It's time to grab those worn-out dungarees—you're going to begin spending a lot of time on your knees and belly.

Common sense tells most of us that when photographing, we stand, focus, and shoot what lies in front of us. This kind of pedestrian approach leads to the occasional eye-catching photo but seldom to those that really command attention. Altering the "normal" view of subjects should be your goal if you want to make attention-grabbing images. The inclusion of a one-way sign was a good start for moving beyond a "normal" cityscape of Tampa, but taking it further by shifting the point of view (looking up from down low) and using a wider focal length positions the sign near the top of the frame. In-camera cropping of the sign creates the illusion of it being both close and farther back in the frame. Once again, the wide angle, combined with foreground interest, is responsible in large measure for this new sense of depth of and perspective. It's also the wide-angle lens that's responsible for the skewed perspective here; the "bending" of the sign, palm trees, and skyline.

Both photos: ISO 200, *f*/22 for 1/125 sec. Left: 16mm focal length. Right: 12mm focal length

When shooting wide and sweeping scenes, the tendency is to step back to get more stuff in the picture. There's a lot of stuff in this poolside scene, and I missed the opportunity to exploit foreground color and shape in my first attempt. But by simply moving closer, the result is a much more graphic and color-filled image.

Both photos: 20–35mm lens, f/16 for 1/125 sec.

17–35mm lens at 17mm

THE WIDE-ANGLE & WILDLIFE

Following a workshop on Kodiak Island, one of the students invited me to join her and her husband (a float-plane pilot) "photographing bears" in Katmai National Park on mainland Alaska. Following our water landing, we dropped anchor, and waded to shore. There to greet us were no less than 20 bears. I was awestruck and soon was engrossed framing up a spawned-out salmon with my 17–35mm zoom at 17mm.

When a large bear moved into the top of the frame, I was so thrilled at its presence that I forgot that the scene in my viewfinder was that of a 17mm super-wide-angle lens (a 102-degree angle of view)—and that the bear was, in fact, much closer to me than I wanted. I slowly looked around, hoping to spot Dave, my pilot and "security guard," nearby and was thrilled to see him 10 feet behind me to the right with his rifle aimed squarely at that grizzly. He nodded to me in a way that told me to stay still, which I did as best as I could, and a minute or two later, the bear made a slow turn and headed back up the stream. Whoooh!

This was the one and only time I became so seduced by a subject in my viewfinder that I completely ignored the danger before me. Making subjects appear small and distant is the vision of this lens, and I should have known better. Fortunately, the story had a happy ending for all. The bear went on to eat more fish, and I got a fairly nice shot.

Wide-Angle Fever: The Hotter the Better!

When I suggest to my students to take out their wide-angle zooms or fixed focal length wide-angle lenses, they are quick to act disgruntled and often comment that they "just don't get how to use this lens." Imagine further their surprise when I suggest that they take out their wide-angle lenses to shoot some great close-ups! I couldn't seriously be suggesting that *great* close-ups await any photographer who pulls a wide-angle lens, could I? You bet, and I would go even further by stating that the wider the angle, the better the close-up.

One of the biggest hurdles all photographers have to overcome is their aversion to the wide-angle lens, or more specifically, their misunderstood vision of the wide-angle lens. Since the general impression of the wide-angle is that all it does is make everything small and distant, it's no surprise that my suggestion to use it for close-ups is met with such surprise. But hear me out; after trying it, you will definitely be looking at the world with a whole new appreciation of how wonderful the wide-angle lens really is. Embrace it. Begin to see, really see, the tremendous potential of this lens for close-up photography.

What does the world look like through the eyes of one of the local tomcats on the small Italian island of Burano near Venice? To answer this question, I chose to meet the cat at its eye level, and that could only mean one thing: lying on my belly. Do I ever feel intimidated at the prospect of dropping to my knees or stomach to get the shot? Absolutely I do, but only when I have an "audience"—like the two elderly couples on their front porches 15 feet behind me while I was making this shot. They had certainly noticed the stranger with the camera gear, and I felt some overwhelming shyness.

At times like this, I simply ask myself, "Am I going to capture a potentially compelling image, or am I just going to walk away because a few people stare?" I usually opt to face my fears, and here, with a pair of steady elbows, I handheld my camera and chose a focal length of 17mm and an aperture of f/16. I preset my depth of field via the distance setting, adjusted my shutter speed until I had a correct exposure, and proceeded to shoot several frames.

Although I speak no Italian, I'm quite sure that a conversation was taking place behind me about the man with the camera lying down in front of a cat. Still, fear of looking "foolish" to those around you should never be a reason for not creating a compelling image.

Nikkor 17–35mm lens at 17mm, f/16 for 1/60 sec.

One of the biggest advantages the wide-angle lens has over telephoto and macro lenses is its ability to render a much, much wider angle of view yet still create an up-close-and-personal image. Depending on the lens and manufacturer, your wide-angle may focus down to 9, 7, or even 4 inches. It's storytelling imagery at its most intimate! In addition, it can offer up this immediate and sometimes much larger foreground with a bit more depth of field than you would ever get when shooting that same flower with the telephoto lens, and this is worthy of your consideration when you want your close-up subject to have a sense of place. An example would be a close-up of a mushroom seen close-up *and* in the context of its forest surroundings rather than a composition limited to just the mushroom.

Developing a vision for the wide-angle lens is not as hard as you might think. And understanding *how* this lens "makes everything small and distant" is perhaps the most important key to recognizing why that is the very reason to use it for close-up photography. Let me explain: The wide-angle *does* push everything in a scene to the background, so to speak, and it does so because it is expecting *you* to place something of great importance in that now-empty and immediate foreground—and I can't stress *immediate* foreground enough, since therein lies the key.

Imagine for a moment that you're getting your living room ready for a party, a party that will find everyone dancing on your living room floor. What do you do with all of the furniture? You might push it all to the back wall to open up the floor so that there's lots of room. It's initially an empty floor, and I will be the first to admit it looks wrong; it calls attention to the fact that no one is dancing. But here comes one couple, followed by another and another, and before you know it, the floor is filled with dancers and now looks like a fun place to be! With this dance party in mind, start thinking of using your wide-angle lens in the same way. Understand that the vision of the wide-angle will push everything back solely because it expects you to fill up that empty foreground with "dancers."

Simply standing and taking the shot from eye level renders a typical view of this tree in the Valensole Plain in southern Provence. Getting down low, however, takes full advantage of the wide-angle lens. The lavender in the foreground awakens the viewer's sense of smell and touch, and the composition is cleaner and more graphic. The inclusion of the small clouds shows how this lens imparts an even greater sense of distance to background elements.

Both photos: 17–35mm lens at 20mm, f/16 for 1/125 sec.

STREET ZOOMS

Is there such a thing as an all-purpose lens? Perhaps not in a single focal length, but with the recent proliferation of compact and amazingly sharp zoom lenses, there just might be the all-purpose zoom lens. Whether your choice is the 17–55mm, 18–70mm, 24–105mm, or 28–70mm, a wealth of compelling imagery is possible. These "street zooms," as I call them, are appropriate when you're heading out the door for a walk in the city or countryside; they're not noted for exaggerating perspective or for compressing backgrounds but rather, simply, for recording "real life."

In addition, most if not all of the street zooms offer a macro or close-focus feature, and this added bonus has allowed me to record some truly compelling imagery, as well. I've been asked on more than one occasion which one lens I could not live without. My answer is always the same, even despite owning the Nikkor 17–55mm F2.8: I still embrace my well-worn Nikkor 35–70mm F2.8 most of all. In reviewing my images over the past fifteen years, it's quite apparent that this one lens has accounted for more than 75 percent of my work! This might seem quite shocking, considering that many photographers are led to believe that to create truly successful imagery they must spend hundreds, if not thousands, of dollars on the widest of the wide-angles and perhaps even more on several telephoto lenses.

As I've often heard, people feel the street zooms "are far too limiting." I could not disagree more. I do agree that a focal length of 28mm or 35mm can make you wish for a wider angle of view at times, especially when you're photographing building interiors or landscapes. And I also agree that when photographing a coastal sunset at the 70mm, 80mm, or 105mm focal length, it is impossible to record that big ball of orange setting behind the distant sailboat. However, these two particular examples are but a small fraction of the photographic opportunities that exist in the world around us. A friend at Kodak recently informed me that the main reason most photographers purchase a camera is to record images of their family, friends, holidays, and vacations—and I know of no better lenses for just this purpose than the street zooms.

My good friend Phillipe introduced me to his friend George, a passionate cigar smoker. While seated together at an outdoor café in Lyon, France—and since I almost always travel with my camera and street zoom—I simply asked George if I could take his picture and just hand-held the camera for this shot.

Environmental portraits are best made with the street zooms. My definition of an environmental portrait is an image in which both the subject and a portion of the surrounding environment are included and defined. In particular, I favor the 35mm and 50mm focal lengths. They are the ideal choices for getting in close without causing facial distortion, and they both do a good job of rendering just enough of the surrounding environment.

Nikkor 35–70mm lens at 42mm, ISO 200, f/5.6 for 1/125 sec.

During a lunch break while on assignment at a steel mill in southern Ukraine, I asked one of the cleaning ladies if she would pose for the camera. Unlike most of the other mill employees, she had an easy smile, which was what drew me to her. Handholding my camera, it seemed natural to place her in the middle of an otherwise desolate factory landscape; alone among her depressing surroundings, she still manages a smile—I love the human spirit! But I also made a point to walk closer to her, changing the focal length ever so slightly and placing her a bit off center in the composition. Such is the versatility of the street zoom.

Both photos: 35–70mm lens, 1/60 sec. at f/11. Top: 35mm focal length. Bottom: 70mm focal length

You know that television ad where the guy says, "I'm not a doctor. I just play one on television"? Well this image could be titled "I'm not a pho-to-journalist. I just pretend I am in the interest of making a stock photograph." This is my daughter Sophie in the foreground and my friend Gregor getting "arrested" by my friend Phillipe, complete with a rented Gendarme costume. Handholding my camera, I chose an aperture that added some subtle depth of field. This enabled me to keep the focus on Sophie, yet with my background, convey the message that the city parks were safe for kids and thugs would be dealt with accordingly.

35–70mm lens at 35mm, ISO 100, *f*/8 for 1/125 sec.

THE TELEPHOTO

Our desire to see objects up close is innate. Prehistoric man, no doubt, wished he could have seen the saber-toothed tiger up on the knoll before it was too late. Along came the telescope and sailors were able to steer clear of approaching pirate ships. And it wouldn't be much longer, with the invention of binoculars, before all of us could go to a football game and put ourselves down on the field with the action. Like telescopes and binoculars, telephoto lenses offer a safe haven for viewing the world around us.

Standing along the shoreline with a telephoto lens, you can observe the power and presence of migrating whales without having to jump in the water next to them. You can get into the nest with the robin and her babies with no worry of disturbing the brood. You can reach a building engulfed in flames without having the slightest concern about your own personal safety. It is the telephoto lens that truly can take us to places we may never otherwise visit—the craters on the moon, for example. It is, for many photographers, a lens of great adventure.

In addition to its ability to make big images of distant objects, the telephoto's other important aspect is its narrow angle of view. This contributes to its ability to cut through visual clutter and make a subject "shout" at the viewer. If the wide-angle is the storytelling lens, then the telephoto is the exclamation point at the end of the sentence, rendering details with eye-stopping clarity.

Telephoto lenses are available from the very moderate 70mm to the extremely large and heavy 2000mm. Although single-focal-length telephotos, such as the 105mm and 300mm, were once the choice of the discriminating shooter, the telephoto zoom, or tele-zoom, has gained tremendous popularity.

Great subjects and viewpoints alone (this one in Nesselwang, Germany) don't guarantee the best possible photographic compositions. Make sure you use the right lens for the subject. The image made with the wide-angle lens (left) is not as successful as the one made with the telephoto (right). That one focuses your attention immediately on the steeple and the mountain range. With my Nikkor 300mm lens and a tripod, I was able to cut to the chase, framing the proud steeple against a backdrop of the German Alps. An aperture of f/32 got me maximum depth of field in the image.

Left: 35–70mm lens at 35mm, 1/125 sec. at f/16. Right: 300mm lens, 1/30 sec. at f/32

THE SUPER TELEPHOTOS

In addition to the more common telephoto lens lengths, there are also the super telephotos, which range in size from 500mm to 2000mm. But these are seldom used by amateurs because of their exorbitant cost. One camera manufacturer currently sells its 600mm F4 lens for $7,800. Any takers? Obviously, these lenses are useful but are, for the most part, reserved for the professional or serious amateur photographer, especially those who shoot sports and wildlife.

If your curiosity about these longer telephoto lenses is too much to ignore, consider calling up the local pro camera shop. Chances are really good they have one of these big guns available on a daily or weekly rental basis. With a little preplanning, renting one of these big lenses could reap big rewards. Who knows? Perhaps on your next African photo safari, you might be the one who captures the "kill" in a fresh and exciting light. And before you know it, you've made $10,000 on that one image—all for the price of a rented lens.

This lone pigeon caught my attention as I approached a fountain in the early morning while walking the streets of Rothenburg, Germany. I already had my camera and 80–400mm lens on a monopod, so from a distance of about 20 feet, I was able to "pull" the bird out of a background of a large hotel wall with numerous windows. In addition to a long 400mm focal length, my aperture choice of f/8 also helped render the background as muted tones and shapes.

80–400mm lens at 400mm, 1/60 sec. at f/8

TELE-ZOOM REDUX

Ten years ago, the telephoto zoom was looked at suspiciously ("Great idea, but it can't possibly deliver the sharpness or contrast required by demanding photographers"). Today, due to numerous advances in technology and design, the telephoto zoom has become the standard for both professionals and amateur shooters. Aside from the DSLR (digital single-lens-reflex) cameras, all other digital cameras are equipped with a fixed and permanent zoom lens that often includes the telephoto range. This standard equipment is affirmation, once again, of our desire to see far objects up close. Rare is the digital camera that offers a super-wide-angle lens as part of its entire zoom range.

Also, until recently, most tele-zooms were either 70–210mm or 80–200mm. Although tele-zooms in this range are still manufactured and purchased, quite a number of photographers are opting for the even lighter and longer tele-zooms: 60–300mm, 80–400mm, and even 100–500mm. Several of these lenses even offer a vibration-reduction (VR) feature that lets you shoot images at shutter speeds normally considered too slow for handholding (i.e., 1/60 sec. and 1/30 sec.). I recently purchased an 80–400mm with this feature, and it really works. But for me, old habits die hard, so more often than not, I still mount the camera and this lens on a tripod.

I believe in using a tripod a great deal of the time. As a general rule, I don't think it's a good idea to use any camera and lens combination off of a tripod when the shutter speed falls below the focal length of the lens. For example, if you're using a tele-zoom with a maximum telephoto range of 300mm, I'd suggest not shooting without the tripod at shutter speeds below 1/250 sec. (This same rule would apply even if you're using the 60mm focal length range of your 60–300mm tele-zoom, since the overall weight of the lens hasn't changed.) If you're not using a tripod, then certainly you could use a monopod when the shutter speed falls below the recommended range for handholding the camera. In addition to obtaining razor-sharp images, the tripod is also vital for learning the art of composition.

There's so much photographic opportunity in a field of wildflowers, not the least of which is the opportunity to isolate with the telephoto lens. If you have a passion for capturing backgrounds of out-of-focus tones and color, the telephoto lens is your best option when presented with a field of flowers. The image to the right was just one of the many singular-theme compositions I made in this field after switching to my telephoto.

Below: 35–70mm lens at 50mm, *f*/11 for 1/30 sec. Right: 75–300mm lens at 300mm, *f*/5.6 for 1/125 sec.

Two qualities of the telephoto are its inherently shallow depth of field and its ability to compress the relative position of objects in a scene, thereby giving the impression that the space is "crowded." Try this great visual tele-zoom exercise that will help you *see* with this unique lens. Frame a person right in the middle of the viewfinder, with the lens set to its shortest focal length; for example, if you're using a 60–300mm, set the lens to 60mm. Make certain the person isn't standing up against a wall or hedge but rather is at least 10 feet away from any background. Also make sure to frame things so that your subject's head is at the very top of the frame and the feet are at the very bottom. Now take the picture.

Then, zoom the lens to the 135mm focal length and walk backward until the person's head and feet are once again near the very top and very bottom of the frame. Take a picture. Notice that when you frame the person at the shorter focal length, the background is far more discernible than when you photograph the person in the exact same proportion in the frame at the longest focal length. This lack of depth of field (the fuzzier background) at the longer telephoto range is why experienced photographers choose this range for selectively focusing subjects such as flowers and simple portraits.

If you can record this effect with a moderate telephoto lens (those in the 135mm range), imagine how much fuzzier you can make backgrounds with the 200mm, 300mm, and 400mm focal lengths. Interestingly enough, the closer you physically move toward your subject, the more diffused and less defined your backgrounds become. In effect, you can turn that busy and colorful wall of graffiti into a sea of multicolored tones by simply choosing to photograph your subject 10 to 15 feet in front of the wall with the tele-zoom set to 200mm or 300mm.

When I saw this man in a small village in France, choosing the telephoto was a no-brainer. I knew the flowers would make a great background. Although the left-hand photograph is a pleasing environmental portrait, it doesn't capture the warmth of his smile or the texture of his face. So I asked him to stand about 10 feet in front of the flower boxes. With my camera and 80–200mm on my tripod, I set the focal length to 200mm and the aperture to f/5.6. This combination of distance between subject and background plus the large lens opening ensured me a razor-sharp image of the subject against a harmonious wash of blurry background color.

Bottom: 80–200mm lens,
1/125 sec. at f/8. Top: 80–200mm
lens at 200mm, 1/250 sec. at f/5.6

THE FISH-EYE

My fish-eye lens is almost always with me. I embrace its vision with great enthusiasm when the right landscape presents itself or when I wish to distort, "to fatten up," a normally familiar subject. The most surprising thing about the full-frame fish-eye is its ability to focus as close as 4 inches from the subject. Equally surprising for the first-time user is the bending of the horizon line that occurs with this lens, and the bending is further magnified when you tilt the lens at 30- to 45-degree angles to the horizon. In my mind, it's a welcomed "global view" that does well with up-close-and-personal subjects while still rendering the whole scene in exacting sharpness. The only caution I would offer when using a full-frame fish-eye is to really check the edges of your viewfinder before shooting, as you may discover your own feet or that front bumper of the car in that distant parking lot showing up in the various edges of the frame—it is truly a *wide* angle of view.

On this particular afternoon in Florida's Everglades, a number of cormorants were drying out their feathers while sitting atop a small fence. They let me get so close that I was soon reaching for my fish-eye lens. This bird gave me all the time in the world to shoot this whimsical portrait. Illustrating the close-up potential of the fish-eye, I handheld my camera, set the aperture to f/22, and focused as close as I could: 4 inches. I then adjusted the shutter speed.

Fish-eye lens, f/22 for 1/60 sec.

It is not the norm for me to use the fish-eye for portraits, but when I do, it's because I want to create a feeling of great scope. Over the course of several hours, I watched this Hindu priest in Singapore receive numerous prayer requests from locals visiting the temple. He was a busy man as he went from one Hindu god to another, both laying down a sacrifice and chanting a prayer for each request. During a brief break, I asked if I could photograph him with his offerings plate, and he gladly obliged. The choice of the fish-eye was deliberate; it allowed me to convey the "all-encompassing power" of both the Hindu priest and the temple.

Nikon D2X, fish-eye lens, tripod, *f*/8 for 1/100 sec.

The earth is round, and there's no better way to convey that than with a fish-eye lens—especially when you're hanging from the skids of a helicopter. You can also shoot the ocean at ground level and record a curvilinear effect, but from above, it just looks more familiar, much like shots of the earth taken by NASA. Conversely (and reminiscent of movies like *A Bug's Life*), the fish-eye can easily represent the grasshopper's view of the world. After more than 35 years of shooting, I can truthfully say that I have yet to fully explore the vast image-making potential of the fish-eye lens.

Above: 14mm fish-eye lens, 1/500 sec. at *f*/8. Right: Fish-eye lens, ISO 100, *f*/22 for 1/60 sec.

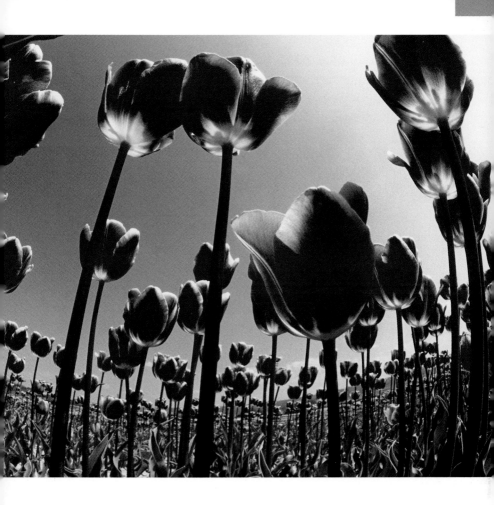

LOOKING UP

When you tire of photographing things straight-on or while lying on your belly, consider looking up. If you choose the right subjects, you'll bring your audience right into the image. Think about using this viewpoint for all types of subjects, whether they be cityscapes, industrial settings, people, nature, or landscapes.

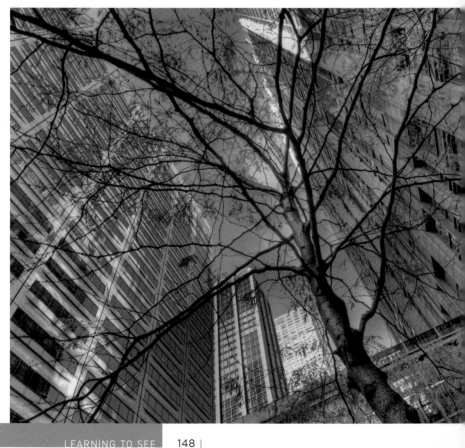

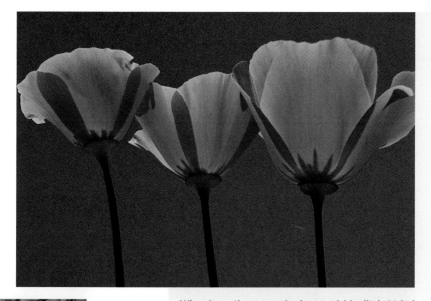

When I saw these poppies in a roadside ditch, I tried to isolate and shoot a small group of them at flower level with my 300mm lens and one extension tube. No matter what I tried, I couldn't get a clean composition. It wasn't until I switched to my 17–35mm lens with the idea of looking up that I found a view that was not only clean but quite graphic. Lying flat on my back with my focal length at 17mm, I was able to compose three blooms against a clear blue sky. (This is also something you can try with the fish-eye lens, as in the image on page 147.)

17–35mm lens at 17mm, 1/125 sec. at f/16

My wife wanted to go shopping in downtown Chicago. I wanted to go shooting in downtown Chicago. We both won! Since this is an HDR image, I shot 7 exposures ranging from +3 to -3 and, upon returning home, loaded them into the computer to create the final exposure seen here. (Complete shutter speed range, all at f/11: 1/8 sec., 1/15 sec., 1/30 sec., 1/60 sec., 1/125 sec., 1/250 sec., and 1/500 sec.).

12–24mm lens at 14mm, ISO 200, f/11

SHOOTING DOWN
FROM ABOVE

Photographing while looking down on a subject is one of my favorite points of view, whether it's from a 10-story hotel or simply from a small stepladder. For the portrait on page 165, for example, I climbed up a ladder belonging to my subject to capture him inside the boat he was building. For the lower shot on page 169, I was up in my apartment several stories above the scene. When I asked a neighbor's son to jump headlong into the pool for me (page 194), I was atop a 12-foot ladder.

It's always my goal to record compositions that are clean and simple, yet graphic and colorful. As a result of many prior experiences shooting downward, I knew that the cleanest and most graphic composition of the ball and fins would result from a high viewpoint. Atop a 12-foot stepladder at the edge of the pool, I had my subject take one step into the pool and my assistant float the ball into position. Once the water became calm, I took this shot while handholding my camera.

Nikkor 35–70mm lens at 70mm, *f*/11 for 1/125 sec.

NO HORIZON

Making successful compositions would be relatively easy if all outdoor subjects included the horizon line. But most of us have extended our range of subject matter far beyond the traditional landscape and, subsequently, will need to learn to create good compositions even when no horizon lines are present. When you shoot down from above it is particularly easy and often desirable to eliminate the horizon from the frame. Sometimes, the sky can serve to lead the eye right out of a shot; at other times, it can weaken a strong, graphic shot.

For some, trying to compose without the horizon as a Rule of Thirds positioning guide is tantamount to driving blindfolded, yet the solution is rather easy. You can laminate two small pieces of clear plastic adhesive together, and with a felt-tip marker, draw two evenly spaced horizontal and vertical lines on this. You now have a wallet-sized Rule of Thirds grid that you can use in any situation. Look through it to determine the most harmonious composition. After a few months of looking at all your subjects through your grid, you'll no longer need it—even when no horizon line is present. (Note: Some cameras have grids on the focusing screen or the camera monitor. If yours does, embrace it with fervor!)

The image at left suffers from the inclusion of the sky, which leads the eye right out the top of the frame. To get the elevation necessary to exclude the sky, I stood on a ladder (my wife was also on a ladder to clear the tall flowers). Without the sky, the eye is contained within the picture borders and doesn't wander away from the subject.

35–70mm lens, 1/125 sec. at *f*/16

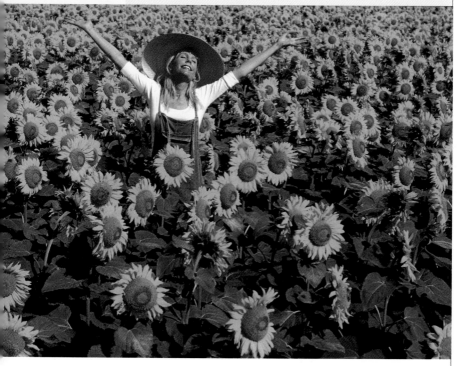

Looking down from atop a large coal storage facility, I captured this lone Caterpillar pushing around mounds of coal. To correctly meter all that black coal, which would have wreaked havoc with center-weighted or even matrix/evaluative metering, I used my camera's spot metering while my lens 80–200mm lens was at 200mm and aimed at the Caterpillar. With an aperture of *f*/11, I adjusted the shutter speed until 1/60 sec. indicated a correct exposure. I then zoomed out to 80mm to get the coal in the frame and took the shot. When I did this, the meter indicated that I was way off (wanting me to shoot at 1/15 sec.), but I ignored it, thus ensuring that the black coal would indeed appear black, not an overexposed gray.

80–200mm lens at 80mm, *f*/11 for 1/60 sec.

WHAT IF. . . ?

Once you begin discovering how your lenses see, don't be surprised if you find yourself consumed by the question "What if. . . ?" What if you focus on a passport lying on the sidewalk and include a businessman getting into a taxi in the background? What if you focus close on a broken windowpane with a solemn-looking little boy, glove and bat in hand, in the background? What if you focus on part of the hand and thumb of a hitchhiker on a busy interstate? What if you focus close on a used syringe in an alleyway? What if. . . ?

Choosing a vantage point from above and shooting down can often re-
veal some new, exciting compositions of tired, worn-out subjects. Most
often, a high viewpoint is combined with a wide-angle or "normal" lens.
Rarely is it used with a telephoto, unless you're really high up, such
as on the rooftop of a skyscraper or in a helicopter. But since I was
in one of those rule-breaking moods, I shot this picture of my friend
Fabrice while looking down from my second-floor window. Due to the
telephoto's inherent compression of space, the normally 6' 2" Fabrice
appears quite foreshortened.

80-200mm lens at 160mm, 1/125 sec. at f/8

SEEING THEMES

Without a theme, some photographers feel like they're a glass of milk spilled on the table: Shooting aimlessly, not quite sure where the images may "fall," they feel panic and frustration. Having a theme in mind will organize both the thought and visual process of image-making, and for many photographers, a "winning" theme has become the basis of their first coffee table book. Themes can be as simple as shooting only flowers over a certain time period or as challenging as shooting only people with red hair, as famed street photographer Joel Meyerowitz has done. Simply put, a theme gives you a reason to get up and head out the door—or to shoot the door if doors are your theme.

105mm lens, ISO 100, *f*/8 for 1/250 sec.

80–200mm lens at 200mm, f/8 for 1/60 sec.

17–55mm lens at 55mm, f/8 for 1/160 sec.

Above: 105mm lens, ISO 100, f/16 for 1/250 sec., 1600 White Lightning monoflash (shot in studio)

Right: 300mm lens, 1/250 sec. at f/5.6. Opposite: 35–70mm lens at 70mm, ISO 100, f/5.6 for 1/160 sec.

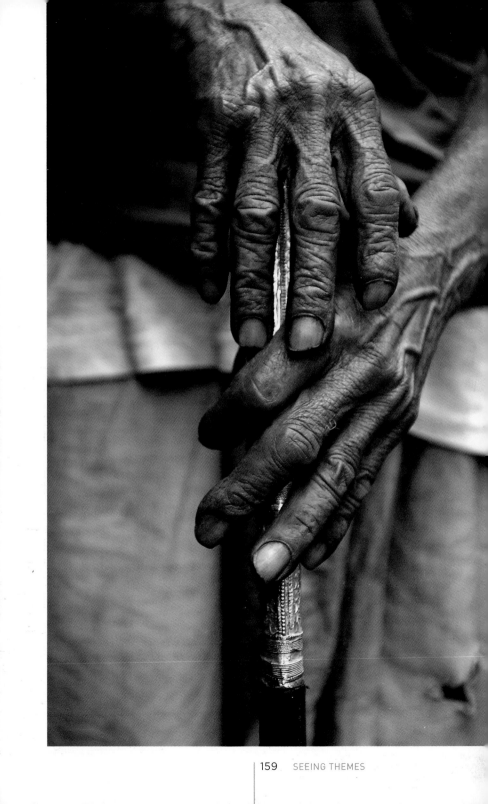

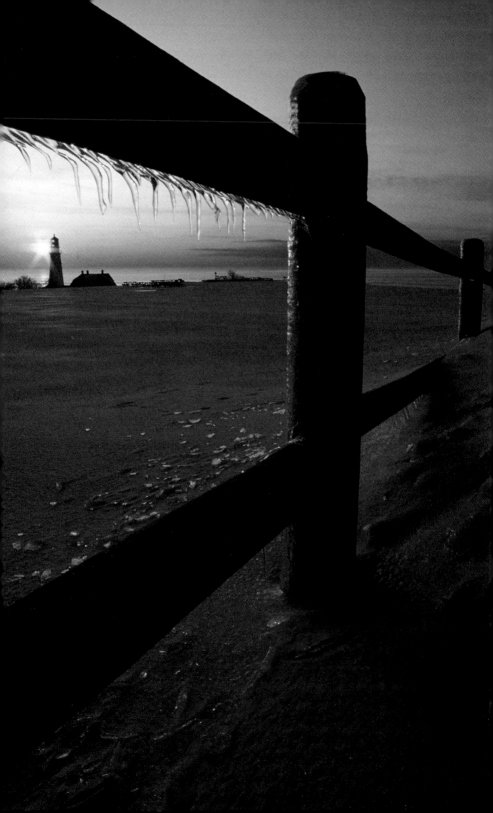

DESIGNING A STRIKING IMAGE

The kinds of images that command the most attention usually involve commonplace subjects composed in the simplest way. They're successful because they're limited to a single theme or idea—and they're always organized without clutter. But many of the pictures taken by amateur photographers today are made in haste and either have too many points of interest or lack a single focus. The lack of direction and confusion alienates the eye, forcing it to move on and seek visual satisfaction elsewhere.

Successful photographs rely on order. The elements that establish order are line, shape, form, texture, pattern, and color. These are the elements of design, and we'll explore them all in this chapter. Every photograph, regardless of subject, regardless of success, contains at least one if not several of these elements, all of which have tremendous symbolic value—particularly line, texture, and color. Usually, we see and utilize these elements unconsciously. Your memory and life experiences affect your sensitivity to various visual components, and this in turn affects how you use and arrange them in your compositions.

LINE

Of the six main elements of design—line, shape, form, texture, pattern, and color—which is the strongest? Line! Without line, there's no shape. Without shape, there's no form. Without shape and form, there's no texture. And without line or shape, there's no pattern.

A line can be long or short, thick or thin. It can lead you away or move you forward. It can be felt as rigid, active, soothing, or threatening. The emotional meanings of line cannot be overlooked. Some of us experience a thin line as sickly or unstable, yet others see it as sexy, cute, and vulnerable. A thick line, for some, may feel stable and reliable, but for others it may seem unhealthy and stern.

In nature, curved lines dominate. They are the wind, the rivers, the surf, the dunes, the hills. Most people interpret curved lines as soft, gentle, restful, and relaxing. Straight and jagged lines are also present in nature, with the most obvious jagged lines being mountain ranges. Straight lines have shaped much of history, as wars were fought with arrows, knives, spears, and swords. Jagged lines are often interpreted as sharp, dangerous, forceful, chaotic, and threatening. Even the Wall Street investor is all too familiar with the chaos caused by the jagged line. Being conscious of the subtle feelings associated with line allows you to manipulate a photograph's emotional and visual impact.

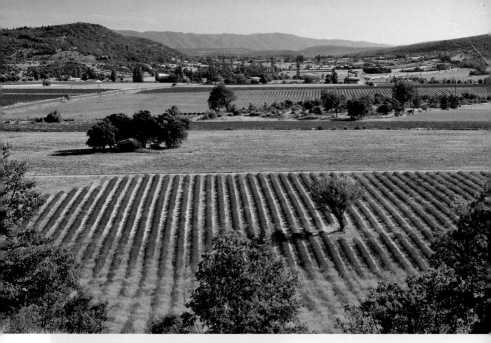

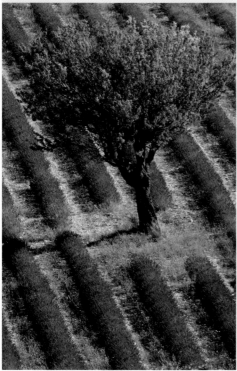

After the short climb up a small hill in the French countryside, I was not at all disappointed by what greeted me below: the oft-seen lone tree in the field of lavender. Note how the first image doesn't exploit the design elements that abound in this scene. It surely is a "nice" picture, but it's hardly a bold, strong, forceful image. So, deciding to make line my main emphasis, I rotated my camera to the vertical position and was able to render a more dynamic composition in which line is king—both the lines of lavender and the line of the tree trunk. And of course the contrast of the green tree against the purple lavender doesn't hurt at all either. (See page 188 for more on color.)

Both photos: Nikkor 80–400mm lens, ISO 100, f/16 for 1/125 sec.

Although the S curve occurs abundantly in nature, it's also evident in the man-made roads and trails that wind through the country-side. Considering that this is a flat landscape, I'm glad someone had the "compositional foresight" to build a curved road through this pastureland in Bavaria, Germany. Clearly, it could have been built straight, since there are no rocks or trees to avoid. So when I saw this scene in my rearview mirror, I felt compelled to stop the car and photograph it. With my camera mounted securely on a tripod, I chose an aperture of f/32 for maximum depth of field and then simply adjusted the shutter speed to 1/30 sec.

Nikkor 300mm lens, f/32 for 1/30 sec.

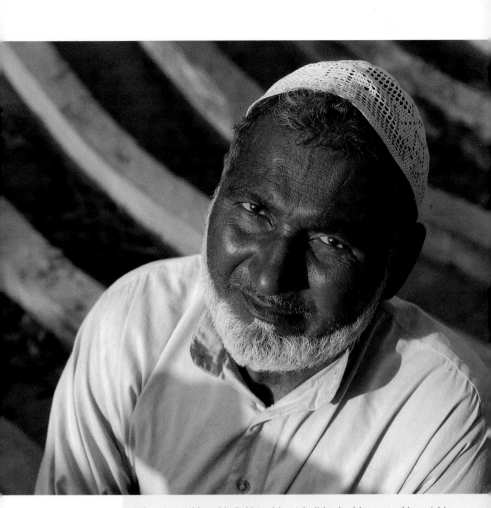

When I met him, this Pakistani boat builder had been working at his craft for over 40 years and had finally reached the level of master builder. He agreed to take a few moments from his busy day to pose for me, and as I handheld my camera, I felt it would be interesting to frame him against a background of the inner hull skeleton of one of his boats. The lines of the boat's curved structural ribs are a strong graphic element that adds visual interest and complements the off-center placement of the subject. Note, however, that this element doesn't overwhelm the subject, and that's due to the relatively large aperture (f/4), which throws the background slightly out of focus and gives it slightly less weight.

Nikon D2X, 17–55mm lens at 30mm, f/4 for 1/500 sec.

This past August, the family cat had, as my wife likes to call it, a "gift" for me: a very dead, young cardinal. Soon, after removing some of its feathers, I was immersed in the art of bird photography (1). I had just sprayed the feathers with water to create the look of morning dew when something happened that was *not* part of my plan but rather just good, old-fashioned dumb luck. When I set the blue spray bottle down (2), the low-angled light of late afternoon passed through it, and cast a bluish glow across a portion of the feathers. This additional element did not disappoint, making my intentional diagonal positioning of the feathers (3) even more active than it would have already been.

Micro-Nikkor 200mm lens, ISO 200, *f*/16 for 1/160 sec.

The Power of the Diagonal

Every line evokes an emotional response, and that's certainly true when we talk about the diagonal line. It is solid, decisive. As any cyclist knows, it presents a challenge going up and offers an exhilarated rush going down. The sense of movement, activity, and speed that it evokes can often breathe life into an otherwise static composition. Sometimes, the photographer makes a deliberate decision to photograph a composition with the camera turned on a diagonal, but there are many natural diagonals to be found if you just take a look.

In both of these images, it's my point of view—shooting at an angle to the direction of the lines in some way—that creates the diagonals and elevates the sense of urgency, movement, and speed. Coming at the steps in the pool from an angle emphasized their three-dimensionality and color, something that would have been lost had I come at them head-on. In addition, the diagonal lines lead the eye into the shot.

In the other case, a snowy day in Lyon found me hanging out on my terrace with my camera on a tripod and pointed down at the small intersection in front of my apartment building. Instead of framing the lines straight up and down and side to side in the frame, I positioned the camera so that the lines were slightly on angle. While I loved the very graphic effect of the lines, I also felt that this monochromatic scene needed a splash of color. One thing I discovered on that cold morning was that there aren't a lot of red cars in the world. It seems gray, white, and black are the most popular choices, but I was determined to wait for a red car—and finally, my determination paid off! Since I was already in position with my exposure set, I managed to get off one perfectly framed shot as the car passed through the scene.

Top: Nikkor 35–70mm lens, f/11 for 1/250 sec. Bottom: Nikkor 17–55mm lens, f/11 for 1/15 sec.

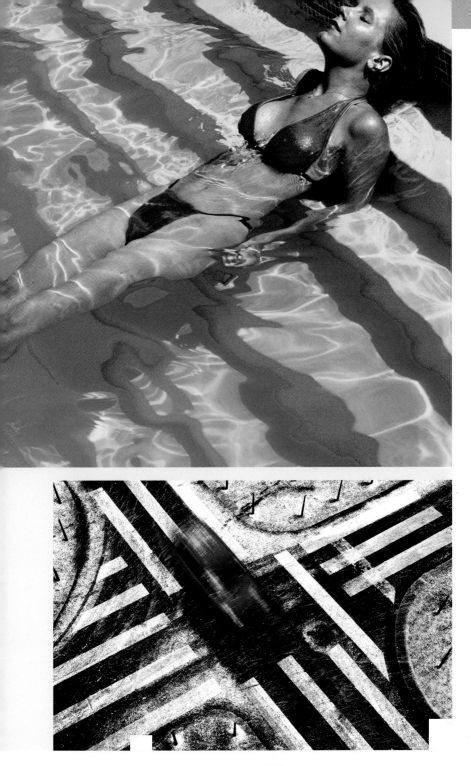

SHAPE

Shape is more fundamental than form, texture, or pattern because shape is the principal element of identification. You may think you smell a fragrant rose, but until you see its shape, you can't make a positive identification. You may hear a sexy voice on the radio, but unless you actually see the shape of the speaker, who knows how comprehensive that sexiness is?

From prehistoric through modern times, man's need and ability to identify objects by shape has endured. This ability and the lack thereof provide, alternately, security and anxiety. If the caveman could not readily identify the shape of that herd on the horizon, he very well might have walked right into that family of woolly mammoths with only a bit of "rope" instead of his spear. During World War II, if soldiers from differing countries hadn't had different helmets, they might have ended up shooting at their own comrades. As the shape of the car comes into view, you can now relax, knowing that, although she arrived later than planned, your daughter has returned home safely from college. Horror movies play off our anxiety about the shape of the unseen, and most have a standard script that keeps the monster unseen for better effect. No one actually sees the creature, leaving the imagination to run wild. The audience wants this "thing" identified, because seeing its shape would finally reduce, if not eliminate, everyone's anxiety.

When composing a photograph that depends primarily on shape, there are two things to remember. First, shape is best defined when the subject is frontlit or backlit. Second, there should be a strong contrast between the shape and its surroundings.

If you want to shoot silhouettes, there are no better times than just before and several minutes following sunset and several minutes before and after sunrise. Form and texture both vanish at these times, leaving only stark outlines and profiles against the sky. The silhouette is the purest of all shapes, so it is not surprising that it continues to be the most popular of all shapes to shoot.

Without fail, every Saturday kids could be seen Roll-erblading along the wide and long walkways outside the opera house in Lyon, France. In the early morning light, long shadows would be cast across the granite walkway as the sun came up and through the arched entryways. Additionally, the sun would pierce the low-hanging, red-globed lights and cast a wonderful red shadow onto the walkway. Confining my compo-sition to these two strong elements of design (shape and color) resulted in a striking image.

Nikkor 17–55mm lens, ISO 100, *f*/8 for 1/500 sec.

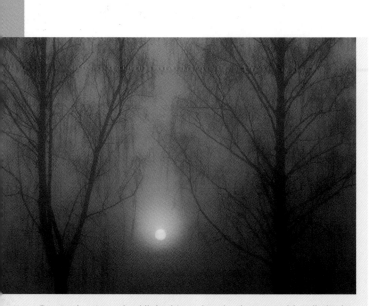

Due to the strong backlight, it's such a simple composition, limited to shape. The many silhouetted lines on both sides of the circular sun tell us we're looking at a tree. If not for the foggy sunrise that morning, this is one image that I know would have never gotten my attention.

Nikkor 105mm lens, ISO 50, *f*/16 for 1/250 sec.

THE STRENGTH OF THE CIRCLE

The circle is by far the strongest shape. It can symbolize not only the sun but the moon, Earth, and planets, and it evokes feelings of completion, universality, psychological wholeness, and warmth. A circle will oftentimes unify a composition by providing a center of power, and no circular object is more powerful than the sun.

While in Prague, I found myself in the front row at the starting line for a 26K marathon. What caught my attention before the race were the many shapes of the shadows that spilled across the blue carpet at the starting line. I figured there was a good chance that the runners' feet and legs would pass through this area near the top of my frame once the starting gun fired, so I wasted no time in preparing and sizing up the scene. As luck would have it, the runners did, in fact, come into the top of this composition, and the combination of shape and line made for an unusual and arresting photograph.

12–24mm lens, ISO 200, *f*/11 for 1/500 sec.

FORM

Basically, form is seen in three dimensions, while shape has only two. Form assures us that an object has depth and exists in the real world. Since communicating form depends on light and the resulting shadows, it's best to photograph a subject under sunny skies and sidelighting to reveal its form. The contrast between the light and dark areas of a sidelit shape give it form.

Circles, squares, rectangles, and triangles all evoke different emotional responses. When the forms of these shapes are revealed, these responses are amplified. A backlit circular shape represents wholeness, yet when sidelight reveals the form, the curvilinear shapes that result take on sensual meanings, reminding us of the human form. The three-dimensional forms of squares, rectangles, and triangles suggest the man-made world.

Landscape photographers know the importance of form and shape. Both are often vital to the success of a landscape image. Sidelit landscapes are most often preferred, since sidelighting reveals form better than any other lighting condition. In this series of photographs, I handheld my camera and began near the edge of this field of rolled bales of hay, choosing a sidelit point of view and a composition that emphasized the dramatic sky. After the first exposure, I walked closer to the bales and made another photograph. Then I moved even closer until one bale filled almost half of the lower portion of the frame. In all three photographs, form and shape dominate the composition.

All photos: 17–35mm lens, 1/125 sec. at f/16

TEXTURE

Perhaps no element of design is more capable of exuding deep emotion than texture. Even as you only witness someone being thrown from a bicycle, a chill goes down your spine when you see the person skidding across a gravel pathway. In our daily language, we use texture to describe most everything. A rough day, a soft touch, a sharp mind, a dull movie, a sticky mess. A woman's soft voice may arouse delicate or vulnerable feelings, but a man's gravelly voice may elicit fear or feelings of aggression. A hard-nosed boss seldom wins the affection of employees, whereas the smooth-talking boss often does. These are just a few examples of texture's influence.

Although we use texture as a means of describing events in our lives, it's not as readily apparent in photographic work. Texture, unlike line or shape, doesn't shout to make itself known. Of all of the elements of design, it is the one that is most often "hidden." The challenge in seeing, as well as conveying, texture depends on one critical element: lighting. A compelling image of texture (unlike line, shape, pattern, or color) is dependent on low-angled sidelight. So, it's often imperative that you search for texture on sunny days in the early morning or late afternoon hours. Although some texture-filled subjects are obvious, like sidelit tree bark, others require much closer inspection, and you may find your macro lens getting lots of use.

Once you begin to see texture, you may discover its use in creating compelling landscape imagery. As a foreground element in a vast compositional landscape, texture can arouse a heightened emotional response from viewers as their sense of touch is ignited.

I awoke one morning to find frost covering much of the windows inside my house. The oil furnace was broken at the time, and the temperature had dropped to single digits overnight. As one who believes that when life gives you lemons you should make lemonade, I was quick to grab my gear and shoot these magical frosty textures. With the camera on a tripod and parallel to the window, I chose an aperture of *f*/11 and simply adjusted the shutter speed to 1/30 sec.

Micro-Nikkor 105mm lens, *f*/11 for 1/30 sec.

Along the south shore of Maui lies Makenna Beach. Arriving just after sunrise, I had the beach all to myself. I spent 15 minutes or so watching the incoming surf, discovering its pattern of creating a much bigger wave every fifth wave. It was this bigger wave that held my interest, as it was the only one capable of truly coming ashore. Holding my camera while lying on my belly at the edge of the beach, I began firing once the fifth wave broke. With such a large portion of the frame filled with the texture of the sand and remnants of surf, it's no surprise if you feel like you're at the shore.

17–35mm lens at 17mm, 1/125 sec. at *f*/22

Texture as a background can elicit strong responses and provide information. I doubt if anyone would think this road sign is out in the countryside; the man-made feel of the background texture leaves no doubt that this sign is in, or very near, an industrial area.

35–70mm lens, 1/125 sec. at f/8

A strip of blue painted metal, with a few holes punched along the way, makes for a graphic image of color, especially when composed against the backdrop of a red car parked nearby. The addition of the early-morning fog and the resulting condensation (texture) suggests that the once-sleepy metal strip has just stepped out of the shower.

70–180mm lens, 1/30 sec. at *f*/11

There are a number of patterns working together in this image: the text on the newspaper, the bars of the cage, and the birds inside it. They combine to form rich visual interest for the eye. Since I wasn't satisfied with the gray concrete background behind the cage, I had my assistant hold a piece of fabric 3 feet behind the cage.

80–200mm lens at 180mm, 1/250 sec. at f/8

While on assignment in Singapore, I spent several days in the Little India district photographing many of the people who live and work there. I noticed one man sitting in front of his shop reading a newspaper. Following my request to take his picture, he kindly obliged, and I simply framed him in front of the patterned background against which he was already seated. Since he "disrupted" the pattern, he became the focus.

105mm lens, 1/250 sec. at f/5.6

If there's an outdoor market nearby and diffused light overhead, grab your camera gear and tripod. Because of the color and patterns, outdoor markets are a favorite haunt of mine. The vendors often create very graphic displays with their fruits and vegetables.

Often, I travel very light at these markets, carrying just my camera and 35–70mm Nikkor lens. The lens is wide enough for some shots, yet with its moderate telephoto end, I can just as easily come in tight when closer cropping is needed. For the shot of spices, I handheld my camera and a 12–24mm lens, got up on my tiptoes, and shot down (rather than across them); this resulted in a much more compelling image of pattern.

Top: Nikkor 20–35mm lens at 28mm, *f*/11 for 1/60 sec. Bottom: 12–24mm lens, ISO 100, *f*/11 for 1/60 sec.

When my wife arrived home from the grocery store with a new box of multicolored straws, I grabbed them before the kids could disturb them and placed them on the table. I needed my macro lens to fill the frame, since in reality, they only took up about 3 square inches. I moved in close, filling the frame and shifting the camera's plane so that it was at a slight angle to the ends of the straws (rather than parallel); this brought a sense of movement to the composition. As an alternative to the macro lens, you could use your 35–70mm zoom lens with an extension tube.

Micro-Nikkor 105mm lens, tripod, *f*/22 for 1/8 sec.

Along the banks of the Saône in Lyon, the antique booksellers are out in force every Saturday and Sunday. In addition to finding some really great French literature, the keen eye will also find numerous pattern compositions. As I attempted to shoot a storytelling image of foreground books and the distant hilltop cathedral, I realized, "This shot just isn't coming together (thanks to the abrupt, distracting concrete wall separating the two subjects), but it's a pattern shot for sure!" I simply turned my attention to the books, leaned over them, and shot down to reveal nothing but pattern. And to bring some life to the arrangement, I tilted the camera on a diagonal.

12–24mm lens at 24mm, ISO 100, f/11 for 1/160 sec.

While in Vermont several years ago, I spent some time shooting in a local park in Burlington. All of my attention was given to the ground at my feet ; leaves were everywhere, and following the previous night's rain, they were rich with color and covered in droplets. I soon got the idea to turn over all the leaves except one, knowing that the eye would sense the importance of the lone red leaf because it was different from the others. This is an effective way to use pattern as a tool to call attention to a subject, much like the photo of the Indian man on page 183.

Nikkor 35–70mm lens, tripod, ISO 100, *f*/11 for 1/30 sec.

COLOR

Some time ago, I was sitting in a café in France when two young men walked in and sat within earshot of me. What caught my attention was one young man's over-stuffed camera bag and the two Nikon F100s hanging from his neck. Over the course of the next 30 minutes, their discussion centered around photography, and of all that was said, one comment made by the man with the gear stood out the most: "Color is so obvious. Where is the surprise in that? The real art in image-making lies in shooting black and white."

This is not the time to begin a debate on what constitutes art in photography, whether in color or black and white. However, it *is* the perfect opportunity to address the fact that color is indeed obvious. It is *so* obvious, in fact, that many photographers don't see it at all! If people really saw color, they would be far too consumed by the need to shoot color *if only* for color's sake.

To really see and become an effective photographer of color there's much to learn. Color has many messages and meanings. You must also become aware of color's visual weight, the impact it has on line and shape, and its varied hues and tones in order to use it effectively.

Although the subject of color is deserving of its own book, I'll limit my discussion to the primary (red, blue, and yellow) and secondary (orange, green, and violet) colors. Primary colors are so called because they cannot be created by mixing any other colors together. The mixing of any two primary colors results in a secondary color: Mixing red with blue makes violet, mixing red with yellow makes orange, and mixing blue with yellow makes green. Color is often discussed in terms of temperature, with reds, yellows, and oranges (associated with the sun) often described as warm colors, and blues, violets, and greens (associated with water and shadows) often described as cool colors.

Red is the color that advances the most of all colors. So for example, if you were to place red, orange, yellow, green, blue, and violet signs in a field all at equal distances from you, the red sign would appear closer than the others. Of all the colors you can place with red, blue would offer the greatest contrast, in large part due to blue

The color wheel is an ordered arrangement of subtractive colors that helps to show their relationships to one another. For example, pairs of colors that fall opposite each other on the wheel are called complementary colors; when placed side by side, these pairs complement and intensify each other. Also, each primary color falls opposite a secondary color, and each secondary color falls somewhere between the two primary colors from which it is made. Colors that fall side by side on the wheel are referred to an analogous colors. The relationships go on and on. Studying the color wheel can help you get a better feel for colors and how they affect one another. Color wheels can vary in the numbers of colors they include; some show 6 colors, while very commonly a wheel will show 12, as this one does.

being one of the colors that recedes the most. Yellow, like red, is a color that advances, as is orange. Green, the most dominant color in nature, recedes, like blue. Violet, or purple, is also a recessive color, even more so than blue and green.

So, where does one begin to look for color? Many outdoor photography enthusiasts will head for the mountains, deserts, beaches, or flower meadows, while a few others start their search on city streets, in alleyways, and even in auto wrecking yards.

You don't have to go far to find the color green; it is most dominant in the spring and summer in both agriculture and nature. It's rarely found in the man-made world, however. So when I saw the pattern of the buckets of strawberries against a backdrop of green table, I was quick to frame a shot, using the sign as visual interest to break the pattern. Red and green are complementary colors (meaning they fall opposite each other on the color wheel), so they each serve to enhance the other. The green of the table also nicely picks up the strawberry leaves.
Leica D-Lux 3, ISO 100, f/8 at 1/125 sec., Aperture Priority mode

Regardless of where your search takes you, make it your goal to shoot compositions that first and foremost say *color*, as opposed to *landscape*, *flower*, *portrait*, or *building*.

I often suggest to my students that they begin their search for color with the aid of a tele-macro lens. I'm a big fan of the Nikkor 70–180mm micro lens, but any tele-macro lens (or moderate telephoto with a macro feature or telephoto used with extension tubes) will do the trick. Narrowing your search to the much smaller "macro" world will result in a much higher success rate.

Many of my students who do this soon discover that they're seeing color possibilities not just with their close-up equipment but also with their long telephotos and their wide-angle zoom lenses. One student's remark following several days of shooting color with her macro lens probably best sums up the feelings of most: "I feel like Lazarus. The discovery of color has awakened me!" Yes, color is obvious—it's everywhere; so, the path toward creative image-making benefits from a much higher awareness of the color that surrounds you.

TWO SETS OF PRIMARY COLORS

The primary colors that I refer to in the text here—red, blue, and yellow—are known as *subtractive* primary colors. From them we get the subtractive secondary colors—violet, orange, and green. The subtractive color system involves colorants and reflected light. It uses pigments applied to a surface to subtract portions of the white light illuminating that surface, and in this way produces colors. Combining the subtractive primary colors in equal parts produces the appearance of black. Color painting, color photography, and all color printing processes use subtractive color.

However, there is also another set of primaries called *additive* primary colors, which are red, green, and blue. From these we get additive secondary colors—cyan, magenta, and yellow. Additive color involves light emitted from a source before it is reflected by an object; it starts with darkness and adds red, green, and blue light together to produce other colors. When combined in equal parts, the additive primary colors produce the appearance of white. Television screens, computer monitors, digital and video cameras, and flatbed and drum scanners all use the additive color system.

Again, it's the *subtractive* colors that I'm talking about here. They have been used by artists for centuries, and they are the ones you should keep in mind when working with color.

As long as I've got students to teach, I'll continue saying the following: "First and foremost, make it an obvious picture of color!" Rather than looking for rocks, trees, waterfalls, birds, flowers, fire hydrants, or bridges, focus your energy and vision on red, blue, yellow, orange, green, or violet. Color first, content second! It was the color—the yellow breaking up both the blue and the surrounding patterns—that first got my attention and enabled me to see this image. If you're out in the field, where you might have less control over subject matter, you have to make sure to really *see* what's happening with the colors around you. Sometimes with just two primary colors, you can do more with less; the one occurrence of yellow is a graphic break from the patterns of blue background bodies and foreground fish baskets, and it balances the main squatting figure in blue. The two standing figures in light, neutral-colored garments then frame things up nicely and tie in to the tones and colors of the fish.

Nikon D2X, 12–24mm lens at 12mm, *f*/16 for 1/60 sec., Aperture Priority mode

The graphic strength of this image is helped not only by its composition but by its color relationships, which I thought out before making the image. Orange and blue are complementary colors, falling opposite each other on the color wheel; as with all complementary pairs, one color is cool while the other is warm, but both are of equal strength, so they intensify each other. In addition, orange and red are analogous colors, being contiguous on the color wheel. Analogous color schemes can sometimes become monotonous, so successful use of analogous colors often involves using the complement of one of the analogous colors as well, which happens here with the blue background (again, the complement of orange). This same technique is seen in the pool image on page 151: analogous colors of blue and green with red (green's complement).

70–200mm lens at 100mm, f/5.6 for 1/400 sec.

Colors can make a splash—literally! The contrast of the yellow ball (an advancing color) against the blue water (a receding color) serves to strengthen the feeling of depth in this image. Standing atop a 12-foot stepladder enabled me to shoot down into the pool while holding my camera. Over the course of about 30 minutes, my model made 108 jumps into the pool for me, and I got a number of winners. This was one of my favorites.

35–70mm lens at 50mm, 1/500 sec. at f/8

If there's one thing I've learned in my years of image-taking and image-making, it is this: The more prepared I am, the greater my chances of getting *the shot* when Lady Luck shows up. I was simply wandering the backstreets of Cuba some years ago, quite taken by the many colors—colors that seemed cheerful, despite the hardships that so many Cubans were facing. Directly ahead of me, the small street I was on came to an end, leaving the choice of turning right or left; but just before I reached the end, a young Cuban boy entered the scene from the left. Quickly falling to one knee, I braced my camera tight against my chest and quickly fired off 3 frames. The early morning sidelight, combined with the vivid tones of blue, yellow, and red created a composition that is deep with color and contrast. The fact that the boy was wearing a red shirt—getting me all 3 primary colors in one shot—was pure luck.

80–200mm lens, ISO 50, *f*/8 for 1/250 sec.

Just before dawn on Miami Beach, the sky was a light magenta color. The added magenta hue enriched even further the shades of purple in this scene directly across from the beach: both the classic Chrysler and the Colony Hotel are made even more vivid and, of course, elegant due to our associating purple shades with royalty. Early-morning or late-afternoon light can help or hurt you in your efforts to photograph color, so keep an eye on the color of the light. A bright yellow field of sunflowers at sunrise will not record a true yellow until several hours after sunrise due to the excessively orange light of sunrise; it's best to shoot that field a few hours after sunrise, when true yellow can reign.

Nikkor 35–70mm lens at 50mm, *f*/11 for 1/8 sec.

Clearly, paying attention to color and its emotional messages is an important step toward developing photographic maturity. Likewise, so is paying attention to monochromatic color. Images of monochromatic color are comprised of shades of just one hue (color) or are devoid of any colors other than black, white, and shades of gray. The winter season is the most likely time for finding monochromatic images of the latter type, although I've shot a few in the summer (for example, two empty, white rocking chairs on a gray porch against a white house). To record monochromatic images of winter snow scenes, you must plan on doing so on overcast days or while the snow is falling, and choose subjects that are stark, dark shapes. These three windmills (which I came upon in West Friesland, Holland, following several hours of snowfall) sure fit that bill nicely!

17–35mm lens, 1/30 sec. at f/16 for a +1 exposure

SCALE

The human shape is perhaps the most unmistakable in all the world. As a result, when you include it in any large and expansive landscape, an obvious sense of scope and scale results. How can such a tiny subject grab your attention when it doesn't even come close to filling the frame? The answer lies in a basic law of visual perception: The smaller a subject is in relation to its surroundings, the more unusual it appears, and the more unusual it appears, the more it stands out. This happens regardless of whether that landscape is a nature scene or something more urban or industrial.

Note that I often tell my many nature landscape students that if they one day hope to make money with their camera, they would be wise, after shooting that landscape, to make another exposure that includes a person in the scene. Landscape images that include a person more often than not have a higher market value than those that don't.

A shape that replicates the letter H and the addition of the human element lend themselves to a dynamic composition of size and scale. Likewise, no one will disagree with the following statement: "That is one large ship!" Nothing can call attention quicker to scale and a landscape's surroundings than the human form. There's nothing like it; it allows the eye to get a fix on the scale of the surrounding scene.

Left: 80–200mm lens, *f*/16 for 1/2 sec. Above: Nikkor 300mm lens, ISO 50, *f*/16 for 1/60 sec.

COMPOSITION

There may come a day when setting a creatively correct exposure is all done by the camera, but I can't ever imagine a time when a camera tells you the best point of view or the best light conditions. There is one constant with the art of image-making: the need to create effective and powerful compositions. This ability lies solely with you, the photographer, and no amount of technology can ever take your place. (Not even Photoshop's Crop tool, which is a crutch that keeps you from walking barefoot; only when you are barefoot can you really feel—and therefore *see*—the ground in front of you.)

What exactly is photographic composition? Photographic composition is based, in part, on order and structure. Every great image owes much of its success to the way it is composed, which is, in essence, the way the elements are arranged. As with any good story, song, or even potato salad, several ingredients combine when putting together a compelling composition. Along with the design elements we've just discussed, composition is a big part of designing a successful image, so the remainder of this chapter will cover its various important aspects.

The images seen up to this point have, indeed, all made use of some if not all of the compositional elements we'll now address in detail, including filling the frame, format, tension, and balance. These last two, in particular, dominate every successful composition. Tension, which is the interaction among the picture elements, affects the viewer's emotions. Balance organizes these visual elements and keeps the viewer from tripping over the photograph's intent or meaning.

Much like a slingshot and a small stone, this tree-lined country lane is composed of two strong converging parallels with the "stone" being the lone biker in red, the most advancing of colors. The elements of design and the Rule of Thirds (see page 224) are both alive and well in this simple yet graphic image.

Nikkor 300mm lens, ISO 100, f/16 for 1/125 sec.

Envision the imaginary grid of thirds and this image comes as close to perfect as one will get. In addition, it's an image of depth, thanks in part to the use of the 35–70mm lens and 35mm focal length, and the placement of the young boy in the left third of the background. The main subject's hat (near the top horizontal third) and his shirt (near the bottom horizontal third) support his striking and character-filled face, which in turn dominates a full two-thirds of the horizontal and vertical grid. (And the good sidelight doesn't hurt, either.)

Nikkor 35–70mm lens at 35mm, ISO 100, f/5.6 for 1/30 sec.

FILLING THE FRAME

Getting the right balance and arrangement of picture elements sounds easy enough, yet ineffective composition prevails, and the number one reason why is that photographers are constantly "blowing things out of proportion." Your brain constantly does this, seducing you into thinking that everything looks good when you look through the viewfinder. Your brain has this uncanny ability to make very selective "image magnification," deliberately eliminating the clutter above, below, to the left of, and to the right of your subject. This quick "read" enables you to identify what you're looking at, in effect making you believe that there really is only that moose in what is actually a very cluttered landscape.

Your brain filters out the visual clutter to keep you from going nuts. Every day your eyes and ears are exposed to, and bombarded with, literally thousands of sights and sounds. Rather than go crazy from this onslaught, the brain has this magical ability to filter out much of the "noise" that surrounds you, allowing you to concentrate on driving the car or to talk to a friend in a crowded mall or to read a book in a hectic restaurant. You can be reading the newspaper on a crowded bus and not hear the hot stock tip being discussed by the two gentleman seated behind you. And likewise, you can be so focused on that moose in your viewfinder that you fail to see that its hind legs merge with several branches of a nearby tree or that its overall size in the viewfinder is actually much, much smaller than you think.

In my Art of Seeing class I have every student choose one of two familiar subjects: a person or a flower. They are then instructed to *overfill* the frame: cut off the forehead or cut off the flower petals. It's a surprisingly revealing exercise. Overfilling the frame reveals just how easy it is to achieve impact. It's not a common thought to crop off a person's forehead or ears when shooting a portrait, but creative imagery has never been about common thought. Getting close is all about forming an intimate relationship, and intimacy creates impact! Lying at my subject's eye-level and focusing so close I cut off part of his head resulted in an impactful image of my neighbor's son, Manuel. Similarly, looking down on my daughter and overfilling the frame resulted in something that's not your typical portrait.

Top: 300mm lens, 1/500 sec. at $f/4$. Bottom: Micro-Nikkor 70–180mm lens at 100mm, $f/5.6$ for 1/90 sec.

In breaking down the many problem areas in photographic composition, the number one problem continues to be the failure to fill the frame. Unless you've made a point to fill your frame, your viewers will "fall asleep." Sure, they see your subject, but they also see all of the other stuff that surrounds it; it's that other stuff that tells them that tsomething is missing. That thing that's missing is *impact!* If you want to put your audience to sleep, always stand farther back than you should from your subject, don't focus as close as you can, don't zoom out your telephoto lens as much as you can, and whatever you do don't ever drop to your knees and shoot from the ground's viewpoint or climb some stairs and shoot from the bird's perspective. If, on the other hand, you do want to create frame-filling images that have impact, then do just the opposite!

Which of these two images would you rather display on your wall? If you're like most people, it's the photo on the left. If given a choice, we all would take that front-row seat that holds the promise of seeing *every-thing*. After composing and taking the picture, look at the LCD monitor. As a general rule, if your subject isn't touching—or at least coming very close to touching—the edges of the LCD, you're in the balcony.

Nikkor 17–55mm lens at 55mm, ISO 100, *f*/11 for 1/200 sec.

exercise:
LEARNING HOW TO FILL THE FRAME

This is one of the best exercises I can offer to help you over-come your inability to fill the frame. Grab your camera, lenses, and tripod, and go out and shoot nothing but letters (and/or numbers) for a whole week. You will "see" letters (and numbers) that you never noticed before, which will undoubtedly lead to other subjects you never noticed before. One thing leads to an-other, as they say, and this is true here.

You *must* make sure to fill the frame with that *one* letter or number; do this by either using the right lens or walking closer or both. In some cases, you may even find yourself lying down or climbing some stairs. As you begin your search, make it a point to *only* pick letters with great character and color. And where do you find these letters? Antique stores are great haunts, as are junkyards; so are old signs, graffiti, harbors, and even industrial yards.

You also may discover that you're partial to some letters or numbers. The letter K was always a favorite of George Eastman, who said, "The letter K seems to be such a strong and incisive sort of letter." Not surprisingly, the name Kodak was the result of a simple request from George Eastman, who said he didn't care what he called his company as long as the name began and ended with the letter K.

Grocery-store produce scales, parking meters, license plates, boats, manhole covers, street signs, building signs, and plaques are just some of the places you'll find letters and numbers.

Another way to get a more satisfying background involves carrying a few large pieces of fabric with you. Depending on your fabric choices, this can result in much better or more vibrantly colored backgrounds than what is actually there. That is exactly what happened here when I had my daughter Chloë hold a piece of fabric behind her sister Sophie.

70–200mm lens at 200mm, *f*/5.6 for 1/160 sec.

IN-CAMERA CROPPING

Everything—and I do mean *everything*—in your viewfinder that is within the plane of focus will record in the image exactly as you frame it. That includes all the visual clutter above, below, and to the sides of the subject. Everything else that's not within the plane of focus (background and foreground elements that are of out-of-focus tones or shapes) could interfere in your composition. So again, before pressing that shutter release, inspect the scene in your viewfinder top to bottom, right to left. Either stand back from the viewfinder or simply close your eyes, and picture in your mind what you believe to be true; then look through the viewfinder or open your eyes to see if this same image is in fact in your view-finder.

When you do this, don't focus as much on the subject as on its surroundings; does the negative space surrounding it suggest the subject is *not* filling the frame? Does your background place further emphasis on the subject or call attention away from it? If your camera has a depth-of-field preview button, press it to see if that background will render the effect you seek.

There's no better time to change your cropping in a bad composition than just before you press the shutter release. Photo software programs can do this for you, of course, but only after the fact. Don't you value your time more than that?

On an assignment for *Popular Photography* magazine, I came upon this small lizard at Busch Gardens in Tampa Bay, Florida. With my camera mounted on a tripod, I zoomed to the longest focal length of 180mm. I could argue that I had filled the frame, since I was, after all, at the longest focal length, *but* I had yet to focus as close as I could, so that argument would be weak. It's true that I couldn't bring the lizard any closer by zooming the lens out farther, but I had another option—often the only one and the easiest and most obvious way to fill the frame: walk closer to the subject. As I did this, I made sure my steps were, of course, slow and gentle, also making a point to keep one eye on the viewfinder to determine when I was close enough. In the closer version, the lizard fills the frame in a way that satisfies the viewer's curiosity and desire to see the lizard up close.

Both photos: 70–180mm lens at 180mm, 1/250 sec. at *f*/5.6

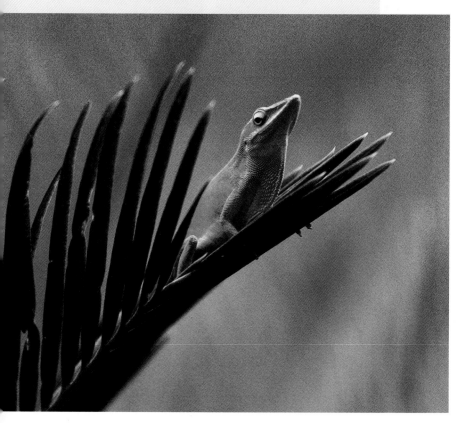

Contrast:
Dark Backgrounds

Just as jewelry is often displayed on black velvet to enhance its appearance, shaded areas are often used as backgrounds to set off subjects photographically. These shaded areas record as black (a severe underexposure) because the photographer is exposing for the brighter foreground subject. The result is contrast to the extreme. At other times, black is an integral part of the scene, and again, we can see black's power in creating contrast.

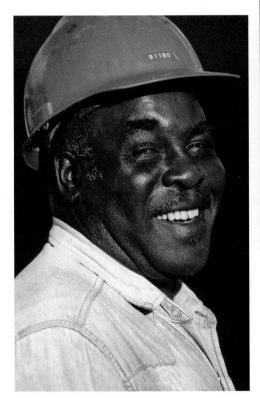

One of the challenges with the color black is to not be fooled by the light meter's tendency to overexpose it; the meter, without fail, will suggest exposure times that are much longer than they should be when presented with dark or black subjects, rendering them dark gray. So how do you successfully meter a dark subject against a black background? To properly expose Monroe (an oil refinery worker in Black Lake, Louisiana), I set my exposure for the sunlight falling on him (not for the area of open shade behind), metering off his shirt (a mid-tone). This rendered the background area a severe underexposure (i.e., black). As for the leaf, I simply moved in really close until my frame was filled with *only* the leaf. Once I set my exposure off that composition, I backed off to reframe the composition you see here—all the while ignoring my light meter, which was now telling me that my exposure was too dark.

Opposite: Nikkor 105mm lens, *f*/11 for 1/125 sec. Above: Micro-Nikkor 105mm lens, ISO 50, *f*/11 for 1/125 sec.

In the far-left image, the circled flower and the arrow indicate my intended subject and the contrast in the background behind it. I knew all that great open shade in the background would be rendered as black (an underexposure), since my exposure would be for the frontlit flower. My first attempt (left) fills the frame somewhat, but the contrast between sunlight and shade in the background divides the scene in two. This contrast between half-black and half-gray is really distressing to the eye. (We'll look more at 50/50 splits later on, but let's just say, it's a distraction you don't need.) By making a very minor shift in my point of view (getting in closer and raising the camera ever so slightly), I eliminated the gray background, wrapping that flower in the "black" of the open shade behind it and filling the frame even more.

80–200mm lens, f/5.6 for 1/320 sec.

HORIZONTAL VS. VERTICAL

Due to camera design, it's only natural that most of us end up shooting all of our subjects inside a horizontal frame. Sadly, on average 90 percent of the amateur photographer's pictures are horizontal. Just how serious is this problem? A student once asked me if it was worth the money to buy a camera that shot vertical compositions. Yikes!

So, why would you ever want to shoot verticals? To bring a feeling of dignity to the subject, that's why! The vertical line and the vertical format both convey strength and power; however, since we favor the horizontal, we manage to squash down obvious vertical subjects to make them fit inside the horizontal format. The biggest danger in doing this, of course, is that you have to back away farther from the subject to make it fit inside the horizontal picture frame. And even though you make it "fit," you're now left with "clutter openings" on both the right and left sides of the frame. The easiest solution is to turn the camera to its vertical position. Voilà, the clutter is gone!

I'm often asked what is the best time to shoot a vertical. Right after the horizontal! Not always, but most of the time, you can compose each and every subject in *either* the horizontal or vertical format. It may take some moving around, shifting your point of view, moving closer or backing up, or even changing a lens; however, the benefits of shooting your subject in both formats are obvious. The biggest one is that you won't see a loss in image quality; when you end up cropping a horizontal into a vertical on your computer, there's always a loss in image quality. If you make it a point to crop in-camera from now on, you'll spend less time on the computer afterward, giving you more time to shoot. Additionally, should the day come when you're ready to take your work to the marketplace, you'll be more than ready for clients who ask if one of your horizontals is available as a vertical.

For me, the horizontal version of this particular subject seems less hurried, less urgent than the vertical, which feels more like a matter-of-fact, straight-to-the point kind of statement.

Both photos: Nikkor 12–24mm lens at 12mm, Canon 500D close-up filter, ISO 200, f/8 for 1/320 sec.

Yaquina Head Lighthouse along Oregon's central coast has become one of the more challenging lighthouses to shoot at sunset in the past few years, and this has everything to do with accessibility while the sunset is taking place. There is only one public access road on the south side, which the park service closes every night at sunset. This leaves but one alternative and that is a lone road on the north side of the lighthouse that dead-ends atop a bluff shared by half a dozen million-dollar homes. You would be smart to arrive at least 1 hour before sunset to avoid the potential crowds that are just as anxious as you to get this shot. The bluff can only accommodate so many shooters, you know.

With my tripod-mounted camera and the addition of my FLW magenta filter, I chose an aperture of *f/22* to force the longest exposure time: 4 seconds to be exact. Over the course of the next few minutes, I shot various compositions, keeping in mind my instruction to my students that the best time to shoot a vertical is right after shooting the horizontal. Note the different feels: the horizontal is far more restful and, perhaps it can be argued, even lethargic, yet the vertical says *proud, dignified,* and *ready to serve.*

70–200mm lens, FLW magenta filter, *f/22* for 4 seconds

THE GOLDEN SECTION
AND THE RULE OF THIRDS

Since the human mind seeks order, its response to chaos is one of immediate alarm, and then it quickly attempts to impose order onto the disorder. Like people assessing damage after a tornado ("We've got a 2-block-wide path of destruction stretching half a mile"), the mind needs order to feel safe. This need for order extends to art. The eye also seeks a clear "winner"—a clear main subject. It doesn't like a "tie" (more on this on page 228). This has to do with the unpleasant tension that results when a composition is visually indecisive.

At its core, every successful painting is the direct result of an orderly and cohesive composition and pattern. To better express order and what they felt were artistic compositional ideals, the ancient Greeks devised a proportion guideline that is still being used today: the Golden Section. Also often called the Golden/Greek Mean, the Golden Ratio, or the Golden Rectangle, the Golden Section refers to a geometric/spatial relationship. Most commonly, this refers to a rectangle in which the longer sides are roughly one-third greater than the shorter sides, for example, a 6 x 9–inch rectangle. This proportion became the standard for much of the painting and architecture of ancient Greece and continued to be seen as an ideal proportional guide into the Renaissance.

Soon, artists were realizing the eye's preference for threes and thirds, and they started laying an imaginary grid of two evenly spaced horizontal and vertical lines over this ideal rectangle, dividing the shape into nine equal sections also of those same ideal proportions. This imaginary grid became known as the Rule of Thirds, and artists still use it today to help determine optimum subject placement. How important compositional elements are placed with respect to these lines and their intersecting points determines the success of an image. Placing important elements at these points of intersection—also referred to as the *sweet spots*—often improves things substantially.

To determine the most important element in a composition, ask yourself a few questions: What is this picture about? What should I include or

When considering this sunrise scene, I felt the interest was greatest below the horizon, so I allotted two-thirds of the image to the land and one-third to the sky. I made sure I framed things so that the sun fell near the upper left intersection point of the grid rules.

75–300mm lens at 300mm, tripod, 1/60 sec. at f/16

THE GOLDEN SECTION AND
THE RULE OF THIRDS

Even when you're making portraits or working in the vertical format, you should follow the Rule of Thirds. It creates a pleasing balance in terms of subject placement. Here, one eye falls near the upper left sweet spot, and both fall on the upper grid line. The mouth and hand fall near the lower grid line. If both eyes had been placed dead center in the frame, the image would have been much more static, with less visual interest. (A note about the background: I used a piece of fabric I had with me, just as I showed on page 212.)

Nikon D2X, 70–200mm lens at 135mm, f/5.6 for 1/400 sec.

exclude? Will the main subject be in the left third or right third? Is the emphasis going to be above or below the horizon line? When it comes to landscape photography, the question of horizon line placement is paramount, and the answer is a simple one 99 percent of the time: If interest is greatest *above* the horizon, then place the horizon line near the *bottom* third; if interest is greatest *below* the horizon, then place the horizon line near the *top* third.

When I took this shot in Holland, I kept the Rule of Thirds in mind. As I used the bike riders to lend a sense of scale to the vast landscape, I strove to keep them near one of the four sweet spots. All rules are made to be broken, of course, but the Rule of Thirds is one you should break as little as possible.

Nikon F5, 80–200mm lens at 200mm, *f*/16 for 1/125 sec., Kodak E100VS

THE GOLDEN SECTION AND
THE RULE OF THIRDS

Odd Numbers and the Preference for Three

Did you know that most people are more comfortable with odd numbers than with even ones? At the craps tables in Las Vegas, lucky seven or lucky eleven are the numbers of choice. And among odd numbers, the favorite is the number three. Think of Three Blind Mice, the Three Musketeers, the Three Stooges, and the Three Little Pigs. Plus, there are three Charlie's Angels; three Power Puff Girls; and Huey, Dewey, and Louie (Donald Duck's nephews). Lest we forget, the third time's a charm (speaking of charm, the television series *Charmed* centers around three sisters), and of course, in baseball it's three strikes and you're out. Do you suppose this all has something to do with our psychology and the way we "see"? As noted before, the Greeks figured this out long ago, and it's a point continually proven by the influence of the Rule of Thirds.

Outside Atlanta, these three young men were having a great time on a very hot summer day. They had been launching themselves repeatedly from the base of this waterfall into the shallow river beyond. Using a monopod and a "Who cares?" aperture, I took a number of shots. Nothing posed about it—just a pure candid.

80-200mm lens, *f*/11 for 1/250 sec.

Note the inclusion of three postcard racks in this high dynamic range (HDR) image. (See page 314 for more on HDR.) Although they're all roughly the same height, their placement, combined with my lens choice and point of view, renders an image of great depth.

Nikkor 12–24mm lens at 18mm, tripod, ISO 200, f/22, merging 1/8, 1/15, 1/30, 1/60, 1/125, 1/250, and 1/500 sec.

THE GOLDEN SECTION AND
THE RULE OF THIRDS

BREAKING THE RULES

Never place your subject in the center of the frame; it will create a static feeling. Never place your horizon line in the middle of the frame; it will create a feeling of indecision and negative tension. And, whatever you do, don't forget to always fill your frame.

Don't you just love rules? As my parents will attest, I have always loved rules. Not so that I could follow them, but rather so that I knew where the boundaries were. That way, I could clearly see that I had crossed a boundary and could take delight in knowing that I was breaking a rule.

There are always exceptions to compositional guidelines and rules. Sometimes, a subject looks best centered in the frame. Sometimes, a horizon line that divides a picture directly in half works. It's important to not always rely on rules, otherwise you might not develop confidence in your vision when it differs from that of others.

Large tidal pools, big rain puddles, ponds, and lakes all lend themselves to shots of reflections that often require splitting the frame in two equal parts, contradicting the never-place-the-horizon-in-the-middle-of-the-frame rule. Although I did that here, I still made use of the Rule of Thirds, breaking the image into horizontal thirds: the sky in the top third, the cows and land in the middle, and the reflection in the lower.

17–35mm lens, 1/30 sec. at *f*/16

Why am I not a wildlife photographer? Patience! You need a lot of it, and when they were giving out the patience genes, I quickly got bored and left the line that everyone else was standing in. With what few wildlife shots I have made over the past 35 years, all but only one or two involve animals that are either caged, asleep, or a near a bird feeder. The exception was that day I spent photographing brown bears in Alaska. (See page 127.)

This elk encounter was a surprise to both of us—I actually woke him up when I stumbled upon him after shooting in a nearby wildflower meadow in western Montana. Fortunately, he was as dumbfounded by my presence as I was by his. After he stayed as still as a statue for several minutes, it was clear to me that he wasn't interested in fleeing nearly as much as I was, so I simply raised the camera to my eye and I managed to get off 2 frames before the film counter indicated I had reached the end of the roll. Yes, I said *film counter*, which should give you an idea of how old this image is. I made it in 1987 on Kodachrome ISO 64 slide film. Attempting to change to a new roll and fire off a few more frames proved futile, since it was at this moment that the elk stood up and hurried off into the thick brush you see just beyond him in the image.

And clearly, he's centered in the frame here (breaking the no-centering "rule"), but he also fills a large portion of it, and that helps. Most of all, the outward movement of his velvety antlers pulls the eye out of the center and keeps you from feeling the bull's-eye effect normally associated with dead-center subjects.

Nikkor 300mm F4 lens, ISO 64, *f*/5.6 for 1/250 sec.

This is one of my favorite images to date, and the reason is because I personally love the message here: defiance, indifference, even "rebel." What drew me to this particular group of parakeets was the fact that all but the central bird were facing the same way. Trust me, I didn't go to the cage and attempt to get the middle bird to turn around. And as I made the shot, I kept saying to myself, "Don't turn around, whatever you do." And by golly, it didn't for the next 11 shots! I made this image with the birds near the top third and lower third, too, but I am convinced that this is the *only* placement that works—running right smack through the middle. Sometimes, "rules" just shouldn't be enforced, as they impede progress, and this is one of those cases.

70-180mm lens at 160mm, 1/250 sec. at *f*/5.6

Deliberate Mergers

In some situations, you'll want to deliberately merge separate elements, sometimes for humor, other times for abstraction. The goal of a successful merger is to cause a momentary sense of disorientation.

This amusing image was an intentional merger of the art director on one of my commercial assignments with the famous fountain in Lake Geneva, Switzerland. I asked him to pose for the camera with his lips pursed, so as to suggest he was blowing a stream of water out of his mouth.

80–200mm lens, tripod, f/22 for 1/30 sec., Aperture Priority mode

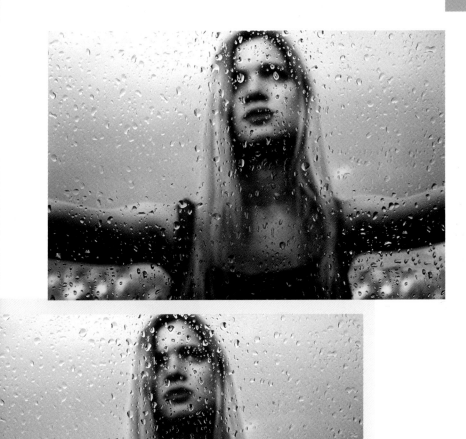

When we lived in France, Celine would babysit my two daughters. Celine was also interested in "teenage modeling," but on our first outing together, it did nothing but rain most of the afternoon. So I asked Celine to stand with her arms outstretched on the car's roof and shot a rather abstract image of her through the rain-soaked glass.

After taking several shots, I got the idea to deliberately merge several of the large raindrops into her eye areas in postprocessing. While not a naturally occurring merger, the effect was still eerie enough to spook my daughters into behaving well when Celine babysat—lest they wake the "devil."

35–70mm lens at 35mm, ISO 100, *f*/8 for 1/30 sec.

FRAMING WITHIN
THE FRAME

While the camera viewfinder does serve to help you frame your subject in a compelling way, one *surefire* way to make an image more appealing is to use foreground elements to call attention to, and frame, the main subject in the background. To successfully frame within the frame, you can't use a foreground framing element that distracts the eye. Additionally, you should ask yourself the following questions: If I removed the foreground subject, would I miss it? Will the frame enhance the overall composition? If the answers are no (for example, the foreground frame dominates or is more of a distraction than a complement), then the framing isn't working.

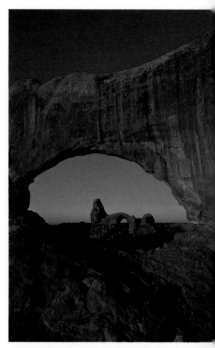

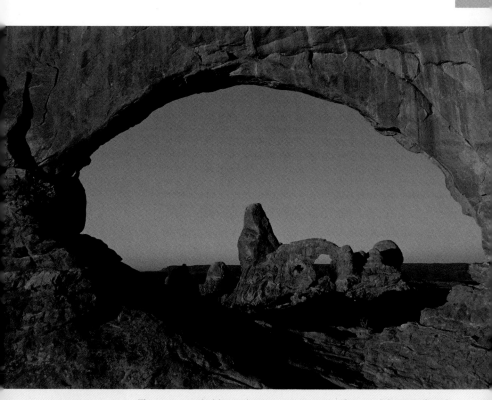

There are probably no better occurrences of natural frames than in Arches National Park in Utah. Like so many photographers before me, I made the trek to Window Arch at dawn to shoot the obvious frame-within-a-frame composition. The vertical version isn't nearly as compelling, though, as the sky gives the eye a chance to "escape" out the top of the image—something you want to avoid with any composition. Effective design relies heavily on the idea of containment.

Both photos: 35–70mm lens at 35mm, 1/60 sec. at *f*/16

A NOTE ABOUT PICTURE EDGES

Countless photographers suffer from "tunnel vision." All their focus is directed toward the middle of the frame. They forget about the need for boundaries to define the edges and to contain and complement the main subject. The lack of clearly defined edges is tantamount to spilling a glass of milk on the table. You've got to catch the milk before it runs off the edge. If you think of the eye as spilled milk, you'll soon realize the need to hold the attention of the eye and not let it run off the edges of an image. This is one of the surest and shortest routes to successful image design.

WORKING YOUR SUBJECT

Does creating successful compositions come easy to me? After 30 years of shooting, at times it does, but more often than not I still find the need to "work" a subject in much the same way that a sculptor chips away at a stone. I see the end result in my mind, but getting there requires me to "chip away." This may involve a change in point of view, in focal length, or in time of day. It may involve a simple change in exposure to limit or increase depth of field, or in shutter speed to achieve the desired effect. Again, the need to look, *really look*, for distractions in the background cannot be overstated. Also important is that willingness to break the rules, even if that means arranging and rearranging subject matter *before* you make the photograph.

The images on these and the next 2 pages reflect my first trip to the lavender fields, which easily explained my need and desire to "work the subject" as much as I did over the course the 3 days I was there. How many ways could I photograph this lone tree? From down low within the rows of lavender with a wide-angle was one approach; the use of the wide-angle lens really pushed the tree back, diminishing its size but, in turn, letting me really see and feel the lavender flowers. In addition to using different lenses and points of view, working your subject also includes varying compositions. Is the horizon more favorable in the top third or bottom third? I can decide which I prefer later, but certainly not while I'm out here shooting. Remember, I'm working the subject! (And the opportunity to really work a subject is unlimited in the digital age, as concerns about film costs have been silenced.)

Both photos: Nikkor 12-24mm lens at 12mm, ISO 100, *f*/22 for 1/80 sec.

Switching to the 70–200mm lens results in a completely different image: one of vivid color and compressed space and distance. The field of lavender appears to be even fuller of both flowers and scent. And finally, taking to the air with my rented bucket truck revealed the bird's-eye view and revealed a strong image of line and color. There isn't one "best" shot here, but rather a collection of images that each can stand alone simply because I took the time and effort to "work the subject."

Opposite: Nikkor 70–200mm lens at 135mm, ISO 100, f/22 for 1/80 sec.
Above: Nikkor 35–70mm lens at 50mm, ISO 100, f/8 for 1/500 sec.

PICTURE WITHIN
A PICTURE

It happens time and time again in all my on-location workshops: A student makes a compelling shot and then begins to pack up his or her camera gear and move on. But almost without fail, every picture has, waiting inside it, *another* picture. If you're at all serious about increasing the number of striking images you make, staying with your subject longer is the way to do just that.

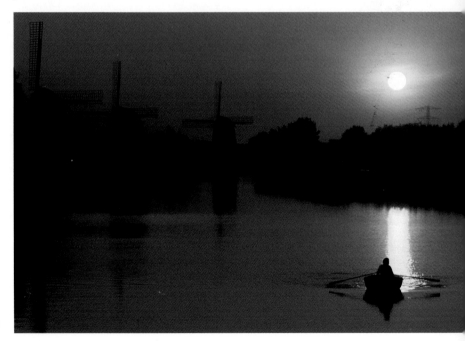

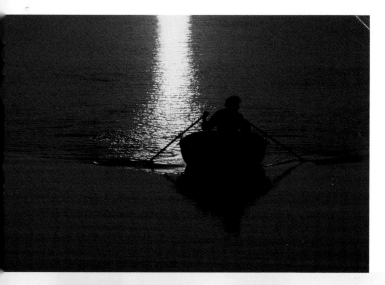

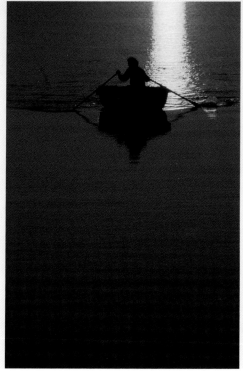

From atop a small bridge in the town of Stompetoorn in Holland, I set up to shoot a sunset with three windmills and a canal. The silence was soon broken by a man and his rowboat. At first, I cursed his presence (to myself, of course) but then soon realized it was a good thing. I began firing rapidly, making numerous interpretations of the scene and zooming out from 75mm to the 300mm focal length of my zoom lens.

All photos: Nikkor 80–200mm lens. Opposite: *f*/16 for 1/125 sec. Above and left: *f*/8 for 1/500 sec.

COMPOSING ACTION

When composing motion-filled subjects in a horizontal frame, whether at blazingly fast or much slower shutter speeds, it's a good idea to give that action "room to move" across the frame. Normally, this means composing the action within the first two-thirds of the frame. The direction from which the action enters the frame will determine if this is the left or right third. You can see the difference this makes here, and the technique is in evidence in images on pages 75, 87 (bottom), 251, and 97, and others, as well.

When photographing this bike race, I followed the action with my cam-
era as it came into the viewfinder. In addition to panning, I zoomed the
lens from 20mm to 35mm to create the explosive effect that results
from zooming during a slow shutter-speed exposure.

20–35mm lens, 1/4 sec. at f/22

To make this action image, I staked out one of the jumps at an equestrian event. I felt that from a low viewpoint its lines would be a powerful visual element. Handholding my camera, I chose to shoot in Aperture Priority and Burst modes. I pressed the shutter release as soon as I saw the horse enter the frame from the left. Nine frames later, the horse was out of frame. When you compare the earlier shot (below) to the later one in the series (opposite), it's easy to understand why you might feel a bit shortchanged by the later one: The action is on its way out of the frame! It's as if it can't wait for you, as if you're trying to get on board a moving train that has already closed its doors and started pulling out of the station.

17–35mm lens at 17mm, ISO 200, 1/1000 sec. at f/8

THE IMPORTANCE OF LIGHT

Well-meaning photographers stress the importance of light or even say that "light is everything." This kind of teaching—to see and shoot the light—has led many students astray. Am I antilight? Of course not! The right light can bring importance and drama to a given composition. But often, the stress is on the light instead of the creatively correct exposure.

Regardless of what you're trying to do with your imagery, the light will be there. Students often think an exposure for the light is somehow different than for a storytelling image, an isolation image, a panning image, and so on. But what has suddenly changed? Does a completely different set of apertures and shutter speeds exist only for the light? Of course not! An exposure is still a combination of aperture, shutter speed, and ISO. And a creatively correct exposure is still a combination of the *right* aperture, the *right* shutter speed, and the *right* ISO—with or without the light. The light is the frosting on the cake; it has never been—and never will be—the cake.

THE BEST LIGHT

Where do you find the best light for your subjects? Experienced photographers have learned that the best light often occurs at those times of day when you'd rather be sleeping (early morning) or sitting down for dinner (late afternoon/early evening, especially in summer). In other words, shooting in the best light can be disruptive to your "normal" schedule.

But unless you're willing to take advantage of early-morning or late-afternoon light—both of which reveal textures, shadows, and depth in warm and vivid tones—your exposures will continue to be filled with contrast and without any real warmth. Such are the results of shooting under the often harsh and flat light of the midday sun. Additionally, one can argue that the best light occurs during a change in the weather (incoming storms and rain) that's combined with low-angled early-morning or late-afternoon light.

You should get to know the color of light, as well. Although early-morning light is golden, it's a bit cooler than the much stronger golden-orange light that begins to fall on the landscape an hour before sunset. Weather, especially inclement weather, can also affect both the quality (as mentioned above) and color of light. The ominous sky of an approaching thunderstorm can serve as a great showcase for a frontlit or sidelit landscape. Then there's the soft, almost shadowless light of a bright overcast day, which can impart a delicate tone to many pastoral scenes as well as to flower close-ups and portraits.

Since snow and fog are monochromatic, they call attention to subjects such as a lone pedestrian with a bright red umbrella. Make it a point, also, to sense the changes in light through the seasons. The high summer sun differs sharply from the low-angled winter sun. During the spring, the clarity of the light in the countryside highlights the delicate hues and tones of flower buds and trees. This same clear light enhances the stark beauty of the autumn landscape. Light plays, perhaps, the greatest role in determining the mood of an image.

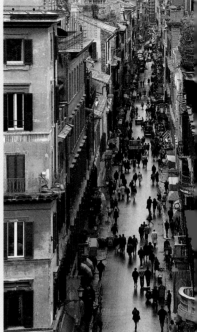

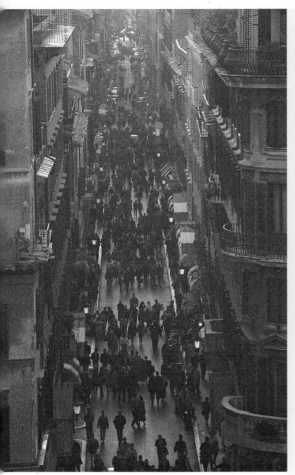

To make this shot, I set up my camera on a tripod atop the steps near Piazza di Spagna in Rome. It had been raining for three days, and I felt it would be a far better photograph if I could just have some light. The next day, the skies finally cleared, and I returned to the same spot late in the afternoon. The street was backlit and displayed the warmth I had previously been looking for.

Both photos: 80–200mm lens at 200mm. Right: *f*/22 for 1/15 sec. Left: *f*/22 for 1/60 sec.

I felt really good after recording this lone Dutch elm beside a small dike in Holland (above). The low-angled light of late afternoon cast its warm glow across the land-scape, and I was there to capture it. But that good feeling was soon replaced with an even greater high when I happened upon the same scene two days later but un-der the even more dramatic low-angled frontlight of an oncoming storm.

I made both images without a tripod and with the same ex-posure. For both, I used f/16 and preset the focus via the distance setting on the front of the lens to assure maximum depth of field front to back. For both, I adjusted the shutter speed for the light fall-ing on the tree. The difference is the "frosting"—the light. But it was still necessary to decide what kind of cake I wanted to make: in this case, one that relied on the conscious selection of the right aperture first, a storytelling aper-ture.

Both photos: 20–35mm lens at 20mm, f/16 for 1/125 sec.

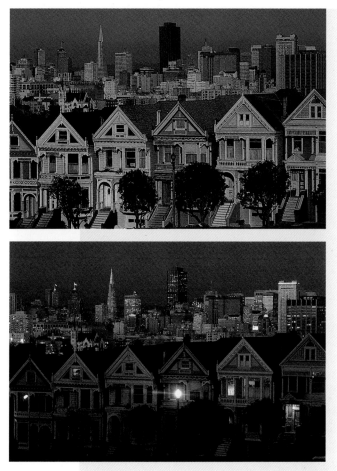

The difference in the color of daytime and dusk light can be seen clearly in these images of San Francisco's Bryant Park. To get the depth of field I needed in the daytime image, I chose *f*/22 and then adjusted the shutter speed to 1/60 sec. For the dusk exposure, I began with *f*/2.8, metered off the sky (see page 298), and adjusted the shutter speed to 1/4 sec. Since I still needed the great depth of field, I switched to *f*/22 and did the math to get the new correct exposure: Since I stopped the lens down 6 stops (*f*/2.8 to *f*/4 to *f*/5.6 to *f*/8 to *f*/11 to *f*/16 to *f*/22), I increased the exposure time by an equal number of stops (1/4 sec. to 1/2 sec. to 1 second to 2 seconds to 4 seconds to 8 seconds to 15).

Both photos: 80–200mm lens at 200mm. Top: *f*/22 for 1/60 sec. Bottom: *f*/2.8 for 15 seconds

exercise:
EXPLORING LIGHT

You can do one of the best exercises I know near your home, whether you live in the country or the city, in a house or an apartment. Select any subject, for example the houses and trees that line your street or the nearby city skyline. If you live in the country, in the mountains, or at the beach, choose an expansive composition. Over the course of the next 12 months, document the changing seasons and the continuously shifting angles of the light throughout the year. Take several pictures a week, shooting to the north, south, east, and west and in early-morning, midday, and late-afternoon light. Since this is an exercise, don't concern yourself with making a compelling composition. At the end of the 12 months you'll have amassed a knowledge and insight about light that few professional photographers—and even fewer amateurs—possess.

Another good exercise is to explore the changing light on your next vacation. On just one day, rise before dawn and photograph some subjects for one hour following sunrise. Then head out for an afternoon of shooting, beginning several hours before and lasting 20 minutes following sunset. Notice how low-angled frontlight provides even illumination, how sidelight creates a three-dimensional effect, and how strong backlight produces silhouettes. And of course, take note of dusk. It's the dusky light that unveils a host of shooting opportunities that turn the ordinary daytime shot into something far more regal.

Photographers who use light to their advantage aren't gifted; they've simply learned about light and have thereby become motivated to put themselves in a position to receive the gifts that the "right" light has to offer.

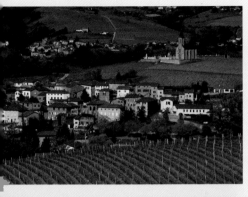

Made in Beaujolais, France, this series compares the light in the same scene from season to season. It might be surprising, but the image metered pretty much the same in every season, as I made a point to always return on sunny days.

All photos: 80–200mm lens, tripod, *f*/16 for 1/125 sec.

FRONTLIGHT

Just as time of day or time of year produces different light effects, so does the direction of light. Let's start with frontlight (or frontlighting). This is light that hits the front of your subject (so it is to your back and hits your subject straight on). Due to frontlight's ability, for the most part, to evenly illuminate a subject, many photographers consider it the easiest kind of lighting to work with in terms of metering, especially when shooting landscapes with blue skies.

So, is it really safe to say that frontlight doesn't pose any great exposure challenges? Maybe it doesn't in terms of metering, but in terms of testing your endurance and devotion, it might. Do you mind getting up early or staying out late, for example? The quality and color of frontlight are best in the first hour after sunrise and during the last few hours of daylight. The warmth of this golden-orange light can make portraits more flattering and enhance the beauty of both landscape and cityscape compositions.

To capture the frontlight falling on this mustard field, I handheld my camera and set my lens to 24mm. I then set the aperture to f/22 and preset the focus via the distance settings on the front of the lens, which assured me that everything would be sharp from 2 feet to infinity. With the camera in Manual mode, I metered off the blue sky above, adjusted my shutter speed, and recomposed the shot.

20–35mm lens at 24mm, f/22 for 1/60 sec.

Both these portraits benefit from warm frontlight; however, they were made at different times of day. The warm glow washing over the lavender farmer from Provence was the result of late-afternoon light. The appeal of the gold miner comes from his warm smile and the golden early-morning frontlight that makes getting up early worth the effort.

Both photos: 80–200mm lens at 200mm. Left: f/5.6 for 1/500 sec. Right: Nikon F5, f/5.6 for 1/400 sec., Kodak E100VS

Overcast and Rainy Days

Of all the different lighting condi-
tions that photographers face, over-
cast light and even rainy days can be
considered to be the safest, at least
in terms of exposure. This is because
overcast frontlight illuminates most
subjects evenly, making meter read-
ing simple. This assumes, of course,
that the subject isn't a landscape that
includes a dull gray sky. If that's the
case, the exposure and composition
will require some extra care and may-
be the use of filters (see page 392).

Overcast light, with or without
rain, also gets autoexposure cameras
to perform well, since overall illumina-
tion is balanced. The softness of this
light results in more natural-looking
portraits and richer flower colors; it
also eliminates the contrast problems
that a sunny day creates in wooded
areas. In overcast conditions, I often
shoot in autoexposure mode, either in
Aperture Priority if my exposure con-
cerns are about depth of field or the
absence thereof, or in Shutter Prior-
ity if my concern is about motion (i.e.,
freezing action or panning).

ON CLOUDY DAYS, HEAD TO THE FOREST

Are you often frustrated by the extreme contrast that results when
working in the forest? Go on a cloudy or rainy day! Sunny days
are the worst time to be in the woods, since the combination of
light and dark is often so extreme that no amount of bracketing
will ever produce a compelling image. Save the forest for overcast
days, and don't forget to use your polarizing filter. (See page 386
for more.) On rainy days, the polarizing filter will reduce, if not
eliminate, much of the dull glare that reflects off the many wet
surfaces. Rainy days are a magical time in cities, too. Colorful um-
brellas abound, and the streets are a reflection-lover's paradise.

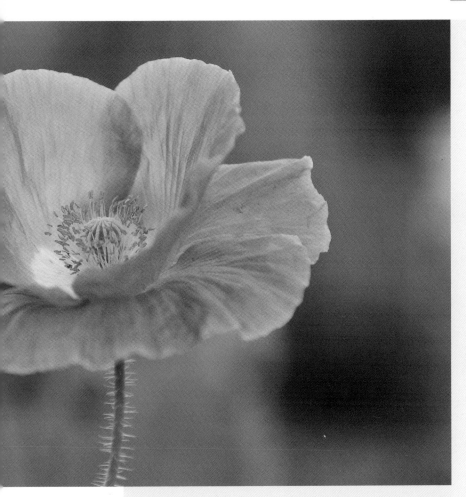

Just as photographing in the woods on sunny days yields images with too much contrast, shooting flowers on sunny days results in the same problem. Overcast days are best for flower close-ups (unless you want to shoot with flash); correct exposures will be much easier to record, and you can certainly shoot in Aperture Priority mode without fear.

Nikkor 300mm lens, 36mm extension tube, ISO 100, *f*/5.6 for 1/160 sec.

Even, overcast frontlight heightened the color in this scene and made it relatively easy to expose. To capture the motion, I handheld the camera and followed the pedestrians, panning left to right as they walked by.

70–200mm lens, ISO 100,
1/30 sec. at f/11

While driving around the German countryside, I ran out of gas in front this woman's farm, and she generously offered me several liters to get me going again. But before I knew it, I had spent more than 5 hours with her, talking about life on the farm. The overcast light reduced contrast and shadows, and since the bench was against a wall, depth of field was of no great concern. I selected Aperture Priority mode and a "Who cares?" aperture, and let the camera choose the shutter speed for me. Afterward, she invited me to stay for lunch, and we were enjoying one of the best lunches I had had in years when she informed me that the roasted chicken I was raving about was the same chicken I had photographed her with only a few hours before. Yikes!

80–200mm lens at 100mm, *f*/11 for 1/60 sec., Aperture Priority mode

Rainbows

If you're not a fan of rain, then you'll never be able to plan ahead for rainbows. Rainbows are one of the most challenging subjects in all of photography. Why? One reason is that they require you shoot in inclement weather, which most photographers are averse to doing. Another is that capturing them also depends in large measure on luck: luck that clouds to the east will open up, at the same time allowing early-morning frontlight to illuminate rain falling in the western sky, or that clouds to the west will open up, at the same time allowing late-afternoon frontlight to illuminate rain falling in the eastern sky. Yet another is that when you're finally presented with that rainbow shot, you *must use your polarizing filter*, as it will intensify the colors of the rainbow.

In addition, you should use the wide-angle lens with a "Who cares?" aperture, since everything is at the same focused distance (infinity) and since you'll want to include not only the rainbow but also the landscape below it.

The weather in the French Alps on this day had all the hallmarks of rain-bow conditions: clear skies behind me and storm clouds in front. When the first of several rainbows appeared, I jumped from my car. I handheld the camera and made sure to include the small village below for both scale and drama. And I left satisfied, knowing that even if I didn't get another shot off the rest of the day, it would still be a rousing success—such is the feeling when capturing a rainbow.

17–55mm lens at 55mm, polarizing filter, ISO 100, *f*/11 for 1/125 sec.

Springtime in Lyon, France, is a magical time, in terms of weather conditions, as the strong hold of winter does battle with a determined spring. Storms combine with numerous sun breaks in the early-morning hours—a perfect mix for rainbows. With my camera in Aperture Priority mode, I simply selected my *f*/11 aperture, aimed, focused, and shot—and yes, I also used my polarizing filter.

Nikkor 17–55mm lens at 17mm, polarizing filter, ISO 100, *f*/11 for 1/125 sec., Aperture Priority mode

Texture's ability to elevate, to create depth, to intensify a subject's roughness or smoothness, sharpness or dullness is made even more apparent when that subject is sidelit. The rusty gouge in this door and the autumn leaves opposite possess a three-dimensional appearance when sidelit. This 3-D effect disappears immediately from the rusty door when a passing cloud blocks the sun overhead. Similarly, when I block the sun with a large reflector, the autumn leaves show some subtle depth due to their layering, but this depth is far more tame and less defined than when they are basking in low-angled sidelight.

All photos: ISO 200, f/11 for 1/320 sec. Above: Micro-Nikkor 200mm lens. Opposite, top: Nikkor 35–70mm lens at 35mm

Backlight without Silhouettes

As we've just seen, when backlit, solid objects can render on film as dark, silhouetted shapes. Not so with many transparent or translucent objects, such as feathers and flowers, which seem to glow when backlit. In addition, there are times when you won't want a backlit solid subject to be silhouetted; you want to retain the interior details of the form.

To make this portrait in backlight without silhouetting the subject and losing all the details of his face, I put my lens at 200mm and moved in even closer (with my aperture set at f/5.6) to take a meter reading off his face. I then recomposed the scene you see here but kept the exposure I had set—even though my light meter was now telling me I was about 1 1/2 stops overexposed. The meter did this because when I backed up the brighter backlight behind the subject influenced it. Since this area was of no concern to me, I ignored the meter and used my initial exposure.

Nikon F5, 80–200mm lens at 200mm, f/5.6 for 1/125 sec., Kodak E100VS

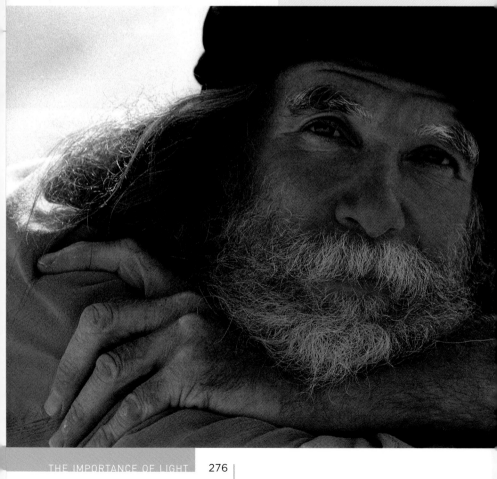

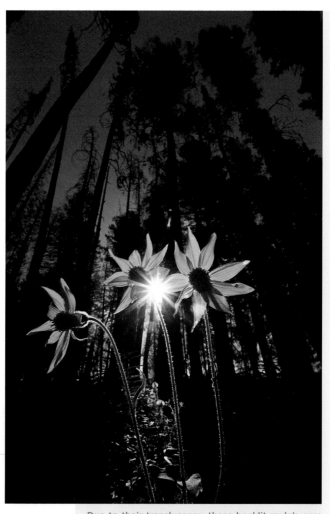

Due to their translucency, these backlit mule's ears in a small forest in Oregon seem to glow rather than fall into silhouette like the trees behind them. I chose this low viewpoint specifically so that I could showcase both translucent and solid objects, and although this might seem like a difficult exposure, it really isn't. Holding my camera, I set my focal length to 20mm. With an aperture of *f*/22, I moved in close to the flowers, adjusting my position so that one of the flowers blocked the sun. I then adjusted my shutter speed until 1/125 sec. indicated a correct exposure in the viewfinder. Then before I took the shot, I moved just enough to let a small piece of the sun out from behind the flower to be part of the overall composition.

20-35mm lens at 20mm, *f*/22 for 1/125 sec.

Backlight and Reflectors

For backlit subjects that you don't want to silhouette, you can certainly use electronic flash; however, if you don't want to use artificial light outdoors, try reflectors. I do trust Nikon's matrix metering and made many of the images in this guide in Aperture Priority mode. But even though my dependence on manual metering has lessened, I still find it necessary to meter in Manual exposure mode when presented with "difficult" lighting situations. Sometimes, the camera's light meter will still be fooled and render either an over- or underexposure.

Of course, Photoshop can help when you really blow an exposure, but I'd rather get it right in-camera than spend that time on the computer. That's where the reflector comes in. A reflector is a circular piece of highly reflective fabric stretched tightly over a collapsible metal ring. The fabric is either shiny gold, shiny silver, or a sheer white material. Sizes can range from 12 inches to up to 3 feet in diameter. When pointed toward the light source (the sun in most outdoor cases), it acts likes a dull mirror, reflecting back much of the light onto the subject.

If you're willing to use a reflector, you increase the range of what you can do in the field with natural light. I say *willing* because reflectors are a "necessary evil." Granted they are really lightweight and easy to carry along with your camera bag, but just like a tripod, a reflector is one more thing to fiddle around with before you can take the image. Still, it's worth the effort.

Backlit outdoor portraits are classic difficult exposures but not if you know where to take your meter reading—and you use a reflector. You must work when the sun is low in the sky (early morning or late afternoon). That warm light often illuminates the edges of backlit hair, creating a warm, healthy appearance, but there is a risk of the light meter being fooled by this excessively bright rim light, which can cause a false meter reading. This is what happened in my first attempt; the meter's exposure was okay for the backlight but not for the face, which is about 2 stops too dark. So, I had my wife hold an 18-inch reflector with its gold foil side facing the western sky and sun. Gold light was then "bounced" onto her, and this added fill light made the same exposure correct for the face.

All photos: f/5.6 for 1/500 sec., Aperture Priority mode

Backlit flowers are another classic example of a subject that's "difficult" to expose. But you can create striking images if you know where to take your meter reading, know where to "place the sun," and, again, are willing to use a reflector. Indeed, low-angled backlight illuminates flowers with a glow that only backlight can produce. I stress *low-angled* here since most shots like these are only possible shortly after sunrise or just before sunset.

Reflector use is a must, as you can see. I made both versions with the same exposure, but in the second, the addition of the reflector enabled me to throw some fill light onto the front of the subject, recording an image that makes use of both frontlight and backlight and that reveals more of the interesting details in the scene.

Both photos: Nikon D300, 12–24mm lens, tripod, *f*/16 for 1/500 sec., Manual mode .

Using Sunny 16 to Contrast Dark with Light

I always advise looking at the "dark side" to find some surprisingly bright moments. It's a concept that, I'm sure, would have a few psychiatrists shaking their heads, but in terms of photographic exposure, this is one idea that really does result in some incredible imagery—and, contrary to what I said at the start of this chapter, it really is *all* about the light!

Humans have this amazing ability to see light and dark simultaneously, from deep shade to direct sunlight. Our eyes see details in the shadows despite the presence of areas in these shadows that are also lit by full sun. In photographic terms, it's estimated that the human eye can scan a scene and formulate an image with a 16-stop exposure range. A film camera can *hope* to record a range of light and dark of around 5 stops, and a digital camera, a range of around 7 stops. Regardless of camera format, when a scene offers up something other than a 5- to 7-stop range, highlights can get blown out or shadows can record much too dark.

However, I want to call your attention to those scenes with foreground subjects in shadow for which you can meter for a much brighter background. These are absolutely wonderful exposure opportunities, and you can use the Sunny 16 Rule to capture them.

With my camera and tele-zoom mounted on tripod, I caught this woman in Burano doing her laundry as other residents used a nearby passageway that fell in shadow. Calling on the Sunny 16 Rule for this strongly sidelit scene, I chose *f*/16 for depth-of-field reasons, and to increase color saturation a wee bit, I shot at 2/3 underexposed, which meant 1/160 sec. with ISO 100. I consider it very lucky that this woman came into the scene and started hanging her laundry, as it added some much-needed interest to the foreground.

70–200mm lens, *f*/16 for 1/125 sec.

Arriving in Brooklyn about an hour after sunrise, my son and I took advantage of a large area of open shade by the water. The rising sun was still a good half hour from being high enough to shine its light over the 12-story buildings behind us that were casting their shadows over our spot. As Justin played his guitar for all within earshot, I stood behind him to frame his silhouette against the early-morning front-light. Perhaps surprisingly, this is a simple Sunny 16 exposure; with the camera in Manual mode and my aperture set to *f*/16, I was able to record an exposure at 1/125 sec. with ISO 100.

17–55mm lens, ISO 100, *f*/16 for 1/125 sec.

EXPOSURE METERS

As I mentioned earlier, at the center of the photographic triangle is the exposure or light meter. It's the "eye" of creative exposure. Without the vital information the exposure meter supplies, many picture-taking attempts would be akin to playing pin the tail on the donkey—hit or miss. This doesn't mean that you can't take a photograph without the aid of a meter. A hundred years ago photographers recorded exposures without one, and even 25 years ago I was able to record exposures without one. Of course, 100 years ago photographers had a good excuse: There were no light meters then. I, on the other hand, simply failed (on more than one occasion) to pack a spare battery for my Nikkormat FTN; once the battery died, so did my light meter.

You can see how the Sunny 16 Rule would become invaluable if you were shooting frontlit subjects on sunny days and your light meter battery went dead—but only on sunny days! One of the great advances in photography today is the auto-everything camera; trouble is, when the camera batteries die, the *whole camera* dies, not just the built-in light meter. Make it a point to *always carry* an extra battery or two.

Despite this obvious shortcoming of auto-everything cameras, it cannot be ignored that today's meters are highly sensitive, sophisticated tools. Not long ago, many photographers headed home once the sun went down, since the sensitivity of their light meters was so poor they couldn't record an exposure at night. Not so today. If ever there were a tool built into the camera that eliminates any excuse for not shooting 24 hours a day, it would be the light meter.

Exposure meters come in two forms: as separate units not in the camera or as a feature that comes built into most of today's cameras. Handheld light meters require you to physically point the meter at the subject, or at the light falling on the subject, and take a reading of the light. Then you set the shutter speed and aperture based on this reading. Built-in meters enable you to point the camera and lens at the subject while continuously monitoring any changes in exposure. This is called through-the-lens (TTL)

Here's a very easy-to-meter frontlit scene in San Francisco. Note the direction of the sun: It comes from behind me, frontlighting the toilets, the bride, and the distant building and flagpoles. The light is evenly distributed throughout. It's a simple "aim and shoot" exposure that lends itself to Aperture Priority mode. Whether your camera has averaging, center-weighted, or matrix metering, it will record a correct exposure of this scene without any difficulty what-soever.

17–55mm lens, tripod, *f*/11 for 1/250 sec.

metering. These light meters measure the intensity of the light that reflects off the metered subject, meaning they're *reflected-light meters*. Like lenses, reflected-light meters have a wide or very narrow angle of view.

Several less-expensive cameras have had averaging reflected-light meters built into them. This meter is useful when a scene contains areas of light and shadow, because the meter measures both areas and gives an average reading based on the two. This reading usually is adequate to successfully set an exposure. However, in situations with much more shadow than light, or much more light than shadow, an averaging reflected-light meter tends to result in either overexposure or underexposure.

The spot meter is another type of reflected-light meter. Spot meters used to only be available as handheld light meters, but today they are a feature of some camera bodies. They measure light at an extremely narrow angle of view, usually limited to 1 to 5 degrees. As a result, they can take a meter reading from a very small area of an overall scene and get an accurate reading from that one specific area regardless of how large an area of light and/or dark surrounds it in the scene. My feelings about using spot meters haven't changed much in 25 years: They have a limited but important use in my daily picture-taking.

Yet another type of light meter is the center-weighted meter. Unlike averaging or spot meters, center-weighted meters measure reflected

light throughout the entire scene yet are biased toward the center portion of the viewing area. To use this meter successfully, you must center the subject in the frame when you take the light reading. Once you set a manual exposure, you can then recompose the scene. If you want to use your camera's autoexposure mode but don't want to center the subject, you can press the exposure lock button and then recompose the scene so that the subject is now off-center; when you fire the shutter release, you'll still record a correct exposure.

Unlike early-morning backlight, which renders silhouetted waves, late-afternoon frontlight reveals the various hues and tones of the incoming surf in Cancun. This is another simple exposure that can easily be shot in Aperture Priority mode. Whether you choose this or Manual mode, you should consider deliberately underexposing by -1/3 exposure when shooting simple frontlit scenes. This minor adjustment can give your image a subtle boost in color.

So, for extreme depth of field to render sharpness from front to back I needed f/22, and for freezing the moving waves in relative sharpness I needed 1/250 sec. After adjusting my ISO to 400, I was able to make this 1/3-stop underexposure. For focusing a scene like this with a telephoto lens, I find that focusing a third of the way into the scene when using small apertures renders relative sharpness throughout the entire scene.

Nikkor 200–400mm zoom lens at 320mm, ISO 400, f/22 for 1/250 sec.

And finally, there's matrix metering. It's rare that today's cameras don't offer a metering system built on the original idea of this. Matrix metering relies on a microchip that has been programmed to "see" thousands of picture-taking subjects, from bright white snowcapped peaks to the darkest canyons and everything in between. As you point your camera toward your subject, matrix metering recognizes the subject and directs you to the appropriate exposure. Yet, as good as matrix metering is, it still will come upon a scene it can't recognize, and when this happens, it will hopefully find an image in its database that comes close to matching what's in the viewfinder.

The type of meters you have built into your camera depends on your type of camera. If you're relatively new to photography and have a camera with several meter options, I strongly recommend using matrix metering 100 percent of the time. It's the most reliable and has fewer quirks than center-weighted. I've witnessed my students switching from center-weighted to matrix metering repeatedly in the field. Not surprisingly, due to each meter's unique way of metering, they would often come up with slightly different readings. Students were unsure which exposure to believe, so they took one of each. This is like having two spouses; dealing with the quirks of one spouse is at times too much, let alone two? Several years ago, I made the full switch from center-weighted metering to Matrix mode.

So just how good are today's light meters? Both center-weighted and matrix metering prove accurate 90

LIGHT METERS & ISO

There isn't a single light meter on the market today that can do any measuring, calculating, or metering until it has been fed one piece of data vital to the success of every exposure you take: the ISO. In the past, film shooters had to manually set the ISO each time they switched film types. If you still use a recent-model film camera, chances are good that the camera sets the ISO automatically (via the DX bar code on the film cassette).

Digital shooters, on the other hand and despite all the technology advances, must resort to the old way, telling the meter what

percent of the time. That's an astounding number. Nine out of ten pictures will be correctly exposed, whether in Manual mode (still my favorite) or semi-autoexposure mode (Aperture Priority for storytelling or isolation and Shutter Priority for freezing action, panning, or implying motion). With either metering, when your subject is frontlit, sidelit, or under an overcast sky, you can simply choose your aim, meter, compose, and shoot.

In addition, I recommend taking another exposure at -2/3 stop with slide film, +2/3 stop with color negative film, and -2/3 stop when shooting digitally. This extra shot will be a comparison example, and you can decide later which you prefer. Don't be surprised if you pick the second exposure. Oftentimes, this slight change from what the meter indicates provides just the right amount of contrast to make the picture more appealing. That's all you need; with the sophistication of today's built-in metering systems, it's often unnecessary to bracket like crazy. (See page 321 for more on bracketing.)

The photo industry has come a long way since I first picked up a camera. With today's automatic cameras and their built-in exposure meters, much of what you shoot will be a correct exposure; however, keep in mind that the job of recording creatively correct exposures is still yours.

ISO to use. There are a few DSLRs that set ISO automatically (and continue to do so as light conditions change), and man, do I ever hate to see shooters use this feature! Unless you're heading into some dark wine cellar to shoot oak barrels and wine bottles lit by a single ceiling light, I would set your ISO to 200 and leave it alone. Of course, you can always change it from one scene to the next if you wish, but for me, ISO 200 is going to record 99.9 percent of all images I shoot. Leaving my ISO set to 200 means one less thing I have to give my attention to.

18% REFLECTANCE

Now for what may be surprising news: Your camera's light meter (whether average, center-weighted, matrix, or spot) *does not* "see" the world in either living color or black and white, but rather as a *neutral gray*. In addition, your reflected-light meter is also calibrated to assume that all those neutral gray subjects will reflect back approximately 18% of the light that hits them.

This sounds simple enough, but more often than not, it's the reflectance of light off a subject that creates a bad exposure, not the light that strikes the subject. Imagine that you come across a black cat against a white wall, bathed in full sunlight. If you move in close and let the meter read the light reflecting off the cat, the meter will indicate a specific reading. If you then point the camera at only the white wall, the meter will render a different reading. This happens because although the subjects are evenly illuminated, their reflective qualities differ radically. The white wall will reflect approximately 36% of the light, while the black cat will absorb most of the light, reflecting back only about 9%.

When presented with either white or black areas, the light meter freaks. White and black especially violate everything the meter was "taught" at the factory. White is no more neutral gray than black; they're both miles away from the middle of the scale.

In response, the meter renders these extremes just like it does everything else: as a neutral gray. If you follow the meter's reading—and fail to take charge and meter the right light source—white and black will both record as dull gray versions of themselves.

To successfully meter white and black subjects, treat them as if they were neutral gray, even though their reflectance indicates otherwise. In other words, meter a white wall that reflects 36% of the light falling on it as if it reflected the normal 18%. Similarly, meter a black cat or dog that reflects only 9% of the light falling on it as if it reflected 18%.

Due to the extreme contrast in this image, I used my "palm pilot" (i.e., my hand) to arrive at a correct exposure here. (See page 294 for more on this.) This was a classic "Who cares?" aperture situation, so I found myself at f/11 with my camera on a tripod. With the focal length set, I placed the palm of my left hand in front of the lens, making certain that it was being sidelit like the scene before me, and simply adjusted the shutter speed until an exposure of +1 was indicated. (A correct exposure was indicated at 1/200 sec., while a +1 exposure was indicated at 1/100 sec.) I then lowered my hand, asked the subject to smile, and pressed the shutter release, and voilà, a correct high-contrast exposure!

Nikkor 35–70mm lens at 50mm, ISO 50, tripod, f/11 for 1/100 sec.

A challenging exposure, perhaps, but not near as challenging as try-ing to stay warm. With the aid of binoculars, I spotted this burrowing owl at a considerable distance from the lone desert road on which I had been driving. I made the decision to park my Jeep and creep as close as I could, on foot, low to the ground in the hopes of getting nearer. Ten minutes later, I was set up with my camera and lens on a tripod that was low to the ground. As is often the case when meter-ing snow scenes on overcast days, I set my exposure to +1 and fired off several frames. With my camera in Manual exposure mode, I first chose an aperture opening of f/5.6 and then adjusted my shutter speed; although at 1/200 sec. my meter indicated a correct expo-sure, I chose to shoot this scene at 1/100 sec. (a 1-stop overexpo-sure). My light meter was, of course, offering up an exposure time that would get me gray snow, but I wanted the snow to be white!

400mm lens, ISO 64, f/5.6 for 1/100 sec. (slide film)

With my camera and 105mm lens on tripod, I set the aperture to f/32 and focused one-third of the way into this winter scene of the North Falls at Silver Falls State Park in Oregon's Willamette Valley. Focusing one-third of the way into a scene when using a telephoto and when at the smallest aperture (i.e., f/32) is a general rule of thumb when you wish to record the maximum depth of field. With my aperture and focus thus set, the final task of metering remained, but since this was another overcast day in snow, it was really quite easy: I followed the "rule" of setting a 1-stop overexposure when shooting snow scenes on overcast days. Of course as I adjusted my shutter speed, the light meter indicated a correct exposure at 1/8 sec. (as usual, wanting to make the snow gray), but since I wanted white snow, I went to the next slowest shutter speed (1/4 sec.), which proved to be correct.

105mm lens, ISO 64, f/32 for 1/4 sec. (slide film)

THE SKY BROTHERS

The world is filled with color, and in fairness, the light meter does a pretty darn good job of seeing the differences in the many shades and tones that are reflected by all of this color. But in addition to being confused by white and black, the meter can also be confused by backlight and contrast. So are we back to the hit-and-miss, hope-and-pray formula of exposure? Absolutely not! There are some very effective and easy solutions for these pesky exposures: They're what I call *the Sky Brothers*. When working under difficult lighting situations (sidelight and backlight, for example), you may be unsure just where to point your camera to take a meter reading. Just simply turn to the Sky Brothers. They're not biased. They offer the one solution that works each and every time.

On sunny days, *Brother Blue Sky* is the go-to guy for those winter landscapes, black Labrador portraits, bright yellow flower close-ups, and fields of deep purple lavender. This means you take a meter reading of the sunny blue sky and use that exposure to make your image. When shooting backlit sunrise and sunset landscapes, *Brother Backlit Sky* is your man. This means you take a meter reading to the side of the sun and use that reading to make your image. When shooting city or country scenes at dusk, *Brother Dusky Blue Sky* gets the call, meaning you take your meter reading from the dusk sky. And with coastal scenes or lake reflections at sunrise or sunset, call on *Brother Reflecting Sky*, meaning you take your meter reading from the light reflecting off the surface of the water.

Warning: Once you've called upon the Sky Brothers, your camera's light meter will let you have it. Let's say you use Brother Blue Sky to shoot that frontlit snowscape. Trust me on this one: If you listen to your meter's advice and readjust your exposure, you'll end up right back where you started—a photograph with gray snow! So once you've used the Sky Brothers, set the exposure manually, or "lock" the exposure if you're staying in automatic before returning to the original scene. You can then shoot away with the knowledge that you are right no matter how much the meter says you're wrong!

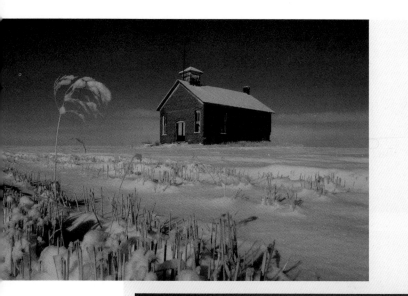

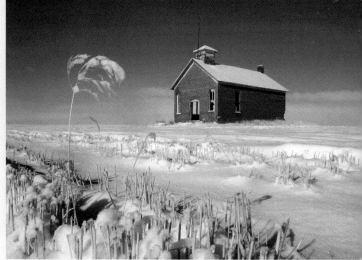

When I aimed my camera at this schoolhouse in a winter landscape and followed my light meter's exposure, I got gray snow. This will happen whether shooting manually or in autoexposure mode. And why not? The meter is doing exactly what it should with a white subject: making it gray. But since snow is white, you have to intervene with Brother Blue Sky. So after setting f/22, I pointed the camera to the sky above the schoolhouse and adjusted my shutter speed until the meter indicated 1/60 sec. as the correct exposure. I then recomposed and presto! White snow. (Of course, after I metered the sky and recomposed, the meter told me I was wrong. But just as with a 2-year-old throwing a temper tantrum, ignore it!)

24mm lens, f/22 for 1/60 sec.

From my spot on a narrow country lane near the town of Ursum in Holland, I framed up a row of poplar trees. With the help of a friend, who was to run through the scene on cue, I called on Brother Backlit Sky: Since depth of field wasn't a concern, I chose *f*/11, pointed the camera at the sky to the right of the sun, and adjusted my shutter speed until the meter indicated 1/250 sec. was correct. I then recomposed and gave Ron the cue to start running.

800mm lens, *f*/11 for 1/250 sec.

Chaos is perhaps the best way to describe the result of a traffic signal with all its lights lit. Over the course of the 8-second exposure (which I chose to render the traffic as colorful streaks), I was able to record all three lights, since the exposure began just several seconds before the light changed from blue-green to yellow to red. Use of a tripod and Brother Dusky Blue Sky was, of course, in order.

80–200mm lens at 135mm, ISO 100, 8 seconds at *f*/11

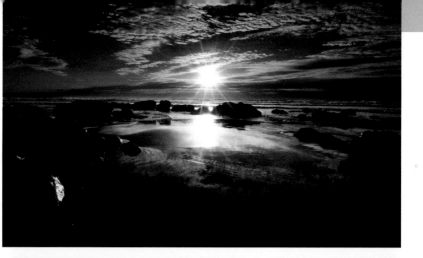

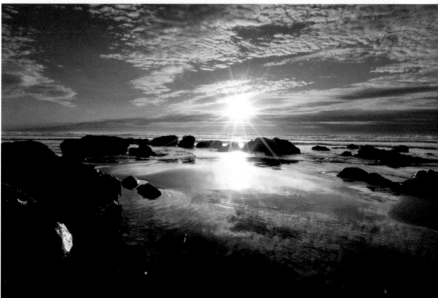

When shooting classic backlit reflection, I lean toward taking my meter reading off the reflection itself, calling on Brother Reflecting Sky and, in effect, pointing my camera to the reflection on the wet sand below the horizon line. The reason I don't call on Brother Backlit Sky is that a reflection absorbs at least a full stop of light, sometimes more; if you do take your meter reading from the sky to the side of the setting sun, you end up with a reflection about 1 1/2 stops underexposed (top). Granted, when I used Brother Reflecting Sky (bottom), the sky was about 1 1/2 stops overexposed, but it's a welcome trade-off since I'd rather have a bit more detail and color in the reflection.

Bottom photo: Nikon D300, 12–24mm lens at 14mm, ISO 200, *f*/22 for 1/50 sec.

MR. GREEN JEANS
(THE SKY BROTHERS' COUSIN)

Mr. Green Jeans is the cousin of the Sky Brothers. He comes in handy on overcast or cloudy days. Mr. Green Jeans is a real lifesaver when shooting compositions that include "hot" subjects, for example, a bride in her white wedding dress outside in a garden or that white waterfall in the forest. Mr. Green Jeans is just as reliable when shooting dark subjects, for example, your black Lab catching a Frisbee at the park. However, Mr. Green Jeans needs to be exposed at -2/3. In other words, whether you choose the aperture or the shutter speed last, the exposure reading is "correct" when you see a -2/3 stop indication—which means you adjust the exposure to be -2/3 stops from what the meter tells you. If there's one thing I've learned about Mr. Green Jeans, it's that he's as reliable as the Sky Brothers, but you must *always* meter him at -2/3.

Oftentimes, I'll head out the door to a meadow or marsh with my macro lens shortly after sunrise to wait for something to happen. On this morning, a shield bug landed on a nearby blade. With all that green surrounding the dark bug, I was quick to call on Mr. Green Jeans and point the camera at nothing but green. With an aperture of *f*/11, I adjusted the shutter speed until 1/200 sec. indicated a -2/3 underexposure and then recomposed to get the composition you see here.

Micro-Nikkor 200mm lens, *f*/11 for 1/200 sec.

While on assignment for a large flower company, I made what has become one of my all-time favorite images. I was mesmerized by Ijadet's eyes! An employee at the flower plantation near Burjumbura, Burundi, she was intensely camera shy; it took 3 days, but I finally managed to get her to look at me for a grand total of just 1 minute. Again, the lighting challenge here is that the meter "freaks" when presented with dark or light subjects and does everything it can to render them as gray. Due to Ijadet's dark skin color, the meter interpreted her low reflected-light value to mean that the exposure time should be much longer than the "norm." So I put Mr. Green Jeans to use and pointed my camera toward the flowers she was holding. I chose an *f*/8 aperture for this "Who cares?" situation and adjusted my shutter speed until a -2/3 stop exposure was indicated. Then I recomposed for the shot.

105mm lens, *f*/8 for 1/125 sec.

MR. GREEN JEANS
(THE SKY BROTHERS' COUSIN)

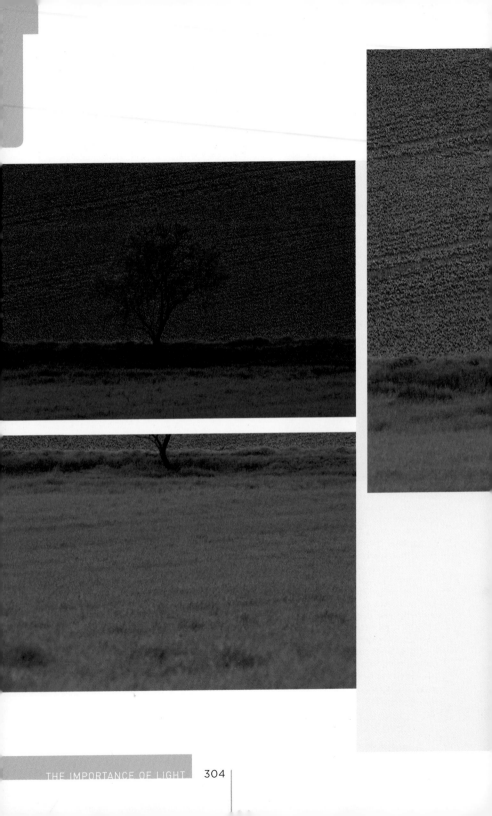

Tulip farmers aren't only found in Holland or the Pacific Northwest but are also very active in and around the town of Pierrerue, France. In mid-April, most of the fields are blooming with color for a mere 5 to 7 days. Tulip farmers don't grow tulips to sell the blooms but rather to sell the bulbs; so, the many fields of flowers are topped (cut just below the stem of the flower) shortly after they bloom. The plant can then place all its energy into growing a larger, stronger bulb instead of a flower.

As I came over a small rise on one of the many country roads in this area, I was greeted by a very large, rolling field of hot pink tulips. I quickly spied a lone tree where the hillside of tulips met a large green pasture. For my first exposure attempt, boy, did I ever get it wrong! The image is too dark because the hot pink tulips were akin to white, meaning their reflected value was more than 18%, and the light meter did what it should when faced with bright subjects: It made them gray, or underexposed. The solution was to point the camera to the green pasture, adjust my shutter speed until a -2/3 exposure was indicated, and recompose.

Both photos: 80–200mm lens at 200mm. Opposite, top: *f*/22 for 1/125 sec. Above: *f*/22 for 1/50 sec.

MR. GREEN JEANS
(THE SKY BROTHERS' COUSIN)

NIGHT AND LOW-LIGHT PHOTOGRAPHY

Low-light images don't only involve those that focus on interpreting motion (as in the section on page 110). There are, of course, more stationary night and low-light subjects, and these have equal appeal. There seems to be this unwritten rule that it's not really possible to get any good pictures before the sun comes up or after it goes down. After all, if "there's no light," then why bother? However, nothing could be further from the truth.

Night and low-light photography do pose special challenges, though, not the least of which is the need to use a tripod (assuming, of course, that you want to record exacting sharpness). Still, the rewards of night and low-light photography far outweigh the sacrifices. It is at dusk that both the light in the sky and any artificial lights are briefly at the same exposure value. Since photographers can record both natural and artificial light at dusk within the same exposure time, it is truly a magical time of day.

HOW TO METER IN LOW LIGHT

Just to reiterate, there's nothing better—or more consistent—than taking meter readings off the sky. This holds true whether you're in backlight, frontlight, or sidelight and whether it's sunrise or sunset. The Sky Brothers are your go-to guys (see page 298). If I want great storytelling depth of field, I set the lens (i.e., a wide-angle for storytelling) to f/16 or f/22, raise my camera to the sky above the scene, adjust the shutter speed for a correct exposure, recompose, and press the shutter release. If I'm shooting in a "Who cares?" situation, I set the lens to either f/8 or f/11. And of course, if the scene is one with some motion opportunities, I again choose f/22 or f/32 depending on the lens to force the longest exposure time regardless of whether or not I need all that depth of field.

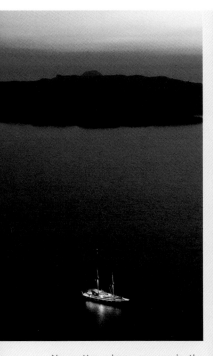

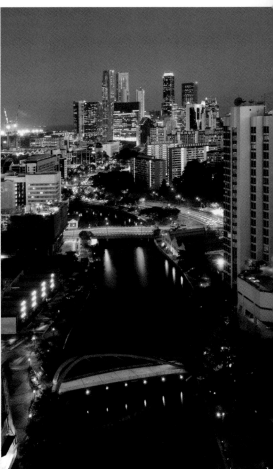

No matter where you are in the world, the magical window of dusky blue light begins about 20 minutes after sunset and lasts only about the next 5 to 10 minutes maximum. In the Greek Islands, a lone sailboat drops anchor against the backdrop of a dusky blue sky. Halfway around the world, the city lights of Singapore contrast beautifully, also against the dusky blue sky.

Above: Nikkor 17-55mm lens, ISO 100, *f*/8 for 2 seconds. Right: Nikkor 12-24mm lens, ISO 100, *f*/11 for 4 seconds

NIGHT AND LOW-LIGHT
PHOTOGRAPHY

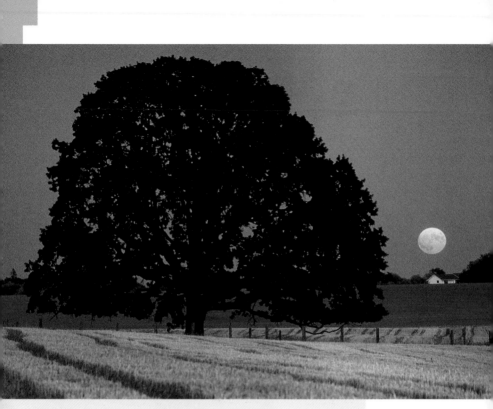

Many photographers watch the moon rise over a country- or cityscape, but few will attempt to shoot it because they aren't sure how to meter the scene. Surprisingly, however, a "moonrise" is easy to expose. It's actually just a frontlit scene—only it's a *low-light* frontlit scene.

Since depth of field was not a concern here, I set the aperture to f/8, metered the sky above the tree, adjusted my shutter speed, recomposed, and fired the shutter release button using the camera's self-timer. (I also could have taken my meter reading from the wheat field in this scene, and it would have been within a cat's whisker of the reading for the sky.)

300mm lens, *f*/8 for 1/8 sec.

IS A FULL MOON REALLY THE BEST MOON?

When shooting "full-moon" moonrises, it's best to take the photograph on the day *before* the calendar indicates a full moon. The day before a full moon (when the moon is almost full and only the experts can tell it's not), the eastern sky and the landscape below are darn near at the same exposure value.

What better place to try your hand at nighttime exposures than New York, and if you time it right, you can be there on 9/11 when they light the sky with a memorial to the Twin Towers. With my camera on a tripod, I raised the camera to the dusky, partially cloudy sky above to determine my exposure and then recomposed. Since this scene didn't present any real motion-filled subjects, it wasn't necessary to increase my exposure time longer than 2 seconds. I've often caught students shooting a scene like this with apertures of *f*/22 and shutter speeds of 15 seconds with no real logic for such a long exposure when *f*/8 for 2 seconds in the absence of any motion will work just fine.

It's important to note that it's entirely possible, once you return to your composition after you've set the manual exposure, that your meter may indicate an underexposure. Just ignore it and shoot.

ISO 100, *f*/8 for 2 seconds

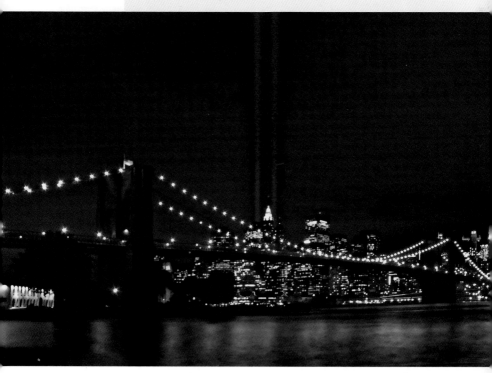

NIGHT AND LOW-LIGHT
PHOTOGRAPHY

I was traveling light when I made this evening shot in Old Lyon, carrying only my Nikon Coolpix 5700. Fortunately, the Coolpix offers up tremendous depth of field while still allowing me to shoot at safe handholding shutter speeds. This begs the question, "Why not just use this camera all the time, since it seems to eliminate the need for a tripod?" The most important reason is that the file size it produces is much too small for my commercial clients.

Nikon Coolpix 5700 at 60mm, f/4 for 1/30 sec.

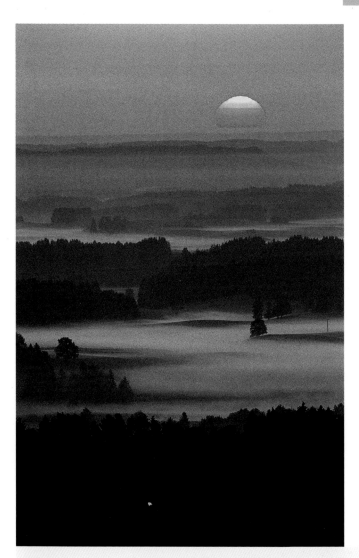

Shortly after moving to Bavaria, Germany, I stumbled across one of several high viewpoints that afforded some really spectacular views of the valley floor below. Having set up my camera and lens on a tripod 15 minutes prior to sunrise—and, of course, pointing my lens in the direction of the colorful predawn sky—I was ready as the diffused ball of orange-yellow sun came up over the eastern horizon.

Because I wanted to capture the details in the backlit landscape, along with the sun itself, I pointed the camera to the left of the rising sun, and with my aperture set to f/22 and focus set one-third of the way into the scene, I adjusted the shutter speed until 1/125 sec. indicated a correct exposure. I then recomposed the scene you see here and fired off about 10 frames.

300mm lens, ISO 50, f/22 for 1/125 sec. (slide film)

NIGHT AND LOW-LIGHT
PHOTOGRAPHY

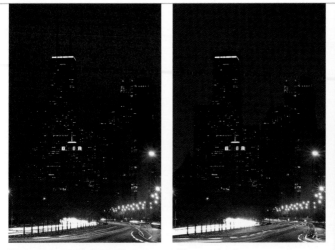

Both photos: Nikkor 35–70mm lens at 70mm, tripod,
ISO 200, *f*/22 for 6 seconds

DON'T WAIT TOO LONG

When it comes to shooting night scenes, I'm *not* talking about the
dark of night but rather the *dusk* of night. Shooting exposures in
the dark of night, namely in cities, is something I'm not fond of
because the necessary contrast that's often needed when making
compelling low-light scenes is missing. If you lose that contrast,
important parts of your subject may disappear into the night sky.

Along Chicago's Lakeshore Drive, I was able to frame up a nice
vertical *at dusk*; however, just 30 minutes later, the vital contrast
provided by the dusky blue sky is gone, and the buildings fall into
the dark abyss of night.

My students and I were about 40 minutes from sunset and all thinking of packing it in as the weather continued to be anything but cooperative. We had already spent the better part of the day resisting the urge to take shelter from the inclement weather that had plagued Whidbey Island, Washington, from 30 minutes before (the hoped-for) sunrise. Finally, shortly before sunset, the skies began to open up and it was about this time that we came upon this lone house on a small knoll. At this time of day and against the remaining dark clouds, the few house lights provided a welcome contrast. Combining the Lee graduated ND 3-stop filter with the Lee sunset filter, I was able to create a colorful and correct exposure of the overall scene.

35–70mm lens, tripod, ISO 100, *f*/16 for 1/4 sec.

HDR EXPOSURES

High dynamic range (HDR) photography is the latest craze for many shooters, and it's one bandwagon that I've actually embraced with zeal! An HDR exposure is the result of "bracketing" a scene of great contrast (for example, a landscape against the strong backlight of sunrise) and then merging all these exposures into a single image via postprocessing with an HDR software program. (Note that this is different from traditional exposure bracketing; see box on page 321.)

In HDR, 5, 7, or 9 exposures are taken, depending on the level of contrast in the scene. When doing this HDR bracketing, don't forget that you're still looking to record the most *creatively correct* exposure, and with that in mind, you must first determine if the image is a storytelling, singular-theme, or "Who cares?" exposure. Once you've decided which aperture to use, do *all* of your bracketing with the shutter-speed dial. Bracketing with your aperture in these cases will alter your depth of field, which could ruin the shot; the background becomes too busy or the storytelling composition doesn't have the maximum depth of field, for example.

Also, your camera may have an "auto-bracket" type of feature. This is a real time-saver when shooting HDR exposures. With the camera set to Aperture Priority mode and auto-bracket set to shoot a 5-, a 7-, or even a 9-stop range, you simply fire away and, voilà, there are all 5, 7, or 9 exposures for your review on the camera LCD. Then you just load them all into the HDR program, click a few buttons, and sit back and wait for the software to churn out what will be a truly enlightening exposure. (Photoshop CS3 does offer HDR processing, but it falls way short of the HDR software from PhotoMatix, which you can find at www.hdrsoft.com.)

Just before sunrise in Tampa, I set up my tripod and camera with the 12–24mm lens. The river below with the city reflection was registering about a 4-stop difference in exposure time from the sky above, and the actual pillars directly underneath the bridge were registering a 7-stop difference in exposure time from the sky above. (I determined this range of exposure time by setting my camera meter to Spot, choosing a "Who cares?" aperture of *f*/11, and pointing my camera into these areas to note the vast range of times.) Seven different exposure times meant I would need 7 "bracketed" exposures for this HDR exposure, from +3 to -3: *f*/11 at 1/4 sec., *f*/11 at 1/8 sec., *f*/11 at 1/15 sec., *f*/11 at 1/30 sec., *f*/11 at 1/60 sec., *f*/11 at 1/125 sec., and *f*/11 at 1/250 sec. I then merged them all with an HDR software program.

With all the "wow's" that come with a successful HDR exposure, why settle for anything other than HDR photography? Well, not every scene shows great contrast; in fact, most are just fine as single exposures. Additionally, if you're shooting motion-filled scenes, by the time you shoot your 7 exposures, both people and cars have moved and won't line up in the finished image, resulting in *ghosting* (when elements look transparent or only portions of them appear). In summary, choose subjects where great contrast is present but little, if any, movement exists.

Having recently moved from Lyon, France, to Chicago, I've discovered that this city has truly gone to the dogs—hot dogs, that is! The folks of Chicago do love their dogs, as attested to by the many restaurants that sell them, and none has held more appeal for me than Wrigleysville Dogs on Clark Street. Truth be told, I have yet to eat one of their dogs, but I'm sure I will soon. On this particular day, I was only interested in capturing the color and charm of the establishment against the imposing drama of the stormy sky. To make this singe HDR exposure, I recorded a total of 7 exposures (seen on these and the next two pages).

With my camera and 12–24mm lens mounted on a tripod and my aperture at f/16, the 7 "bracketed" exposures went from +3 to -3: f/16 at 2 seconds, 1 second, 1/2 sec., 1/4 sec., 1/8 sec., 1/15 sec., and 1/30 sec.

Of the many opportunities that HDR opens up, none is more welcomed by me than the opportunity to shoot correct exposures of strongly backlit subjects—along with any foreground elements in front of those subjects. The correct exposure for these foreground leaves was f/22 at 1/15 sec., while the sun breaking through the tree above was indicating a correct exposure of a 1/8000 sec. at f/22—a difference of 9 stops! Not a problem when it's shot and processed as an HDR image. At f/22 and, as always, with the camera and lens on a tripod, I shot from 1/15 sec. all the way up to 1/8000 sec. (Note: To record the best possible registration of the final HDR image, always shoot your bracketed images on a tripod!)

When I came upon this stall of olives at the Medina in Marrakech, Morocco, it was immediately apparent that I was looking at another HDR opportunity: The foreground bowls, while under a canvas tarp and safe from the hot direct sun, still got a lot of light; yet the background storage area was all walled in and very little available light was visible. To record a correct exposure from front to back, I would need to either use some tricky flash fill lighting or resort to HDR, which was what I did. I used a total of 5 exposures, from f/22 at 1/60 sec. down to f/22 at 1/4 sec.

Nikon 12-24mm, ISO 100

REAL EXPOSURE BRACKETING

Don't confuse the bracketing you do to make HDR images with true exposure bracketing, which serves a different purpose. Exposure bracketing is simply taking any number of varied exposures of the same scene. For example, suppose you're shooting in Manual mode using a "Who cares?" aperture of f/8. You make the image when 1/15 sec. indicates a correct exposure. After this, you take several additional exposures at slower and faster speeds, bracketing the initial exposure: one at f/8 for 1/8 sec., another at f/8 for 1/4 sec., another at f/8 for 1/30 sec., and still one more at f/8 for 1/60 sec. In effect, you just shot a 5-stop exposure bracket. Why would anyone do this? In the days of film, it was hoped that somewhere in a 5-stop exposure bracket, the photographer would find the one "good" exposure—and odds were this would work.

Today's digital cameras have much more sophisticated in-camera metering systems and sensors that allow for a much wider exposure range. In addition, when necessary, one can make exposure "corrections" in postprocessing imaging software. Is it fair to say, then, that we no longer need to bracket? Hardly, and this is due to the any number of situations in which there is extreme contrast. Even today's most sophisticated digital cameras still come up short when trying to record details of both light and shadow that the human eye so easily discerns. To approximate the 16-stop range the human eye sees (and eliminate doing true exposure bracketing), you have to move to HDR photography.

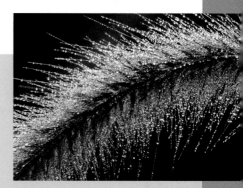

CLOSE-UP
PHOTOGRAPHY

Close and macro photography enjoy great popularity. While such obvious subjects as flowers, butterflies, and dewdrops are ideal for beautiful close-up images, so are more unusual subjects: larger animals, and industrial surfaces, for example. Close-up photography truly is filled with photographic riches. Familiarity can breed contempt—but *not* here. This excitement of making close-up discoveries is so far from reaching its end because nothing is ever familiar; at the slightest twist or turn, a new image is revealed. It is truly a lifelong journey, and like most journeys, there are many ways to get to your destination. You can even do a lot of your close-up investigating on your knees and belly, without leaving your house or immediate environs. Simply grab your camera and macro lens, or anything in the 40–60mm range, and an extension tube—and start crawling around on the floor or in your yard. Keep your camera to your eye and you will soon notice the fascinating textures on that pair of worn-out sneakers or your child's favorite toy. The possibilities are endless.

CLOSE-UP VS. MACRO

Whether you create your close-ups with a telephoto, macro, or wide-angle lens; with or without extension tubes, reversing rings, or close-up filters; from viewpoints that are down low, up high, or straight-on; in front- or sidelight; and in the city or country, you are at the controls. So no matter where you are in your journey, you'll always have the ability to pause, survey the scene, and decide how you wish to preserve it.

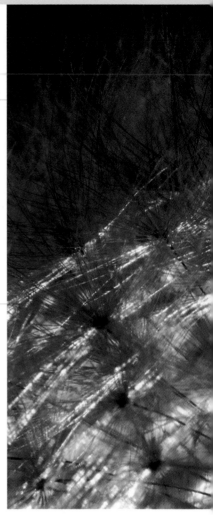

The first stop on the journey is to define *macro photography* and decide if that's your interest or if close-up work is close enough for you. There seems to be a lot of confusion about the word *macro*. The word itself is a prefix derived from the Greek word *makros*, which means *large* or *long*. This is appropriate, considering that images made with a macro lens appear large on the sensor or film and often require long exposure times compared to conventional photography. (Macro exposure times often range from 1/15 sec. to 1 second, whereas conventional exposure times average between 1/60 sec. and 1/250 sec.)

Macro photography is, officially, work that shows 1X (life-size) magnification and greater. So in a side-by-side comparison, the actual size of your subject and its size on the CCD or piece of film on which it's recorded are equal. Only 1X magnifications and greater qualify as true macro shots. Life-size, or 1X, magnification is usually written as 1:1 (one to one). Anything less than 1X should be, and is, defined by me (and other photographers, as well) as *close-up photography*, not macro photography. I've shot a

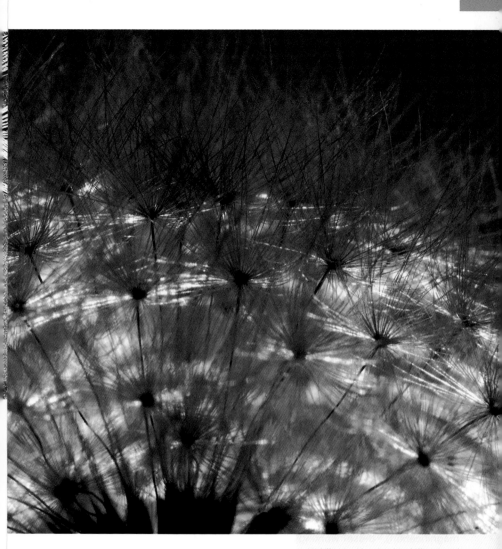

number of images with my Micro-Nikkor lenses, but that doesn't qualify them as macro images. (Perhaps counterintuitively, Nikon calls their macro lenses *micro* lenses.)

Holding a simple dandelion seed head against the backlight of the bright sun to the east reveals this subject in a most striking way.

105mm macro lens, 1/60 sec. at *f*/22

EXTENSION TUBES

Extension tubes are hollow tubes that fit between the lens and the camera body. They commonly come in 12mm, 20mm, 25mm, and 36mm, and yes, even those of you who have an actual macro lens should still buy at least one extension tube, if not a set of three. (Note: These are not to be confused with teleconverters, which have a glass element in them that can sometimes result in loss in sharpness if the optical quality isn't matched to your lens. To get the best teleconverter results, use only those teleconverters that are designed and built by the same folks who built your lens.)

So just how does an extension tube work? Well, the farther away the rear element of a lens is from the CDD or film plane, the closer that lens will focus. Extension tubes get you that greater magnification by increasing the distance between the rear end of the lens and the camera sensor (or film). And you're not limited to using just one tube at a time; when you mount one extension tube after another, your can get your subject even larger. They are a wonderful, must-have addition to that tele-zoom with Macro setting; a 36mm extension tube in combination with your street zoom or tele-zoom with Macro, allows you to record an extreme close-up, if not a macro shot.

One of my favorite combination uses for the extension tube is with a telephoto lens when shooting flowers. For years, I would do this with my Nikkor 300mm lens and one 36mm extension tube, which would knock out my backgrounds, turning the flowers surrounding my main floral subject into these wonderful canvases of out-of-focus color. Today, I do this with Nikon's truly amazing 200–400mm tele-zoom. Like most tele-zooms, this one can focus quite close, rendering a

By the time I made it to the butterfly park on Singapore's Sentosa Island, experience had taught me that this subject matter requires an extension tube. In addition, I made sure to keep the subject parallel to the film plane to assure sharpness. The *f*/8 aperture limited the depth of field enough to render the surrounding palm fronds as out-of-focus areas of color.

80–400mm lens, 36mm extension tube, 1/30 sec. at *f*/8

Since I couldn't get as close to this bee as I wanted with my 70–210mm zoom lens, I added an extension tube. This enabled me to fill the frame with the flower without having to actually be within a cat's whisker of the bee. I also decided to exploit the early-morning sidelight, using the background shadows as contrast against which to showcase the subject.

70–210mm lens at 210mm, 36mm extension tube, *f*/11 for 1/250 sec.

reproduction of roughly 1:4 (1/4 life-size), and it can do so at all focal lengths. It will seldom fill the frame with that lone flower, but with the addition of that one extension tube, I sure can!

Note that there is an extension tube drawback: If you're using three extension tubes at one time with a moderate zoom or tele-zoom lens (of course, on a tripod), your camera and lens will experience some serious wobble (similar to the kind you experience at the outdoor café when one of the table legs doesn't quite hit the ground) when you release the shutter. This translates into camera shake. So if you've ever wanted a great excuse to use a cable release and mirror lock-up, this is it!

USE MANUAL FOCUS CLOSE-UP

This is very important: When shooting any close-up or macro composition, turn off your autofocus and *manually focus every shot*. If you don't, you will lose far too many shots as your autofocus lens seems to experience "seizures" when it's asked to autofocus on close-up subjects; it won't be able to differentiate between the front or back of that flower, and it sure can't tell if you wanted that bee in middle of the flower in sharp focus, either. If you absolutely must rely on autofocus due to poor vision, then prepare to have your patience tested or resign yourself to only shooting close-up subjects that are 100 percent parallel (from edge to edge and top to bottom) to your CCD or film plane.

CANON CLOSE-UP FILTERS

There is just one item on my "Just say no" list, and it's those silly, useless, optically inferior, and ridiculously cheap (both in price and quality) "close-up filters sets" that you find at camera stores all over the world. The Canon close-up filters, however, are another matter. When it comes to close-up filters, Canon is king! These close-up filters are the only ones to consider. (Nikon has ceased marketing its T-series close-up filters, so like it or not, even the most die-hard Nikon fans are going to have to give at least this part of their business to Canon.) Note that these are officially close-up lenses, but they're often referred to as filters because they screw onto the front of the lens, as standard filters do, and are not dedicated macro lenses.

Canon close-up filters are really great! There are three (the 250D, the 500, and the 500D) in various filter sizes ranging from 52mm to 77mm. The 250D is recommended for focal lengths from 35mm to 150mm, and the 500 and 500D are recommended for focal lengths between 70mm and 300mm. Since most shooters own a tele-zoom that offers up at least 200mm, I personally would recommend the purchase of the 500D only.

(The 500 is a single-element, glass-constructed lens; the 500D is a double-element glass-constructed lens, which translates into a wee bit sharper image.)

A few years back, after spending but a few hours in the garden with my 500D and Nikkor 70–200mm F2.8 lens, I was hooked on the practicality of owning this close-up lens. Once I sat down in front of the computer, I could see that the sharpness easily compared with that of my Micro-Nikkor 200mm lens. The only drawback I could find was that the Canon 500D renders only 1/3 life-size magnification, and that's with the 70–200mm lens set to 200mm. But, if you're not all about the itty-bitty critters and are primarily a flower and butterfly photographer, this is one option to seriously consider in lieu of buying a $1300 (as of this printing) Micro-Nikkor 200mm or Canon 180mm dedicated macro lens.

Sure, the wide-angle lens can focus close, but it can focus even closer with the Canon 500D close-up filter. How might a strawberry feel that is about to be picked? Lying on my belly, at the strawberry's level, the combination of my wide-angle lens and the Canon 500D answers that question.

Nikkor 17–35mm lens at 17mm, Canon 500D close-up filter, ISO 100, *f*/8 for 1/160 sec.

Add to this the pocket size of this filter and you'll be quick to arrive at the same conclusion I did and get one right away. When I head out the door in one of my "traveling light" moods, I put the 500D in my pants front pocket and am then ready for all the butter-flies that come my way—without the 2.5-pound weight of my Micro-Nikkor 200mm lens.

Although the 500D is intended for use with a telephoto lens, I dis-covered one of my students, Donna Eaton, using it on her wide-angle lens. In combination with a super wide-angle such as Nikon's 12–24mm lens, the 500D allows for some wonderful up-close-and-personal compositions that also "tell stories" (due to the wide angle of view of the lens). When us-ing this combo, first remove your UV or skylight filter, as the combination of the protective filter and the 500D will cause vignetting in the corners of your composition.

Focus is also continuous with this filter, meaning that when you find yourself photographing at the 200mm focal length at a distance of 7 inches, you can zoom back toward 70mm and the focus distance is still the same 7 inches away. This is differ-ent from extension tubes, which will require you to constantly readjust the focus every time you zoom to a differ-ent focal length.

Since I had left the house in a "traveling light" mood, my only option for filling the frame with this damselfly was my Canon 500D. I was handholding my cam-era, so after placing the 500D on my lens, I picked up and moved forward until the lens was focus-ing at its closest focusing point: 3 feet.

Nikkor 70–200mm VR lens at 200mm, f/8 for 1/320 sec.

THE WIDE-ANGLE FOR CLOSE-UPS?

You bet! It's not the traditional choice, but shooting close-ups with a wide-angle lens is a worthy investigation. Photographers should embrace their wide-angle lens as a close-up lens with fervor. The world of wide-angle close-ups, in many respects, provides even more fertile ground for as-yet-unexplored territory than the world we normally associate with close-up photography.

Note, though, that a wide-angle lens meant for digital cameras, such as the 12–24mm range, or a wide-angle lens meant for 35mm film in the 17–28mm range will *not* be able to focus with *any* extension tube, because the focus point is now so close that you would, literally, have to climb inside the lens to find it.

Just how close can you get? With an extension tube on a wide-angle lens, really close. With flowers, for example, you can get lost in a world of soft, sensual line, shape, and color. To do this, a large lens opening is critical.

35–70mm lens at 35mm, 12mm extension tube, *f*/4 for 1/60 sec.

BACKGROUNDS

As you may have already figured out by now, the extremely shallow depth of field in close-up photography is, at times, truly frustrating. Yet, that ridiculously shallow depth of field is yours to exploit. With a combination of the right angles of view and the right apertures, you can get backgrounds that truly complement your close-up subjects.

With a patch of grass, a few flowers, and my small spray bottle, I can easily "disappear" for a few hours. Here, I sprayed a small area of grass with "dewdrops" and looked through my lens to find that one perfect dew-covered blade. Once I found it, I simply added some color (from flowers) to the background. Note the distance between the blade of grass and flowers (which I plucked from one of my mother's hanging flower baskets). The elements are remarkably close to each other, yet due to the very shallow depth of field for which macro photography is noted, the flowers don't show up in any detail at all in the background; rather, they play a very strong secondary role, adding soft color.

Micro-Nikkor 200mm lens, *f*/16 for 1/60 sec.

Early one spring, I was quick to use my lens to isolate this one stalk of wild grass and was just as quick to note an absence of any real contrast. As a strong believer in color contrast, I asked one of my students to hold a yellow flower in the background. After checking my depth-of-field preview, I concluded an aperture of f/11 best rendered the background out of focus while still recording a sufficient area of sharpness on the wild grass. You be the judge, but I feel the wild grass "pops" more in the image with the added yellow background.

Micro-Nikkor 200mm lens, f/11

RING FLASH

Imagine being freed up from your tripod because your shutter speeds are closer to those safely handholdable speeds of 1/125 and 1/250 sec., all the while using apertures as small as *f*/16 to *f*/32 with ISO 200! Imagine being freed up from having to use your diffuser to soften the light! Imagine sleeping in for a change and taking your flower shots at midday! Unheard-of, right? But these are just a few of the advantages to shooting macro shots with a ring flash.

As many of my readers already know from my prior books, I've never been a big fan of electronic flash, and it was only recently that I discovered just what I could gain from the use of a simple ring flash. And I feel a sense of loss at having waited as long as I did to embrace its use. It's really that important, that vital, that good!

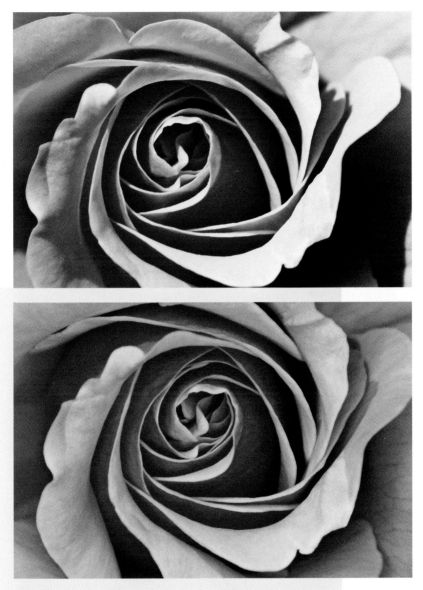

The midday light in this scene creates the shadows that can quickly spoil a close-up or a macro shot. But it is easy to see the difference once ring flash is used; the light can be seen and felt as even and softer. After making the first shot with only natural light, I placed my ring flash on the front of my lens and the power source on my camera's hot shoe. Then with the same aperture and the shutter speed set to a sync speed of 1/250 sec., I again framed the rose, focused, and fired.

Both photos: Micro-Nikkor 105mm lens. Top: *f*/22 for 1/100 sec., Aperture Priority mode. Bottom: *f*/22 for 1/250 sec.

A ring flash is composed of two parts that are connected by a single power cord. The two parts are two half-circle flash tubes embedded in a hard plastic housing. This housing threads onto the front of your lens, while the power source is mounted on the camera's hot shoe. The ring flash provides even, shadowless illumination, helping to make contrast-filled subjects much less so. Additionally, because the flash encircles the front of the lens, it is amazingly close to the subject, which allows you to use some really small apertures (f/16 to f/32); this offers up some great depth of field, and since you're using flash, you'll find yourself shooting at the fast flash sync shutter speed of at least 1/125 sec., if not 1/250 sec., depending on the camera you own. At these speeds, who needs a tripod?

My one ring flash caveat is that I don't like the unnatural black backgrounds they produce in low light. This is the result of the use of small apertures in combination with the limited distance most ring flash can reach. The background is quick to fall off into underexposure that records as black background. My distaste for these black backgrounds is strictly a personal choice; I know of other photographers who go out of their way to shoot in low light to make sure they *do* record a dark, if not black, underexposed background. They love the contrast between subject and background. I'm all for black backgrounds, but those resulting from ring flash look just a bit too artificial for me.

It was the green and bluish colors of this fly sitting on the wing of a dead bird that got my attention. With a ring flash mounted to my lens, the aperture set to f/22, and my shutter speed set to the flash sync speed of 1/250 sec., I moved in as close as I could focus, rendering a 1.5X magnification. A shot like this would be next to impossible to record without the ring flash. The natural light levels were really low (the bird was in the shade of a tree and it was early evening). If I had had my tripod and were going to shoot in available light, I would have had to rely on this fly sitting very still for an available-light exposure of f/22 at 1/4 sec., and considering the feast that was before it, that wasn't going to happen.

Micro-Nikkor 105mm lens, f/22 for 1/250 sec.

NONTRADITIONAL SUBJECTS

If you are intent on experiencing an endless journey in the world of macro photography, then you must also embrace the truth that anything you point the lens at has the potential to be a blockbuster image—*anything*!

Those of us blessed with sight have no trouble taking in the grand cityscape or landscape before us. Given the right combination of light, time of day, season, and even inclement weather, we stand in awe as we look out on these stunning scenes. Hopefully, we have our camera to capture these rare and fleeting moments when they present themselves to us.

But, unlike the rare and fleeting landscape moments we come upon in the world around us, stunning close-ups are seldom rare or fleeting; in fact, stunning close-ups are commonplace, namely as flowers and autumn-colored leaves. Yet as beautiful as flowers and autumn leaves are, they represent a mere fraction of potential close-up subjects.

A simple exercise I suggest to all of my photography students always results in countless discoveries and it goes like this: Place a macro lens on your camera (or a combination of several extension tubes with your street zoom, i.e., 17–85mm lens), and open up the kitchen drawers and start looking at the utensils, *up close*. From there, move on to the home office, and check out the paper clips, thumbtacks, and pencil tips. From there, move into the garage and "jump inside" the toolbox.

Before long, you'll have made the discovery that you truly don't have to travel far at all to find compelling close-ups. When combined with a willingness to improvise and/or create "from the ground up" your very own brand of a close-up image, you will have made the ultimate discovery that the road of compelling close-up photography is, indeed, endless.

Here's an idea. Set up a small table near a south-facing window. Get a piece of matte-finish silver poster board. Fill a spray bottle with water, hold it about 2 feet above the board, and mist the board so that you end up with "dewdrops" atop the surface. Then finish it off with a dusting of powdered paint pigments (found at most art supply stores). Go to work with your macro lens and you will soon find a masterpiece at every turn!

Many kitchen gadgets placed on colored paper can make great close-up and macro subjects. The metallic surfaces of these items pick up the color of the paper. Here I placed this cheese grater on pieces of rose and green paper. Note that the visible scratches aren't digital noise but the wear and tear of daily use.

Top: Micro-Nikkor 105mm lens, tripod, ISO 100, *f*/22 for 1/15 sec. Bottom: Micro-Nikkor 70–180mm lens, *f*/11 for 1/30 sec.

PHOTOGRAPHING PEOPLE

My photography career didn't begin with people as my main interest. Waterfalls and forests, flowers and bees, lighthouses and barns, and sunrises and sunsets drew 99 percent of my attention. This continued for more than 10 years until one day I found myself composing yet another snowcapped peak reflected in a still foreground lake. That day proved to be a turning point as I began to reflect on the absence of people not only in my private life but equally so in my pictures. Spending countless days and weeks in nature was making me lonely. For the next 5 years, I found myself making a slow but deliberate transition: I spent less and less time shooting peopleless compositions. I felt a new passion as I realized that the most vast and varied photographic subject was people. I felt lucky! As the song goes, "People who need people are the luckiest people in the world." And, I was quick to discover that my camera could be a bridge—a way of introducing myself—to people.

OVERCOMING
YOUR SHYNESS

Despite my revelation about photographing people, I still had one hurdle to overcome: my shyness. Since I'm normally an outgoing person, I was amazed to discover just how shy I really was. On more than one occasion, I resolved to abandon my interest in people photography. After all, my landscape and close-up photography was already well received by magazine, greeting card, and calendar publishers. And mountains didn't move, flowers didn't stiffen up, and butterflies never once asked for payment.

I could only conclude that I was afraid of both rejection and intimacy. Unlike the landscapes with which I was so familiar, people can—and oftentimes do—talk back, and they do have something to say. Sometimes, potential subjects would refuse to let me take their picture. But when I heard a "yes" response to my request, my anxiety over being rejected was then quickly replaced by the fear of intimacy. Unlike a flower, which needs no coaxing, people require interaction: I had to get involved with my subjects if I had any hope for spontaneity. Otherwise, if I just simply raised the camera to my eye and took the picture, my subjects would immediately become self-conscious. It was as if I were a doctor with a huge hypodermic needle about to administer the shot of their life.

I was soon approaching subjects with the truth. I would say, "I don't know if you're aware of it, but right now you are at the heart of a truly wonderful picture!" Or, "There are some really wonderful things going on just over there; all that's missing is a person in the scene, and you really are the person who can make that scene a truly wonderful and compelling picture!" Today, this approach often continues to get me the permission I seek, but experience has also taught me that some situations require more diplomacy while others need much less. And the one key thing, above all else, is the importance of showing a genuine interest in the people you're photographing. You'll achieve a greater degree of cooperation and spontaneity when your tone and intent are sincere.

Outside the town of Charja in the United Arab Emirates, I came upon several men playing cards. Although the game itself proved interesting to photograph, I wanted, more than anything, to make a portrait of this particular gentleman. An aperture of f/4 got me a selectively focused image with the man in the background remaining an out-of-focus—yet important—supporting element.

80–200mm lens, f/4 for 1/250 sec.

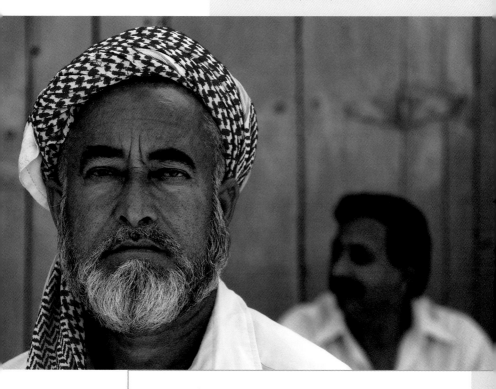

HONESTY IS THE BEST POLICY

Whether you know your subject or are approaching a complete stranger, tell the person why you want to photograph him or her and what it is you have in mind. Be honest about your intentions. I can't overstate the importance of this. Don't walk up to the farmer at the roadside produce stand and tell him you're doing a story for *National Geographic* magazine when you know that's not true. Don't walk up to that woman on the beach and tell her you're doing a story for *Travel + Leisure* when you aren't. Tell the truth!

APPROACHING AND RESPECTING PEOPLE

No one will argue that every successful landscape shot or close-up relies in large measure on its ability to evoke both mood and emotion, and that quite often a bit of luck and opportune timing played a major role; however, I've also learned that luck is seldom a factor when you try to shoot good images of people. Every successful photographer possesses a combination of creative and technical skills as well as the ability to anticipate the decisive moment. But I continue to maintain that beyond f-stops, shutter speeds, great light, the right lens, the right environment, and the right subject lies the most important element of all: the ability to relate to, and understand, what motivates the people you wish to photograph.

And since people are the subject, it is paramount that you embrace what is, perhaps, the greatest rule governing the human condition: You only get one chance to make a first impression.

One of the greatest public relations tools digital photographers have at their disposal is that screen on the back of the digital camera. I can't stress enough just how much easier it has become to overcome the photographic hurdles of people photography. My subjects are now able to enjoy the instant gratification of seeing an image within seconds of my making it—an advantage only a digital camera can provide. This adds to people's willingness to pose and their enjoyment of the process.

But whether you shoot digital or film, sometimes you'll need to be able to pose, direct, and ask your subjects to dress or look a certain way. These tasks may seem relatively easy with family and friends, but they can prove quite challenging when you need the cooperation of someone you met only 10 minutes ago. So, when I photograph people, it is never my intention to embarrass them or to call attention to a particular flaw in their physical appearance. Unfortunately, the temptation to exploit or embarrass a subject is, at times, so great that some photographers succumb to it, and rather than gaining a subject's trust, they turn the camera into an enemy. I'm also not a big fan of shooting from the hip or using a wide-angle lens to distort faces.

This older gentle man was taking a break from his recycling business, smoking from his shisha pipe. I observed him for a while, and then only after making my presence known and talking to him for a bit did I begin photographing him.

12–24mm lens at 19mm, *f*/8 for 1/15 sec.

MY BASIC APPROACH

First, I seldom approach anyone I don't find interesting, which of course is very subjective, since what I find interesting may strike another as completely boring. Second, I find that a few minutes spent simply observing a potential subject (sometimes discreetly) goes a long way toward determining how I want to photograph that subject. It is during these several minutes that I make mental notes about specific mannerisms or expressions I may wish to capture. And as I've stated, it also helps, when I do approach a person, that I explain the reason I'm interested in making the photograph.

PEOPLE PSYCHOLOGY 101

Lucky is the photographer who has a sound understanding of human psychology and the patterns of human behavior. If you're going to be able to motivate anybody to be your subject, you had better be prepared to answer their biggest and most immediate question, whether it's spoken or unspoken: "What's in it for me?" This is a fundamental "law" of human psychology that governs most of what people do.

Also important is tone of voice. It's just another side of human nature: Most of us feel "safe" when the tone of voice is self-assured rather than when it's indecisive and unsure. Your subjects are more inclined to feel motivated not by *what* you say but by *how* you say it; once again, it's the sincerity of your request.

And, no matter where or who you choose to shoot, you should, first and foremost, be motivated to make images that feed the fires of your creative endeavors. Whether or not an image advances your career or wins a photo contest is truly secondary to the greater reward. People photographers often work inside the fiercely protected psychological boundaries that many subjects possess, but whether it be immediate or several hours later, I often feel enriched by the shared experience and am grateful for that best high of all: connecting with others, whether they be family, friends, or strangers.

Digital cameras allow you to switch between color and black and white with the push of a button. When this Ukranian security guard finally smiled, revealing gold front teeth, I had already switched to black and white and so, unfortunately, those gold teeth are forever without color. You can take two lessons from this: (1) If you're not absolutely sure you only need black and white, always shoot in color; you can always convert images later. (2) It may take a little while for subjects to relax.

Both photos: Nikon D1X, 20–35mm lens at 28mm, ISO 200, f/5.6 for 1/160 sec.

UNCONVENTIONAL TECHNIQUES

Perry Thurston was one of those kids in my 4th grade class who always did the opposite of what our teacher, Mrs. Mitchka, asked. When we placed our chairs upside down atop our desks at the end of the day, Perry's chair would be right side up. Perry often spent more time in the principal's office than in class. I have no idea where Perry is today, but I bet he's either an inventor or engineer. He questioned the status quo and always seemed to offer up another way of doing things, right or wrong.

Throughout this book, I've offered a host of techniques that should keep you busy for years, but I'd be an idiot to say that if you deviate from my suggestions you're destined for failure. In fact, I say the opposite. At some point, throw away one of my ideas for "foolproof" exposure and do the opposite, or don't use a tripod and deliberately move the camera during your exposure. For every ten of those that's-not-possible encounters, turn just one into a new possibility. What follows are a few ideas I've tried that, for the most part, violate the "right" way to make an image—yet they somehow work.

MAKING "RAIN"

The rain effect is easy to achieve. Whether you choose to set up your "rain" in the early morning or late afternoon, it's important that you (1) use an oscillating sprinkler, since it is best at making realistic rain, and (2) place it in an area that has lots of unobstructed low-angled sunshine. Additionally, you must face the sun when you shoot, making sure your subjects are backlit (sun behind subject). If your subjects are frontlit or sidelit, you won't record much rain at all, since it's the backlight that creates the contrast, allowing the rain to stand out. Once you have

So, first set your shutter speed to 1/60 sec.; use an ISO of 100 or 200 to make that happen. Then get the correct meter reading by moving in so close that your backlit subject fills most of the frame *before* turning on the water, and adjust your aperture until the light meter indicates a correct exposure. Next, move back a bit and frame up your overall composition, and with the camera on tripod and your exposure set, fire up the sprinkler. Note if the falling rain is cascading down across the entire subject area, and if it's not, move the subject so that they are being completely covered by the rain. Once everything is perfect, start firing away when the sweeping arc of the oscillating sprinkler begins to fall just behind and then onto the flowers.

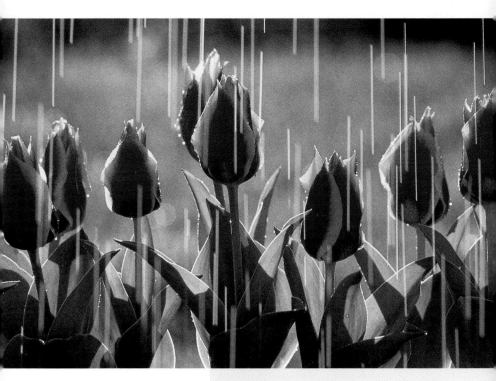

If you're like me, you welcome spring with great enthusiasm. The sun has returned and the rains have subsided—the *real* rain, that is. I used an oscillating lawn sprinkler to make it "rain" on these backlit tulips, and I metered off the green grass behind them. With my shutter speed set, I adjusted my aperture until f/10 indicated a -2/3 exposure and fired away.

80–200mm lens at 200mm, 20mm extension tube, 1/60 sec. at f/10

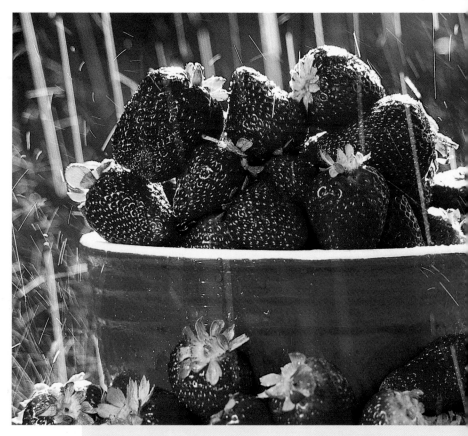

After I'd been using this technique for several years to photograph flowers, I began to place other subjects in my falling "rain," including this bowl of fresh strawberries and my niece's husband, Jason. For the berries, I placed the bowl on a small wooden stool and took a meter reading from the light falling on them. After I set my exposure, I backed up, recomposed, turned on the sprinkler, and fired each time the droplets fell on the bowl.

For the portrait of Jason, I used a garden hose as a water source for the cooling drops of "summer rain." Since Jason isn't transparent, I needed to use a reflector to fill his face with reflected sunlight (to avoid silhouetting him). To take my reading, I filled the frame with his face, set my shutter speed, and then adjusted my aperture. Note the difference the shutter speed makes here in the final effect. At 1/500 sec. (near right), the water doesn't look like rain—proof that you must use 1/60 sec.

Above: 80-400mm lens at 300mm, 1/60 sec. at f/19. Near right: Nikon D2X, 70-200mm lens at 200mm, 1/500 sec. at f/8. Far right: Nikon D2X, 70-200mm lens at 200mm, 1/60 sec. at f/11

"PAINTING"

Until recently, the "rule" of photography was to keep the horizon line straight and, above all else, make sure it's in focus. It was also unthinkable for a photographer to deliberately handhold the camera while using a very slow shutter speed. Those who did were often scoffed at because the resulting images were, of course, blurry and out of focus. Fortunately, times have changed, and the idea of "painting with a slow shutter speed" has been embraced. But, unlike panning, which is already challenging enough, painting is a real hit-or-miss affair. When everything does come together, however, it is truly rewarding.

Painting with shutter speed is a simple technique, really. You simply set a correct exposure that allows the use of 1/4 or 1/2 sec., and at the moment you press the shutter release, you twirl, arch, jiggle, or jerk the camera in an up-and-down or side-to-side or round-and-round motion. (You can even spin around on your heels while pointing the camera above you.) The challenge is in finding the right subject to paint. Just as Claude Monet discovered with his brush and canvas, flower gardens continue to be the number one choice for painting with shutter speed, but don't overlook other subjects, such as harbors, outdoor markets, and even the crowd at an NFL football game. Also, consider painting in low light with shutter speeds ranging from 2 to 8 seconds. The difference here is that your movements would be slower than the quick ones just mentioned, and the resulting effect can mirror the work of a painter using a palette knife, as the exposure time builds up one layer upon another. Presto! An instant abstract painting.

Primroses and crocuses are welcome signs of spring, offering the promise of warm and sunny days to come. Handholding my camera during the exposure, I simply made a circular movement while I aimed down at the flower bed. I was both surprised and delighted to discover that this circular motion recorded a "flock of flying and colorful seagulls." Experimentation can, and often does, prove successful, and again, digital photographers never have to fret over the film cost of these experiments—since there are none!

35–70mm lens, f/22 for 1/4 sec.

While in Seattle a few months ago, I returned with my students to the Seattle Center, where we photographed several motion-filled opportunities. The first one, made with the camera on tripod, includes the Space Needle; I hand-held my camera for the painting shot of just the Ferris wheel. While the exposure is the same for both, to "paint" the wheel, I did my best to pan the camera in the same circular motion of the ride itself.

Both photos: 12–24mm lens, ISO 200, f/22 at 1/2 sec.

What's interesting about this image made at the St. Patrick's Day Parade in New York City is the pattern created by the color and shapes. As the marching band passed by, I panned in a right-to-left direction at 1/2 sec. while at the same time zooming my lens. With zoomed exposures, it's best to begin by framing up your composition first with the widest angle of the lens and then zoom toward the longer end. For example, 17mm to 35mm or 18mm to 55mm or 70mm to 300mm. It takes practice; if your first few attempts don't measure up, you're either zooming too fast or too slow. Don't worry—you'll soon learn the rhythm.

Nikkor 70–200mm lens, 4-stop ND filter, ISO 100, 1/2 sec. at f/22

ZOOMING

A simple and well-proven method of what I call "waking up the dead" is a simple twist or push/pull of the zoom lens. Tripod or no tripod, the choice is yours. Personally, I prefer to use the tripod for simple zooms, as it results in a cleaner image. And just as with painting techniques, finding photographic subjects to zoom is easy.

Zooming can sometimes reveal surprises such as the "God's rays" seen here bursting out from behind this lone oak tree at sunset. Truth be told those aren't God's rays but simply the result of zooming my tripod-mounted lens during a quick 1/4-sec. exposure.

Nikkor 35–70mm lens, tripod, ISO 50, *f*/22 for 1/4 sec.

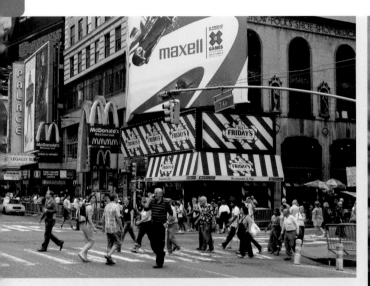

No trip to New York City is complete without visiting Times Square, and no trip to Times Square is complete until you've tried your hand at zooming. The very electrifying energy that results clearly captures the vitality of this hustling and bustling location.

Nikkor 70-200mm lens, 3-stop ND filter, ISO 100, f/22 for 1/2 sec.

ATTACHING
THE CAMERA TO . . .

The great folks at Bogen make a host of fantastic tripods, but they also make a bunch of accessories that allow you to put a camera just about anywhere you can imagine. One of my favorite gadgets is called the Bogen Magic Arm, which at its fullest extension is about 24 inches.

Another is Bogen's suction-cup clamp that, in many ways, is akin to a plunger. It sticks so well it could give Super Glue a run for its money. With the "plunger," you can place your camera on any smooth surface, including walls, ceilings, and hoods of cars as they speed through tunnels.

Then there's the Bogen Super Clamp, a really cool device that lets you attach your camera to most anything—skateboards, bicycles, a tennis racket, a putter—and record images from new points of view.

With a Bogen Super Suction Cup, I was able to mount my camera and fish-eye lens on the hood of my friend Phillipe's car in order to make an exposure as we drove through a tunnel in France. To capture a sense of motion, I needed a slow shutter speed, and to determine my aperture I took a meter reading in the tunnel, before mounting the camera, by standing up through the sunroof and shooting down on the hood. After exiting the tunnel, I took another reading of Phillipe's face illuminated by the bright interior dome light of the car and discovered that this exposure matched the tunnel exposure. We were all set.

Next, I mounted the Nikon remote receiver to the camera, which I in turn mounted to the hood facing us, and we donned our ghoulish masks (I wanted an eerie, *Jacob's Ladder* kind of feel). As we drove through the tunnels, I simply fired the camera from inside the car with the Nikon remote sending unit. After several passes (we had to find the best driving speed), we finally got it right! (Note: Phillipe's blue car recorded an odd bronze, and while trying to correct this in Photoshop, I came across this purple color that I really liked.)

17–55mm lens, ISO 100, 1 second at *f*/11

As it was strong enough to hold my Nikon D2X and fish-eye lens, I mounted my Bogen Magic Arm on the handlebar of a shopping cart and attached a 2-foot cable release. As my wife's friend Catherine pushed her daughter through the grocery store, I tripped the shutter with my cable release. I had determined the exposure before we started moving and also had set my white balance to Fluorescent since I was shooting under fluorescent lighting.

Nikkor full-frame 14mm fish-eye lens, ISO 100, f/16 for 1/2 sec.

PHOTOGRAPHING "GHOSTS"

To photograph ghosts, it is critically important that you believe in them. That's not really true, of course, but if this kind of time exposure seems fun to you, then you'll be interested in this technique. The first place to go looking for ghosts, of course, is an old Victorian-style home, like those in the New England area. Since you can only see ghosts at night, that means long exposures and bringing your tripod. Ghosts are shy by nature, and I've found that it takes about 8 seconds for them to reveal themselves to you. (It's also important that you stand very still since any disturbance to the air could cause the ghost to flee.)

To capture this "ghost," I found myself going into the "cave" (i.e., the basement) of my own apartment building. With my camera mounted on a tripod, I planned the composition seen here, set the aperture, and adjusted my shutter speed until the camera meter indicated a correct exposure. The idea for this shot was originally born after both my daughters watched the movie *The Ring*. My daughter Sophie won the coin toss to play the role of the ghost. Outfitted with a white dress and no shoes, she simply stood in the dirt floor hallway of the "cave," holding perfectly still for the first 4 seconds of my 8-second exposure. Then, at the end of 4 seconds, she bolted out of the picture to her left where there was another short hallway. Since she was only in the shot for half of the exposure time, she recorded only as a transparent, ghostlike subject. Pretty neat, eh?

12–24mm lens, tripod, ISO 100, *f*/8 for 8 seconds

DELIBERATE
OVEREXPOSURE

When was the last time you deliberately shot a composition as overexposed? I don't mean unintentionally overexposed. I don't mean overexposed by 1 or 2 stops. I mean overexposed by 3 or 4 stops. Like any experiment, the results of 3- or 4-stop overexposure won't always be compelling; but since, more often than not, they will, you may want to try this simple trick. The light should be even, and for that reason, frontlit subjects, or those under the soft and even illumination of an overcast day, are best.

With my camera on a tripod, I was able to compose a graphic image of flamingos in the small lake below me in Singapore's Jurong Bird Park. After I made the proper exposure, I adjusted my shutter speed from 1/500 sec. to 1/250 sec (+1 stop) to 1/125 sec. (+2 stops) to 1/60 sec. (+3 stops) to 1/30 sec. for a 4-stop overexposure—and a very different look.

Both photos: 70-300mm lens at 300mm. Opposite, top: f/8 for 1/500 sec. Right: f/8 for 1/30 sec.

USEFUL TOOLS

One of the ongoing challenges photographers face is bringing an idea to fruition. I'm sure I speak for many when I say that as great as our ideas may be, most of them remain unrecorded for many reasons, not the least of which might be the absence of technology to make it happen or perhaps the absence of the knowledge of how to make it happen. My search for new ways of seeing or new ways to get around exposure issues continues, and to borrow a common self-help phrase, whatever the mind can conceive and believe, it can achieve; in today's photographic marketplace, the plethora of equipment, the technology, and the necessary know-how can combine to achieve just about any shot possible. The following items are by no means a complete list of must-have equipment. For some it may be too long of a list, and for others not nearly long enough. The items are, however, those that in my view will allow you to shoot just about anything that crosses your path in available light.

TRIPODS AND
TRIPOD HEADS

Is a tripod really all that important any-more? If you listen to some shooters, especially those using VR (vibration re-duction) or IS (image stabilization) lenses and shooting the higher ISOs, you would think not. But what these photographers don't realize is that a tripod is much more than a simple "stabilizer" for your camera and lens. It is, first and foremost, intended to help you make artful images, since it will force you slow down and really see what you're composing. It will also let you shoot any number of long exposures (1/4 sec. or more) in exacting sharpness.

You'll never record that waterfall cotton candy effect or those endless taillight streaks at dusk without a tri-pod. And, for sure, if you're at all inter-ested in macro photography, the need for exacting sharpness for crystal-clear details always demands tripod use. In addition, since so much close-up photography involves incredibly close working distances, depth of field is at a premium. The depth of field found in close-up photography is often no greater than 1 inch, front to back, even with f/22! The combination of a low ISO and small lens openings means that exposure times between 1/30 sec. and 1 second are the norm—

and are certainly, mostly, far too slow to handhold.

Of the many tripods out there, give serious consider-ation to those with carbon fiber legs. Carbon fiber is much lighter than steel; if you plan on using your tripod re-ligiously, you don't want to be weighted down more than necessary. Next, consider tri-pod height. The tripod head should sit at chest level when all three legs are extended. Then you'll want a tri-pod whose legs can "click out" to go almost parallel to, if not flush on, the ground. Or, look at those tripods that offer a center column that, when ex-tended, can flip to the horizontal po-sition, thus allowing you to shoot low to the ground. This is something you'll need for making great storytelling compositions as well as for shooting macro shots of dewdrops on flowers.

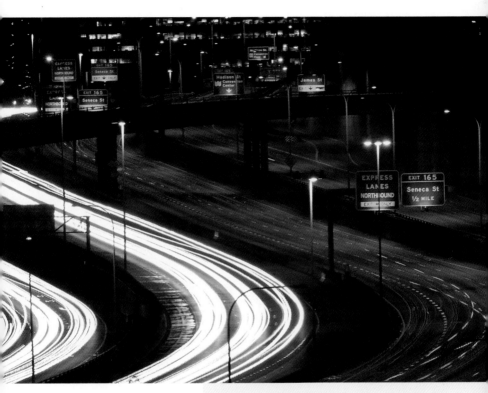

It's always my goal to present moving subjects in the most motion-filled way. That required a longer shutter speed and tripod here.

Nikon D2X, Nikkor 200–400mm zoom lens at 400mm, ISO 100, *f*/16 for 8 seconds, Cloudy WB

Finally, you need to consider the tripod head. This is most important because it supports the bulk of the camera and lens weight. When looking at the many different styles of heads, make a point to mount your heaviest combination of camera and lens on each one as a test. Check if it flops or sags a bit. If so, you need a much sturdier head. It also should be able to shift from a horizontal to vertical format with a simple turn of the handle. Also check whether you can lock it at angles in between horizontal and vertical. Finally, does the tripod head offer a quick release? Some tripods require you to mount the camera and lens directly onto the tripod head by way of a threaded screw. A quick release, on the other hand, is a metal or plastic plate that attaches to the camera body and allows you to secure the camera and plate to the head via a simple locking mechanism. To remove the camera and lens, you simply flick the locking mechanism and lift them off the tripod. There are several well-known ball head manufacturers, including Kirk Enterprises, Really Right Stuff, and my favorite, Arca-Tech.

These are very different types of subjects, but I needed to use a tripod to capture them successfully. On the right, a tripod ensured that I kept my lens parallel to the dew-covered spiderweb to get maximum depth of field. (Remember, depth of field is extremely shallow in close-up work.) For the image above, I had already set up my camera and tripod—and had fired off several frames of the sunburst through this stand of trees—when a couple came up from behind me and continued walking into the scene. Ah, you gotta love Lady Luck!

Above: 70-200mm lens, ISO 100, f/22 for 1/125 sec. Right: Micro-Nikkor 70-180mm lens, f/22 for 1/30 sec.

DON'T GO CHEAP!

I've learned many valuable photographic lessons over the past 30 years, and there is one thing that stands out with absolute certainty: Don't go cheap when it comes to buying a tripod!

What's my barometer for cheap? Less than $300 for a tripod and its related head. A tripod-and-tripod-head combo that costs less will only perform well for about 2 to 3 years with normal use. You're better off buying *one* tripod that costs more up front, because in the long run, you'll be money ahead. As one student put it, "I only wish that this fifth and final tripod I just bought could have been my first!"

SELF-TIMERS, MIRROR LOCK-UP, AND CABLE RELEASES

In addition to the tripod, there are those smaller things that come into play if you want to improve your odds of achieving razor-sharp images: the camera's built-in self-timer, the camera's mirror lock-up feature (not present on all cameras), a cable release, and a wireless remote triggering device.

Whether you use any of these tools will depend in large measure on your shutter speed. Obviously if you're handholding because you feel the shutter speed is fast enough to do so, then you won't need any of these tools; however, there will be many times when your shutter speeds are far too slow to handhold and even slow enough to require the use of a cable release and mirror lock-up. Based on my personal experience, if your shutter speed has fallen below 1/60 sec., you should *not* be shooting without a tripod, and if your shutter speed falls below 1/15 sec., you should *always* be using a cable release or the camera's self-timer, along with the camera's mirror lock-up feature if you have it.

When there's any wind at all, *do not* use the self-timer! In all likelihood, the subject before you is being affected by the subtlest of breezes, and when the wind does stop momentarily, you can't afford to have an additional delay of 2 or 5 seconds for the self-timer to fire the shutter release; the wind could easily pick up again, and if it does, it will do so right at the moment the exposure is being recorded.

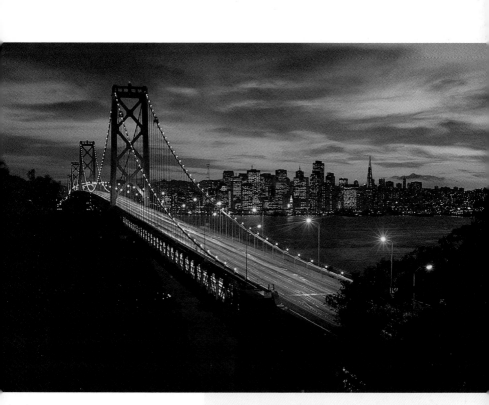

A steady tripod enabled me to shoot this classic scene of the San Francisco skyline. With my camera and lens on a tripod, I set the focal length to 50mm and my aperture wide open at f/2.8. I then pointed the camera to the sky above and adjusted the shutter speed to 1/2 sec. Since I wanted an exposure of at least 8 seconds to capture the flow of traffic on the bridge, I knew that by stopping the lens down 4 stops to f/11 would require me to increase my exposure time by these same 4 stops to 8 seconds. With an 8-second exposure, I tripped the shutter with my cable release.

35–70mm lens at 50mm, f/11 for 8 seconds

SELF-TIMERS, MIRROR LOCK-UP, AND CABLE RELEASES

POLARIZING FILTERS

Of the many filters on the market today, a polarizing filter is one that every photographer should have. Its primary purpose is to reduce glare from reflective surfaces, such as glass, metal, and water. On sunny days, a polarizer is most effective when you're shooting at a 90-degree angle to the sun. For this reason, sidelight (when the sun is hitting your left or right shoulder) is a popular light in which to use this filter. Certainly, *maximum polarization* can only be achieved at a 90-degree angle to the sun; if the sun is at your back or in front of you, the polarizer does you no good at all.

Working in bright sunlight at midday isn't a favorite activity for many experienced shooters, since the light is so harsh, but if you need to make images at this time of day, a polarizer will help somewhat. This is because the sun is directly overhead—at a 90-degree angle to you, whether you're facing north, south, east, or west.

If you're working in morning or late-afternoon light, you'll want to use the polarizing filter every time you shoot facing north or south. You'll be at a 90-degree angle to the sun, and as you rotate the polarizing filter on your lens, you'll clearly see the transformation: Blue sky and puffy white clouds will "pop" with much deeper color and contrast. Why is this? Light waves move around in all direction: up, down, sideways, and all angles in between. The greatest glare comes from vertical light waves, and the glare is most intense when the sun itself is at a 90-degree angle to you. The polarizing filter removes this vertical glare and blocks out vertical light, allowing only the more pleasing and saturated colors created by horizontal light to record on digital media or film. Although there's vertical light around when you're working with frontlit or backlit subjects, there's no need to use the polarizing filter at these times, since the sun is no longer at a 90-degree angle to you.

Since my point of view was at a 90-degree angle to the early-morning light coming in from my left, this scene of Neuschwanstein Castle in the German Alps offered an obvious opportunity to use my polarizing filter. In the first example, I didn't use the filter, and you can see the overall haze, the lack of vivid blue sky and of detail in the distant mountains, and the somewhat flat greens of the valley floor. In the second example, with my polarizing filter on the lens and rotated to achieve maximum polarization, the difference is clear. Even the cloud is more vivid—and has company!

Both photos: 35–70mm lens at 35mm. Left: *f*/8 for 1/250 sec. Below: *f*/8 for 1/60 sec.

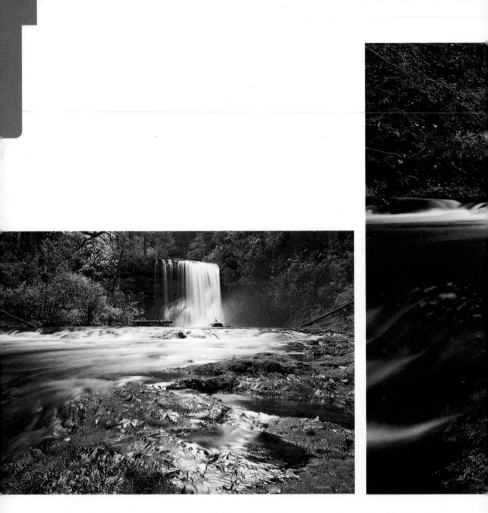

Note that if you shift your location so that you're at a 30- or 45-degree angle to the sun, the polarizing effect of the filter will be seen on only one-half or one-third of the composition, so one-half or one-third of the blue sky will be much more saturated than the rest. Perhaps you've already seen this effect in some of your landscapes. Now you know why.

Are you limited to using polarizing filters on sunny days? Definitely not! In fact, on cloudy or rainy days, there's just as much vertical light and glare as on sunny days. All this vertical light casts dull reflective glare on wet streets, wet metal and glass surfaces (such as cars and windows), wet foliage, and the surfaces of bodies of water (such as streams and rivers). The polarizing filter gets rid of all this dull gray glare.

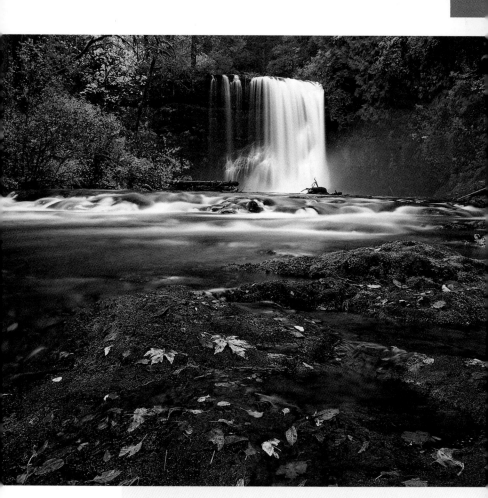

I can't live without my polarizing filter, more for the rain than for the sunshine. It's the one tool that will save you each and every time in the woods on rainy days. It alone can remove all the glare from your rainy-day compositions—no amount of Photoshop ever will! Take a look for yourself. Opposite, without the polarizing filter, note all the glare; the stream, rocks, and leaves are all reflecting the dull gray rainy sky overhead. But above, with the filter, you discover a colorful world that only seconds ago was awash in glare.

Note that because a polarizing filter cuts the light down by 2 stops, I had to increase my shutter speed by 2 stops (from 1/4 sec. to 1 second) to accommodate this. Since that brought the shutter speed to 1 second, a tripod was a must, and I then used the camera's self-timer to fire the shutter release.

Both photos: 24mm lens. Opposite: f/22 for 1/4 sec. Above: f/22 for 1 second

NEUTRAL-DENSITY FILTERS

Is there a filter that can reduce your depth of field, imply motion, or turn that fast-moving waterfall into a sea of frothy foam? You bet there is: a neutral-density filter. The sole purpose of the neutral-density (ND) filter is to reduce the intensity of the light in any scene. It knocks down the overall brightness without interfering with the overall color and comes in stop increments. So for example, a 3-stop ND filter knocks down the brightness of the light by 3 stops.

This reduction of light intensity lets you use larger lens openings (resulting in shallower depth of field) or slower shutter speeds. If, for example, I were using ISO 400 and wanted to create a cotton candy waterfall effect, I would first stop the lens down to the smallest opening, say $f/22$. I'd then adjust my shutter speed until I got a correct exposure, say 1/15 sec. But 1/15 sec. is too fast to record this effect; I'd need at least 1/4 sec. So I'd use a 3-stop ND filter and knock the intensity of the light down by 3 stops. My meter would tell me that $f/22$ for 1/15 sec. is 3 stops underexposed, so I'd readjust to 1/2 sec. (1/15 sec. to 1/8 sec. to 1/4 sec. to 1/2 sec. is 3 stops), which is slow enough to record the effect.

And there are other "problems" the ND filter can solve. Let's say you're photographing a vendor at an outdoor flower market. You position your subject about 10 feet in front of a flower-stand display and want a background of only out-of-focus flower tones. You choose a short telephoto lens (say 135mm) and a large aperture (say $f/4$) to limit the depth of field. As you adjust your shutter speed and reach the end of the dial (say 1/2000 sec.), your light meter still indicates a 2-stop overexposure. You could stop the lens down to $f/8$, but this would increase the depth of field, revealing too much background detail. By adding a 3-stop ND filter to your lens, $f/4$ for 1/1000 sec. yields a correct exposure—and gives the depth of field you want.

Although you can buy ND filters that reduce the intensity of light from 1 to 4 stops, my preference is the 3-stop filter. As you'll see over time, this is all you need when you want to use slower shutter speeds or larger lens openings without the worry of overexposure.

With my camera and 80–200mm lens on a tripod, I set my aperture to *f*/22, knowing full well that a lens opening this small would necessitate the slowest possible shutter speed. To "explode" this meadow of flowers with my zoom lens, I needed a slow shutter speed. How slow? Normally, at least 1/4 sec., if not 1/2 sec. As I adjusted my shutter speed, I noticed that my light meter indicated 1/30 sec. as correct. So I threaded my 3-stop Tiffen neutral-density filter onto the lens, and just like that, I had a correct exposure indication of *f*/22 for 1/4 sec. As I fired, I zoomed the lens from 80mm to 200mm during the 1/4 sec. period.

80–200mm lens, *f*/22 for 1/4 sec.

GRADUATED
NEUTRAL-DENSITY FILTERS

Unlike a neutral-density filter, a graduated neutral-density filter contains an area of density that merges with an area of no density. Rather than reducing the light transmission throughout the entire scene as an ND filter does, a graduated ND filter reduces light only in certain areas of the scene.

Suppose you're at the beach just after sunset and want to use your wide-angle lens to get a photograph that includes the bright, color-filled post-sunset sky, several small foreground boulders surrounded by wet sand, and the incoming waves. Since this is a storytelling image, you choose f/22 for maximum depth of field. Then you point your camera at the sky and get 1/30 sec. But for a meter reading from the wet sand, 1/2 sec. is correct. That's a 4-stop difference in exposure. If you go with f/22 for 1/30 sec., you'll record a wonderful color-filled sky, but the foreground sand and rocks will be so underexposed they'll hardly appear. But if you expose for the sand and rocks, the sky will be way overexposed and all its wonderful color will disappear.

The quickest ways to "change" the exposure time for the sky so that it gets close to matching that of sand and rocks is to use a drop-in neutral-density filter. Unlike a graduated neutral-density filter, which is round and threads onto the front of your lens, a drop-in filter is square or rectangular and drops into a filter holder that you secure to the front of your lens. This lets you slide the filter up or down or turn the outer ring of the holder to place the filter at an angle. And this allows for perfect filter placement in most of your scenes.

So in the situation I described, the solution would be to position a 4-stop graduated neutral-density filter so that the ND area only covers the sky and stops at the horizon line. You wouldn't want the ND area covering anything other than the bright sky. Once the filter is in place, the correct sky exposure would be reduced by 4 stops, and you could shoot the entire scene at f/22 for 1/2 sec.

Just like ND filters, graduated ND filters come in 1- to 4-stop variations. In addition, they come in hard-edge and soft-edge types, meaning that clear section of the filter meets the ND section with either an abrupt change or a gradual transition. My personal preference is the soft edge.

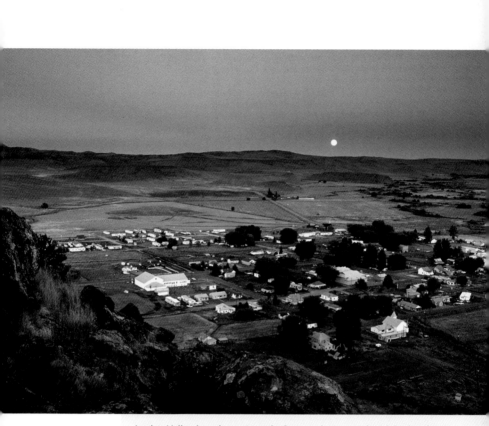

Jordan Valley is a sleepy town in Oregon, just near the Idaho border. It is rich in history, with strong sheep farming and silver mining traditions, and from what I gathered in talking with the locals, the view today from the small bluff that overlooks the town is much the same as it was 100 years ago. To capture it, I set up my camera on a tripod and added a 2-stop graduated neutral-density filter to my lens. Prior to placing the filter on the front of the lens, I took a meter reading of the green landscape below and manually set a correct exposure of f/22 at 1/15 sec. I then recomposed the scene to include the distant horizon and pink sky, and as the moon rose through the eastern sky, I fired off a number of frames. Without the aid of the graduated ND filter, the sky would have been overexposed by 2 stops, resulting in a washed-out look.

35–70mm lens, graduated ND filter, f/22 for 1/15 sec.

The tricky part of this scene was the 4-stop difference between the wheat field and the sky. With my camera on a tripod, I chose an aperture of f/16 and set my exposure for the green field. At first, I recorded a correct exposure of the field but at the expense of the cloud and colorful sky. I was able to record a correct exposure of the green field as well as the cloud and sky only after placing my Lee 3-stop graduated ND filter on my lens.

If you didn't have a graduated ND filter, you could take two separate, correct exposures—one of the field and the other of the cloud and sky—and then use Layers in Photoshop to blend the two exposures into one, ending up with the same thing. But, whew! I get exhausted just thinking about this. A word of advice: If you've got Photoshop, your budget can easily absorb the cost of a graduated ND filter. Buy it now, and get the right exposure in-camera; you'll have more time to spend with your family and friends.

Both photos: 35–70mm lens, f/16 for 1/4 sec.

ALIGNING THE FILTER

If you have a camera with a depth-of-field preview button, use it as you position the graduated ND filter. As you slide the filter up or down, you can clearly see exactly what portions of the composition will be covered by the density of the filter. Using the DOF preview button will guarantee perfect alignment every time.

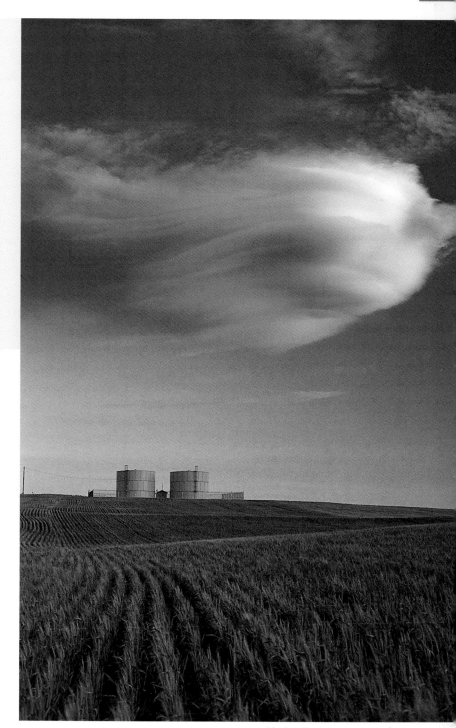

GRADUATED
NEUTRAL-DENSITY FILTERS

INDEX